the worlds of
John Ruskin

D1088213

the worlds of
John Ruskin

Kevin Jackson

PALLAS ATHENE
& THE RUSKIN FOUNDATION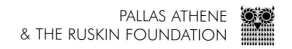

contents

*Opposite: Mountain Rock and Alpine Rose,
1844 (or perhaps 1849).
One of Ruskin's most beautiful early drawings,
this was probably brought to completion on the
spot, almost certainly in the region of Chamonix
in 1844 or 1849. The pencil under-drawing is
quite hasty, with the rocks and trees outlined in
ink, but only simple watercolour wash and a little
red chalk added. In a diary entry from June
1849, Ruskin enthused over 'the Alpine rose
clinging to its warm and tiger-striped crags,
the pines above stretching their arms
over one's heads like nets'*

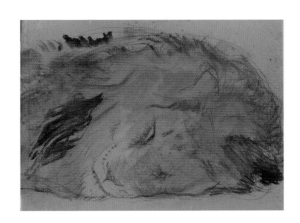

For Mark Godowski

O anima Lombarda
Come ti stavi altera e disdegnosa
E nel mover de li occhi onesta e tarda!

J. Ruskin (se ipsum)
del.

INTRODUCTION

A well-known Victorian writer once proposed that, while philosophers had previously been content to interpret the world, the real point was to change it. (For good and ill, he succeeded: his name was Karl Marx.) John Ruskin, another major prose writer of the Victorian age, interpreted the world with an eye of unparalleled keenness; he then went on to change the world in many different ways, though very few people today are aware of quite how profound and multifaceted those Ruskinian changes have been. This short book, then, is an introduction to some of the ways in which Ruskin interpreted his worlds, and some of the ways in which he changed them.

Why 'worlds' rather than world? Because Ruskin was one of history's great polymaths: he knew many things, and could do many things. He is still best known as an art critic – probably the most influential art critic of any language, at any time – and on those grounds alone he should command our attention. He championed Turner at a time when the conventional opinion was that the poor old man had lost his way, and the young Pre-Raphaelites at a time when people of taste considered them beyond the pale. He drew fresh attention to the generally neglected painters, sculptors and architects of the past, and explained why their work still lived and could inspire. His contemporaries were astounded: some of them said that he seemed, quite simply, to have given them the gift of sight.

This is already a very considerable accomplishment, but it is only a fraction of what Ruskin achieved in the fields of art and architecture. He gave new direction and intelligence to the Gothic Revival in architecture; he raged against the barbarism with which old buildings were either brutally torn down, foolishly neglected or ignorantly restored, and so established the modern tendency in architectural conservation; he was a presiding spirit of the Arts and Crafts movement, and, after his death, a beacon for many very different talents, from Frank Lloyd Wright to the designers of the Bauhaus. He was the first Slade Professor of Fine Art at Oxford, and thus helped establish history of art as an intellectual discipline in the English-speaking world. He taught working people and others how to draw, and explained why that basic skill is so crucial to humankind.

But the world of the visual arts is not the only one Ruskin examined. Long before he became a writer on art, Ruskin had been enchanted by the natural world – first of all the worlds of rocks and stones (his earliest passion, and the consolation of his troubled adult years, was geology), then the clouds and the waters. He watched all these things, drew them, pondered them, and thought about the invisible powers which had made them. (Another of Ruskin's worlds is the world of religion – first of all, the Christian faith, but later the beliefs of the ancient Greeks, the ancient Egyptians and other cultures. Theology and Mythology are two of his major concerns.) It is hardly surprising that he should have become his age's single most important writer on what we now call the environment, or ecology. His late lecture 'The Storm-Cloud of the Nineteenth Century' now seems one of his most frighteningly acute statements about our present atmospheric crisis.

Ruskin saw – the word deserves emphasis, for one of Ruskin's simplest and most urgent messages for us is that we should learn to see – he saw what was causing

Opposite: Self-portrait, Spring 1874.
Having long promised his American friend Charles Eliot Norton a portrait, Ruskin finally made two of himself in the spring of 1874, this pencil drawing and a watercolour (Wellesley College Library). The inscription – 'se ipsum' [by himself] – is in Norton's hand. Norton also added on the reverse 'not a good likeness,' although it seems to modern eyes a sensitive as well as an accurate image. There has often been detected, in the eyes and furrowed brow, an expression of the worry and sadness brought on at this time by the fluctuating relationship with Rose La Touche

that crisis, as the Romantics had seen before him: in the immediate sense, the massive growth of industry and its poisonous by-products; in the larger sense, insane, heedless greed. Ruskin could easily have devoted his whole life to studying art and nature and never troubled himself about social conditions; but he was too honest to deny the evidence in front of his eagle eyes. Looking at the history of Venice as made solid in its buildings, he became convinced that he could detect the rise and fall of a nation in the health and the decadence of the architecture it had made. Looking at the ugliness of contemporary Britain – a latter-day Venice, a mercantile, sea-faring power at the height of its pride – he saw little reason for thoughtful Britons to be unduly proud.

Where other writers might have been content to salve their irritated consciences with the occasional angry essay or speech, Ruskin resolved to do something about the condition of Britain, and the modern world in general. A rich man, he gave away almost all of his inherited wealth to the causes and the people he support- ed. He risked his considerable social and academic standing by telling his wealthy fellow Britons, loud and clear and often, that they were blind and evil. He launched a body which would combat the Dragon of *laissez-faire* capitalism, and called it The Guild of Saint George.

Was his crusade victorious? His own final verdict was probably a pessimistic one, but since his last years were spent in near-silence, we will never know. Yet there is no reason for those of us who still read him to take a dispirited view. Directly or – more often – at two or three removes, so the source has not always been obvi- ous – Ruskin has helped create some of the redeeming features of our own world, and in ways both momentous and subtle. One of his major disciples, for example, was Mahatma Gandhi, who said that reading Ruskin's short tract *Unto This Last* was the turning point of his life. Ruskin's other disciples range from Leo Tolstoy to Marcel Proust.

For the British, one of the most telling consequences of Ruskin's doctrines has been the creation of the modern welfare state, whose architects – Beveridge, Attlee & Co – were all educated in the Ruskinian vein, at Toynbee Hall and else- where. One of the fascinating paradoxes of Ruskin's career is that he was, by his own – highly idiosyncratic – definition, a Tory: a believer in Kings and Queens, hierarchy and obedience, piety and chivalry. Yet from William Morris onwards, his keenest disciples have often called themselves Socialists. Universal education for the young, public libraries, care for the sick and the elderly... all these innovations and others were either proposed or refined in Ruskin's writings, and dismissed by Victorians as sentimental or even mad.

And then there is the private world – or, again, worlds – of Ruskin. As Sir Kenneth Clark pointed out in the early 1960s, Ruskin's reputation took such a severe blow in the first part of the twentieth century that he was all but entirely forgotten, save for some mean-spirited gossip about his married life. That gossip continues, though now it is better informed, thanks to a sequence of good and even great biographies. In material terms, Ruskin's life was blessed: not only was he wealthy, but he had work that enthralled him and which he knew to be im portant. In emotional terms, he was often wretched: a loveless and ill-suited

marriage in his middle years gave way to a tormenting and unrequited yearning in his later life. As he grew older, he suffered more and more from illnesses — mainly, one suspects, psychosomatic in origin — and bouts of madness, culminating in a decade of silence and withdrawal.

Ruskin's enemies have always liked to say that the madness of the last years is already present in the eccentricities and quirks of the earlier writing. His admirers see little if any connection, save in the sense that the savage indignation stirred in him by the vile things he saw may have been more than the most robust mind could bear. Ruskin was ferociously independent-minded, almost to the point of cantankerousness, but that is one of the things that makes reading him such an adventure: his thunderous eloquence unsettles all the stale and standard ideas that clutter up our heads. The world of Ruskin's prose is incomparably strange, and incomparably rich. We can begin our journey by looking at how much Ruskin was a typical product of his age, and how far he became its living contradiction.

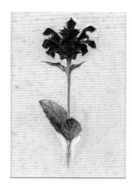

AN AGE OF SUPERLATIVES

The Britain into which John Ruskin was born in 1819 was 'on the brink of an era of prosperity and greatness unrivalled in her whole history.' This sweeping claim is, if anything, an understatement, for riches and power were only one aspect of the story. It also was a period of quite astonishingly rapid innovation and change – one that had profound consequences for all subsequent generations, not just in Britain but throughout the world.

Some pious Victorians, particularly those of an Evangelical temper, believed that Britain's triumph was the manifest will of God, and the just reward for habits of hard work, thrift and caution seldom seem in more feckless nations. Secular thinkers could point to other, more readily demonstrable causes. The century between the defeat of Napoleon's forces at Waterloo on 18 June 1815 and the day the guns began to fire in France in August 1914 has justly been described as a 'long peace' for Britain, a secure time when the age-old threat of invasion by marauding foreign armies seemed an increasingly remote nightmare, and when military conflict always took place comfortably far from home: in China, India, the Crimea, South Africa. Europe was still plagued by wars and revolutions; Britain watched from a safe distance.

After Napoleon's downfall, Britain rapidly regained the pre-eminence it had built up throughout the eighteenth century, and then proceeded to extend it until the country became, simply and incontestably, the world's only super-power. Britain enjoyed this eminence unchallenged until almost the 1890s, when a freshly unified Germany and a vigorously productive United States began to show their waxing powers (though the extent to which Britain had entered a period of economic decline in the late Victorian period did not become fully apparent to most observers until the twentieth century). But in 1870 the annual foreign trade of Britain was of staggering dimensions. £200,000,000 of goods were exported that year – more than the exports of France, Germany and Italy combined, and easily four times more than those of the USA.

An impressive figure, but not an unusual one. Post-Waterloo Britain enjoyed the biggest slice of the world's trade; the largest military navy and the largest merchant one too (more than 20,000 commercial vessels in 1815); and the most sophisticated agricultural methods, though advances in this sector were often overshadowed by the more spectacular advances in other fields. London had grown into the most populous city in the world, and become the world's financial capital.

The phenomenon that fostered all this great wealth was a new thing under the sun: technology, the conspicuous material fruit of a new way of thinking – the scientific way – that had been gathering force for centuries; particularly, in Britain, since the later seventeenth century. Some writers have gone so far as to argue that the first phase of what we now call the Industrial Revolution – the deep foundation for Britain's unprecedented wealth – effected the most dramatic material advance that humanity had known since that unrecorded time, some ten thousand years earlier, when our neolithic ancestors first took some control of their collective destiny by beginning to cultivate the land. (That ancient event is sometimes called the Agricultural Revolution. A second Agricultural Revolution accompanied the rise of industry.) Such a claim may seem extravagant, even wild, but it is far from baseless.

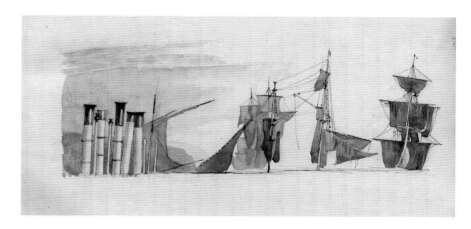

For the first time in history, machinery was being driven by something other than the wind, the waves, gravity or muscle. Steam engines, enormous coal furnaces, coal gas, and ultimately electricity were the crucial agents of change. From the 1780s onwards, Britain's industries began to be properly mechanised, with almost giddying success, especially in the three key areas of coal, iron and cotton. Figures tell the story most succinctly.

Coal production in 1780 stood at about 6 million tons a year; by 1830, the figure was 25 million. In 1788 the annual production of pig-iron was some 61,000 tons; in 1806, 227,000 tons; by 1830, at 700,000 tons. (The story continued. By 1848, Britain was producing half of the world's pig iron; and that quantity went on to treble over the next thirty years.) The most dramatic increases came in what was to be the most important of the three industries, cotton: about 5 million pounds of raw cotton processed in 1790; 56 million in 1800; about 140 million by 1820; and in the later 1820s about 220 million. Approximate increase in each field: four times larger; eleven times larger; forty-four times larger.

Massively increased production is one half of the story of riches; the other half is greater consumption. Traditionally, Britain had exported few commodities other than wool, and imported fairly modestly too – mostly timber, sugar and, in times of shortage, grain. But the birth of the British cotton industry meant, initially, the import of vast quantities of raw cotton from the young United States, and, second, the export of cotton goods around the world, notably to the Far East and other colonial territories – for, despite Britain's loss of a large piece of the New World after 1776, it still prevailed in Canada, the West Indies, and India. This development was another landmark in world history: for the first time ever, a Western country was exporting more to the East than it was buying.

This explosion of productivity, and all the technological, social and economic change transformed the world at a hitherto unthinkable rate. Historians may legitimately argue about the birth of the 'modern' world (a standard way of gaining notice in the profession), but there is no disputing the fact that the world of mass production and consumption – the world we still live in – grew from the Industrial Revolution: which might more accurately be thought of as the initial phase of a much longer Revolution. The harnessing of the atom, the rise of information technology, bio-engineering and space exploration are simply later episodes in that

same story. Pessimists now maintain that this long Revolution will end, soon, when it will leave our planet defiled and our species extinct; optimists, that the unforeseen evils created by each wave of innovations are always corrected by the next wave. Ruskin would almost certainly have been with the pessimists.

Industry was not the only thing that was growing rapidly. The population of Britain grew substantially and rapidly, too. Thanks to better housing conditions, better food, and better medical provisions, more babies survived their infancy, and more adults lived to enjoy or endure a ripe old age. At the census of 1801 – not as accurate as we might wish, but a fair rough guide – the number of Britons was estimated at 11 million, or about double what it had been a century earlier; by 1830 it was already 16 million, and the rate of population growth after Waterloo was the highest ever known. By 1891, the census was recording 33 million inhabitants.

Not that all these long-lived people were spread out evenly across the land: rather, they crowded into the new industrial centres. Manchester's population was about 20,000 in 1750; 90,000 in 1801; 228,000 in 1831. Glasgow also grew at a terrific rate, from 77,000 in 1801 to 202,000 in 1831. Sixteen years after Waterloo, half the population of Britain were townspeople. In terms of simple acreage, much of Britain remained rural and sparsely populated; but by 1850, the average Englishman was no longer a countryman, but an urban industrial worker.

While the country grew more crowded, the rate at which people could travel around it accelerated. An age of canal construction, beginning in the 1750s, provided the nation with some 3,000 miles of highly efficient waterways by 1830. Roads were improved under the system of 'Turnpike Trusts', and thanks to the innovations of Thomas Telford and John McAdam. They opened up the possibility of much faster passenger and postal services by coach, so that journeys which once took a week or more, such as that between London and Edinburgh, could now be done in a couple of days. And soon the railways would be arriving. The Stockton and Darlington railway opened in 1825; the Liverpool and Manchester in 1830 – the Duke of Wellington attended the ceremony; the London to Brighton in 1841.

There were 'manias' of speculation in the new transport systems in 1835-6 and on a greater scale in 1844-5, which led to the building of 5,000 miles of track. The scale of this investment was colossal: by the end of 1850, the paid-up share capital of British rail companies was £187 million. Fortunes could be made in a matter of weeks (and sometimes lost, too). The sheer scale of the enterprise is hard to grasp. As the historian Rebecca Stott puts it: 'In a couple of decades, two hundred thousand navvies achieved a feat of engineering comparable to the construction of the pyramids of Egypt. They were expected to shovel about twenty tons of earth and rock a day...'

Daily life grew more perceptibly more pleasant, and more orderly. Sir Robert Peel's police force, founded in London in 1829 under the charge of the Home Office, and then, over the next thirty years, developed throughout the country, brought new efficiency and discipline to the realm of public order. In the eighteenth century, the powers had always relied on the army as the ultimate guard against disorder – a policy that was savage (civilians were shot dead), unreliable (the army might side with rioters, as they did with Wilkes in 1769) and

counter-productive (the public hated it). Initially derided by the populace, the British policeman soon became respected by the honest and feared by the criminal. Gradually, it was the likelihood of capture rather than the severity of punishment which came to deter crime, and by the end of the century, the streets of Britain were far safer than they had been at the beginning. The lighting of streets by gas added not only to their safety after dark but to their attractiveness.

To sum up: the average, middle-class Briton could reasonably believe that Britain had entered a Golden Age. Snug behind the guns of the Royal Navy, which guaranteed the steady conduct of all the fruits of a swelling Empire back to the mother country, and of its admirable exports out across the world, the ever more confident, influential and plentiful middle classes were busy doing what they did best: accumulating more and more wealth, and all the powers that wealth may bring. Among the happy by-products of all that proliferating capital were astonishingly rapid advances in science and technology; all manner of rational and humane political, educational and legal reforms; and the general spread of what one Victorian thinker called 'sweetness and light'.

However it might look to our eyes after the Century of the Common Man, Britain's government was by general agreement more enlightened, tolerant and open to reform than any of the other major European countries, some of which – led by Russia and Austria – had launched into a savage monarchical and feudal reaction after Napoleon's defeat. It was a wonderful period for British writers – Dickens and George Eliot in the novel, Tennyson and Browning for poetry, Arnold and our own subject, Ruskin for prose. (Only original drama seemed to enter a long slump, though the theatres did a roaring trade with classic revivals and popular entertainments; it was not until towards the end of the century that the art of the playwright revived.) If a single word might sum up an entire age, that word must surely be 'progress'.

Such is the mainly sunny view of Britain under Victoria – a triumphal view that might smack of complacency, even smugness, to sceptics of the day as well as to our more self-critical age, but which would have sounded like sturdy common sense to the kind of Englishman Charles Dickens spoofed in the figure of Mr Podsnap, in *Our Mutual Friend*. And the land appeared to be teeming with Podsnaps. 'Let every man who has a sufficiency for the enjoyment of life, thank heaven most fervently that he lives in this country and this age': sentiments from a work entitled *The Rural Life of England*, published in 1840.

THE DARKER SIDE

Other views are both possible and necessary.

> ...bestial English mob, – railroad born and bred, which drags itself about the black world it has withered under its breath, in one eternal grind and shriek, – gobbling, – staring, – chattering, – giggling, – tramping out every vestige of national honour and domestic peace, wherever it sets the staggering hoof of it; incapable of reading, of hearing, of thinking, of looking, – capable only of greed for money, lust for food, pride of dress, and the prurient itch of momentary curiosity for the politics last announced by the newsmonger.

THE WORLDS OF JOHN RUSKIN

More jaundiced commentators have tended to describe nineteenth-century Britain in very different terms: as a period of bitter conflict, dangerously accelerated economic and social upheaval, and creeping moral uncertainty. For them, the dominant aspect of the age must always be its startling division between the very rich and the appallingly poor: as Disraeli called them, 'the Two Nations' of Great Britain. And the poor were no longer acquiescent in their misery. For example, the year in which Ruskin was born, 1819, is also notorious as the year in which Britain may have come closer to Revolution than at any other time save 1848. It was the year of the so-called Peterloo Massacre, in which 60,000 working-class agitators, demonstrating for the repeal of the Corn Laws at a public meeting in St Peter's Fields, Manchester, were set upon brutally by the police and army. Eleven died, four hundred were injured.

By and large, the press thundered its approval, but less reactionary souls were appalled, and one of the long-term effects of the Massacre was to convince the prosperous classes that bloody acts of repression were not a long-term solution. In part as a consequence of such revulsion amongst the influential, and the slow process of reform it helped to buoy up, violence on such a large scale would not be witnessed again until nearly the end of the century. Yet hostility between the lower orders and the ruling classes was often in danger of turning bloody, and the spectre of proletarian revolution was a persistent bogey-man of the more nervous members of the bourgeoisie. Older Britons could still remember something of the French Regicides, and the Terror which they went on to impose.

In the course of the long peace, Britain was radically transformed from a mainly agricultural nation to the world's first industrial nation, and then, at the end of the century, to its first great financial power. It was not a painless mutation, and the poorest generally suffered worst. If the condition of the lower orders could be said (though not by all) to have improved significantly in real terms by the end of the century, their trials on that uphill road were often dreadful. Driven sometimes by famine – Ireland's 'Great Hunger' is the terrible instance which has been embedded in popular memory, but there were other disastrous crop failures – and sometimes by less dramatic but no less compelling economic pressure, families deserted the land and moved to the new cities, to labour in factories, foundries, mills and mines.

The world had never seen anything quite like these cities before, and to sensitive souls they seemed almost literally like Hell. The smoke of great furnaces blotted out the sun and made the air foul; rivers were poisoned with industrial waste and human excrements (cholera, inevitably, was one of the great killers of the age); working men, women and children could spend almost all their waking hours at brutal, dangerous, maddeningly repetitive toil, then go home to pass their few leisure hours in crammed, insanitary, crime-ridden slums.

These two visions of Victorian Britain are in such stark contrast that it is hard to credit that both might be true. In fact, they are less contradictory than they might seem, and for a simple reason. Victoria's reign was so long – six decades – that the single term 'Victorian' can be applied to at least three or even more distinct periods, so that the general observations which hold reasonably true for one of

these periods are quite misleading when applied to another. The sunny images of wealth, confidence, domestic peace and justifiable sense of national pride, are not such a false evocation of what has been called the High Victorian period, from roughly 1851 (the year of the Great Exhibition) to 1867 (the year of the Second Reform Bill).

But that bright upland of High Victorian felicity had been preceded by the 'Hungry Forties', a time of economic uncertainty and crisis, bitter and sometimes bloody social conflicts and, as the name suggests, drastic shortages of food. It was succeeded by some three decades in which the reported underlying trend to ever greater prosperity was not always visible to those ruined in financial crashes, or by the drastic failures of the farming communities — Hardy's novels chronicle what amounts to the death of an entire culture — or by the growing awareness that other nations, notably Germany, were rapidly catching up with Britain and in some areas taking the lead. The historian Asa Briggs memorably described the years after 1873 as an 'economic blizzard'.

If boundless confidence and optimism radiate through the middle years of the century, doubt, melancholia and even morbidity increasingly crept in as it grew older — at least among the educated classes. There was a decline in religious certainty, and a growing sense of doubt that all was right with the world. (A few lonely voices had been saying such things all along.) To be sure, not everyone was greatly troubled. In the eyes of hard-headed industrialists, the demeaned state of the lower orders was simply the price that had to be paid for the prosperity of the nation as a whole: regrettable, no doubt, but inevitable. Engels, barely heard of in Britain during his own lifetime, records a telling exchange:

> One day I walked with one of these middle-class gentlemen into Manchester. I spoke to him about the disgraceful unhealthy slums and drew his attention to the disgusting condition of that part of town in which the factory workers lived. I declared that I had never seen so badly built a town in my life. He listened patiently and at the corner of the street at which we parted company, he remarked: 'And yet there is a great deal of money made here. Good morning, Sir!'

A more extreme version of this robust middle-class position held that the disgusting nature of Britain's slums was wholly an expression of natural viciousness in the plebian soul: the proletarian was closer to an animal than a rational human being, and had to be kept firmly in check for his own good. It was a viewpoint often shared by a curious new social order, the Respectable Poor, who were often more disdainful of those a rung or two immediately below them on the ladder than were those at the very top.

Indeed, it was on the social ladder's higher rungs that one could find those articulate and thoughtful people who were largely unpersuaded by the argument that squalor and wretchedness were merely the fruit of working-class sin, and whose keen sense of right and wrong compelled them to look beyond their economic self-interest to larger ideas of justice and national well-being. One of the most powerful voices raised in protest against the commercial spirit of the age, and certainly one of the most eloquent, was that of John Ruskin.

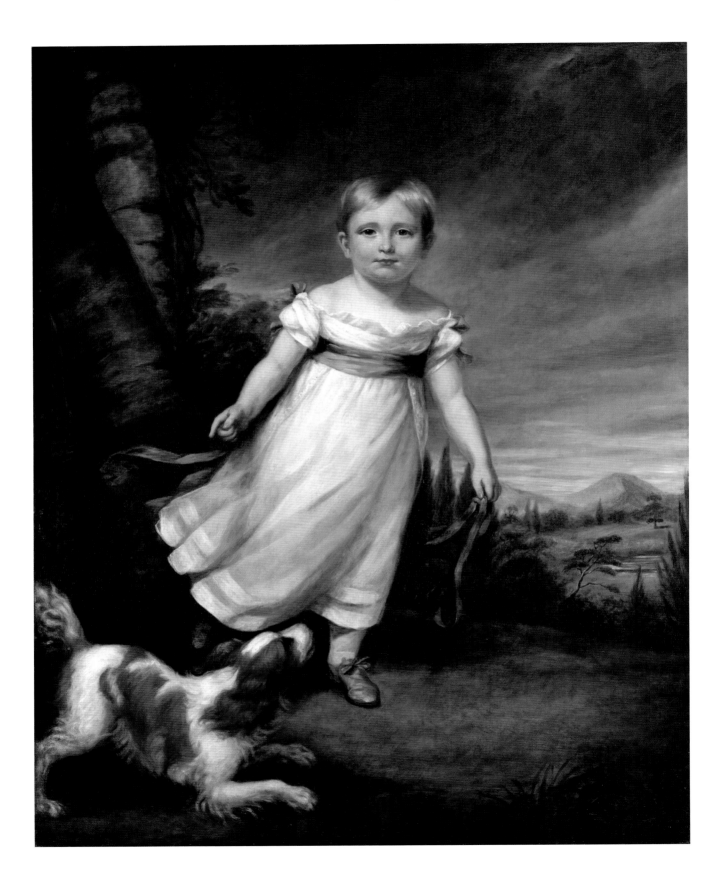

1819-30: EDEN IN SOUTH LONDON

Cynics might well say that Ruskin is the last person to whom anyone with any sense should listen on social matters, since the fellow never did a day's proper work in his life. This is a ludicrous slander, if we define work as something like 'productive activity', for the reality is that Ruskin was astoundingly productive and energetic even by the titanic standards of his famous Victorian peers. (And a pedant might add that he did indeed once have a proper job, though not until he was in his fifties, and only for a few years: in 1870, he was appointed as the first Slade Professor of Art at Oxford University.)

His published works alone run to well over 250 books and pamphlets of various sizes, which were gathered into thirty-eight huge volumes in the Library edition by Cook and Wedderburn (volume 39 is a monumental Index); and to equip himself to write those works, Ruskin spent countless hours in travelling, studying, observing, measuring, drawing and arguing. When not engaged in writing, he would be painting, or lecturing, or visiting schools, or dreaming up projects for social reform and putting them into action, or firing off angry letters to the newspapers, or kindly ones to his many correspondents, or sponsoring charities, or supervising building works and garden designs, or building roads, or buying pictures, or giving away large sums of money to causes he deemed worthy.

On the other hand, it is perfectly true that Ruskin was fortunate enough never to be obliged to work for a living, and never to fear the pains and humiliations of poverty. In his mature years, his books began to sell well enough to make him rich in his own right; but in his youth and early manhood, he was supported generously and entirely by his parents. In this he was quite unlike the other leading literary men of his day: unlike Dickens, he did not need to exorcise the shame of being sent to a factory at a tender age, or fret about making his way in the world through journalism; unlike Trollope, he did not need to squeeze his literary activities into the early hours before the office opened; unlike Disraeli, he advanced his political beliefs wholly outside public office, and never stood for Parliament. (He did not even vote at elections.) And, perhaps most importantly: unlike almost any of his literary peers, he did not need to write so as to please a paying readership. If he felt that he must do so, he could afford to offend his audience; and, increasingly, that is just what he did.

INFANT YEARS

John Ruskin came into the world on 8 February 1819, at 54 Hunter Street, Brunswick Square, London, a substantial four-storey terraced house not very far from the present-day site of St Pancras railway station. To judge by his memories of the place in old age, Ruskin learned to take intense pleasure in the look of things from his earliest conscious years: '...the windows of it, fortunately for me, commanded a view of a marvellous iron post, out of which the water-carts were filled through beautiful little trap-doors, by pipes like boa-constrictors; and I was never weary of contemplating that mystery, and the delicious dripping consequent...' That simile, 'like boa-constrictors', hints at his lifelong fascination (sometimes a horrified fascination) with snakes.

Ruskin was, and would remain, the only child of John James and Margaret Cox

Opposite: John Ruskin aged three and a half, 1822, by James Northcote.
Northcote added the hills in the background 'as blue as my shoes' at the boy's request, 'because the idea of distant hills was connected in my mind with approach to the extreme felicities of life.' Ruskin kept dogs (and cats) all his life, but a bite on the mouth as a child resulted in a slight deformity of his lips about which he remained sensitive.
This painting still hangs where Ruskin placed it, in the dining room at Brantwood

Below, Ruskin's birthplace at 54 Hunter Street, now demolished

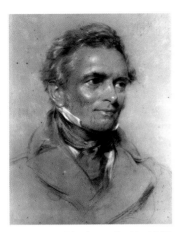

*John James Ruskin, 1848,
by George Richmond.
John James gave this picture
to Ruskin as a wedding present*

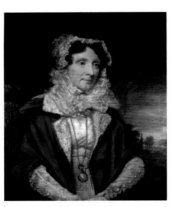

*Margaret Ruskin, 1825,
by James Northcote.
She was born Margaret Cock in
Croydon; the name was later
gentrified to Cox*

Ruskin. (His father had been brought up in Edinburgh, and though Ruskin spent only a minor part of his life in Scotland, he was keenly aware of his Scots heritage. Thanks to his father, he spoke with a mild Scottish accent.) John James (1785-1864) was one of those unremittingly hard-working self-made men whose entrepreneurial spirit helped swell Victorian Britain's riches; though as the family's finances grew more secure, he learned how to take time off from work and enjoy life's more sedate pleasures. He was a highly successful importer of sherry, a partner in the well-known firm he set up with two men whose company he enjoyed, Henry Telford and Pedro Domecq. (John James was in trade, note: not industry. His son had glimpses of the world of commerce rather than production.) Telford was a rich and charming – but honest – idler, a country gentleman passionate mainly about horses, who only bothered to come in to the office when John James was off on his annual holiday. Domecq, a Spanish gentleman of French nationality, was from a family which owned extensive vineyards in Mancharnudo – the source of the company's fine products.

John James's prosperity from mid-life onwards was all the more remarkable in that he began his career in business with no capital or other assets save his personal industry, and with very substantial debts – around £5,000 – left to him by his own, improvident and eventually insane father, John Thomas Ruskin. As Ruskin crisply tells the story of John James's youth: 'My father came up to London; was a clerk in a merchant's house for nine years, without a holiday; then began business on his own account; paid his father's debts; and married his exemplary Croydon cousin.' His father was thirty-two when he finally married in 1818, eight years after the couple had announced their engagement, three months after John Thomas's death by suicide; and Margaret was thirty-six, really quite an old bride by the standards of the age. But Ruskin's brisk summary is misleading in its chronology; it took John James a decade finally to pay off the last of his inherited debts.

It was John James's aptitude for commerce which freed his son from a life of wage- or salary-slavery. He looked back on the early years of Ruskin, Telford and Domecq with justifiable pride: 'I went to every town in England, most in Scotland & some in Ireland, till I raised their exports of 20 Butts wine to 3000.' One might add that he was also lucky in launching his career at the end of the Napoleonic Wars, when importing products from the continent became easier, and the British middle classes were growing prosperous enough to indulge in luxury goods.

Ruskin junior was also fortunate in having a father whose professionally acquired discrimination in fortified wines, and personal liking for well-prepared food, was matched by sound, if unoriginal taste in paintings and literature: his favourite writers included Homer, Shakespeare, Samuel Johnson, Sir Walter Scott, and – a surprisingly racy choice – Byron. The very first lines of Ruskin's autobiography refer to these authors, and to the lasting influence they had on his mind:

> I am, and my father was before me, a violent Tory of the old school; – Walter Scott's school, that is to say, and Homer's.

He proceeds:

> I name these two out of the numberless great Tory writers, because they were my own two masters. I had Walter Scott's novels and the Iliad (Pope's

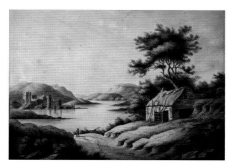

Conway Castle (c.1800-10), a watercolour by John James Ruskin.
As a boy in Edinburgh, Ruskin's father received lessons in watercolour, and this is the best-known surviving example of his work. It was an early memory of the young John, who later recalled how his father had made up stories based on the picture, which hung above his dressing-table. 'The custom began without initial purpose of his, in consequence of my troublesome curiosity whether the fisherman lived in the cottage, and where he was going to in the boat.' (Fors Clavigera, 1875). In later years the picture occupied an important place on the wall of his bedroom at Brantwood, above his favourite still life by William Henry Hunt and among his beloved Turner watercolours

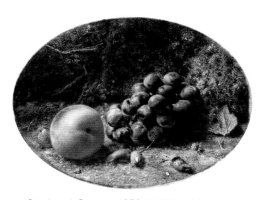

Peach and Grapes, c.1858, by William Henry Hunt It was Ruskin's father who first developed a taste for the work of William Henry Hunt (1797-1864), mostly still life but also including rural genre subjects. This must be the Grapes bought for £40 in 1858, as described in John James's account book. While he sold or gave away most of his other pictures by Hunt, this one Ruskin retained and hung in pride of place over the mantelpiece in his bedroom, below his father's watercolour of Conway Castle. 'Here you see,' he told a friend visiting Brantwood, 'what is probably the most beautiful painting of fruit that Hunt ever did, and it hangs among the Turners like a brooch.' (See illustration on p. 143)

translation), for constant reading when I was a child, on week-days; on Sunday their effect was tempered by Robinson Crusoe and the Pilgrim's Progress; my mother having it deeply in her heart to make an evangelical clergyman of me. Fortunately, I had an aunt more evangelical than my mother; and my aunt gave me cold mutton for Sunday's dinner, which – as I much preferred it hot – greatly diminished the influence of the Pilgrim's Progress, and the end of the matter was, that I got all the noble imaginative teaching of Defoe and Bunyan, and yet – I am not an evangelical clergyman.

It is a richly suggestive paragraph, and two of the things it suggests are Ruskin's fidelity to at least some of his father's values and his scepticism about some of his mother's values. He was not one of those typical young Victorian rebels who had to carry out an early symbolic murder of their fathers or father-figures, since his father was warmly proud of his son's obvious literary gifts and did everything in his power to nurture them. Ruskin's acts of filial rebellion, such as they were, came later in life, and in unusual ways.

Ruskin's mother (1781-1871) was from an Evangelical background, and she was keen to inculcate piety in her son. There was no doubt that she doted on her extraordinary boy, as did John James: as Ruskin would later come to realize, they were the type of parents who damage their children not by neglect or disdain but through excessive love, and inappropriate ambitions. Little John was not 'spoiled' in the modern sense – he might be whipped if he misbehaved, and he learned early how to be polite – but he was coddled and admired.

Both of them hoped that John might grow up to be a leading religious figure (though John James, more relaxed and worldly than his severe wife, also hoped that he might become a poet). They had every reason to expect gratification. The most famous vignette of his early childhood dates from his third year, when he learned how to preach a sermon in imitation of the local clergyman: '...this performance being always called for by my mother's dearest friends, as the great accomplishment of my childhood. The sermon was, I believe, some eleven words long; very exemplary, it seems to me, in that respect; – and I still think must have been the purest gospel, for I know it began with, "People, be good...."' Ruskin's earliest biographer, Collingwood, amplifies slightly: 'The baby Ruskin is seen in his sermon: "People, be dood. If you are dood, Dod will love you; if you are not dood, Dod will not love you. People, be dood..."'

From about 1823 onwards, Margaret began to make him read aloud every morning, first thing after breakfast, from the King James Bible, two or three chapters at a time, starting with Genesis, proceeding to Revelations, and then returning to Genesis. She made him keep up this practice until he matriculated at Oxford; the cadences of the Bible became as intimate to him as his heartbeat, and whatever the fluctuations of his religious belief, the mark on his prose was indelible.

MOVE TO HERNE HILL

When Ruskin was four, the family moved to a spacious, three-storeyed house at 28 Herne Hill – ' a rustic eminence' at that time, today a more built-up South London suburb – where they were to stay for the next nineteen years, until 1842.

Right: Ruskin's own view of No. 28, Herne Hill.
Below: View of the back of No. 28, Herne Hill
and its garden; the view from the
nursery over Forest Hill at sunrise;
and Ruskin's room as a boy,
all by Arthur Severn

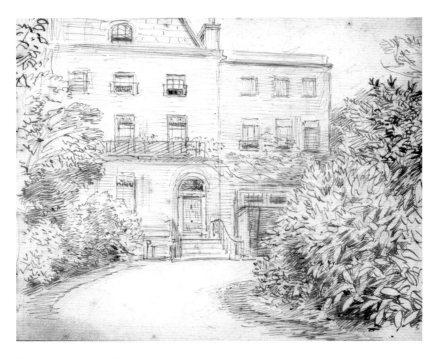

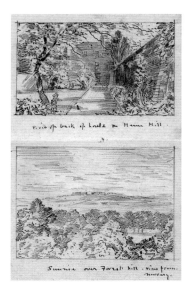

For Ruskin, its chief attraction was its back garden,

> seventy yards long by twenty wide, renowned all over the hill for its pears
> and apples... and possessing also a strong old mulberry tree, a tall white-heart
> cherry tree, a black Kentish one, and an almost unbroken hedge, all round,
> of alternate gooseberry and currant bush; decked, in due season, (for the
> ground was wholly beneficent) with magical splendour of abundant fruit:
> fresh green, soft amber, and rough-bristled crimson bending the spinous
> branches; clustered peal and pendant ruby joyfully discoverable under the
> large leaves that looked like vine.

The luxuriance of the prose here is a token of the joy Ruskin took in the garden, and its precision – 'spinous' – hints at how sharp his eye for natural detail was becoming in these more rural surroundings. Ruskin calls the garden a Paradise, mildly quipping that its only key difference from the original Eden was that here all fruits, not one fruit alone, were forbidden save at specified harvestings. He makes no mention of Edenic serpents, though late in life he was tormented by snake-ridden nightmares. Ruskin recalled that during the early days at the new house they fell into a routine, 'sweetly selfish' way of life, and paid fewer and fewer visits to family or friends – though this impression Ruskin gives of a growing social isolation is contradicted by his father's diaries, which prove that they entertained a wide circles of friends to dinner almost every night of the week.

By this time, Ruskin had become able to read and to write, and he pursued both skills with increasing hunger. John James would bring him home books on all manner of subjects, particularly on the natural sciences – astronomy, meteorology, and most of all geology, which was the boy Ruskin's most ardent study. 'No subsequent passion... had so much influence in my life', he wrote many years later in

Among Ruskin's earliest surviving drawings is a series of maps in pen and ink, copied from books: this one of Scotland is inscribed 'March 27, 1828 / John Ruskin / aged nine.' He was always fond of maps, which appear in many of his books, and recommended them to students in his second drawing manual, The Laws of Fésole

Deucalion, his unusual book on the subject. Had the course of his life run differently, he mused, he might have become the leading geologist of the age. In old age, when he was mentally distressed, working on his mineral collection was the one thing almost guaranteed to soothe him.

John James travelled a good deal in search of business, and from 1824 onwards, when the boy was only five, would often take his son along. The boy had already consciously experienced some of the delights of travel during summer holidays; when John was three, Telford had lent the Ruskins his 'travelling chariot'. The summers were, to boyish eyes, times of high adventure: they went to Scotland in 1824, 1826 and 1827; the West Country in 1828; the Lake District in 1824, 1826 and 1830 – an extended stay, this last; and Derbyshire and Kent in 1829. Their greatest adventure at this time was a short trip to Paris and Brussels in 1825, with a detour to the field of Waterloo. This habit of annual migration set the pattern for a lifetime; it has been calculated that Ruskin spent approximately half his life travelling – almost exclusively in France, Switzerland and Italy. He never ventured further afield, and smilingly declined any number of kind offers of hospitality from his admirers in the United States, on the grounds that he would not wish to visit a country so sad as to have no castles.

In material terms, then, Ruskin enjoyed a comfortable, and emotionally secure childhood. In other respects, his upbringing could be rather stern, though not quite as stern as he suggests in *Praeterita*, where he claims that he was not given toys, and never allowed to have contact with other children. This is not so: though he was not sent to school until he was fourteen, he came into contact with the servants' children, and with those of visitors, and, from 1828 onwards, with a young girl called Mary Richardson, a cousin from Scotland, who was adopted by the Ruskins on the death of her mother. They spent a good deal of time together, and she became in effect an older sister; she lived with the Ruskins until 1848, when she married. Ruskin was fond of her, but she did not seem to stir any early romantic sentiments in his soul.

PRECOCIOUS WRITINGS

By the age of seven, he set himself to writing poems, plays, novels, epics, sermons, and scientific treatises. In *Praeterita* he quotes from his early work *Harry and Lucy*, written between about September 1826 and January 1827. It is remarkable more for its deft plagiarisms of the scientific volumes he had been studying than for its punctuation: 'Harry ran for an electrical apparatus which his father had given him and the cloud electrified his apparatus positively and after that another cloud came which electrified his apparatus negatively and then a long train of smaller clouds...' and so on. Throughout his life, Ruskin was a keen observer of clouds, and there is a pleasing symmetry in the fact that *Harry and Lucy* should have been one of his very first works, and *The Storm Cloud of the Nineteenth Century* one of his last.

At nine he began a poem in rhyming couplets, *On the Universe*; its model was the eighteenth century theodicy (itself a genre that looked back to Milton's *Paradise Lost*):

*An opening from Ruskin's first sketchbook,
with a sketch of a castle and geological notes*

When first the wrath of heaven o'erwhelmed the world.
And o'er the rocks, and hills, and mountains, hurl'd
The waters' gathering mass; and sea o'er shore, –
Then mountains fell, and vales, unknown before,
Lay where they were.

Since Ruskin grew into an exceptionally wide-ranging polymath, one might say that 'the Universe' remained his subject of special interest.

In 1829, a summer holiday in Matlock, Derbyshire intensified his interest in geology:

In the glittering white broken spar, specked with galena, by which the walks of the hotel garden were made bright, and in the shops of the pretty village, and in many a happy walk among its cliffs, I pursued my mineralogical studies on

fluor, calcite, and the ores of lead, with indescribable rapture when I was allowed to go into a cave.

By the age of ten, the budding author made his debut appearance before the reading public when his poem *On Skiddaw and Derwent Water* – the fruit of trips to the Lake District in 1824 and 1826 – was published in *The Spiritual Times*. In the same year, he began to be taught by the first of his tutors, John Rowbotham, who instructed him in mathematics. In 1830, the Ruskins set off for a more extended stay among the Lakes, where the boy poet first set eyes on a much older poet, William Wordsworth. The younger writer was not unduly impressed, recording in his travel diary that:

> We were rather disappointed in this gentleman's appearance especially as he seemed to be asleep the greater part of the time. He seemed about 60. This gentleman possesses a long face and a large nose with a moderate assortment of grey hairs and 2 small grey eyes...

When he returned to London, Ruskin worked his notes up into a long poem in rhyming couplets, *Iteriad, or Three Weeks Among the Lakes*. It is of small literary consequence in its own right, but as a record of the excitements he felt there one can perhaps glimpse the roots of his decision to live out his final days on the shore of Coniston Water.

Ruskin's childhood was, in brief, a safe, comfortable, indulged and stimulated one, if slightly starved of suitable playmates. By treating the child as special (as he unquestionably was), his parents endowed him with the enviable gift of being confident that he was right even when almost everyone else was shouting or muttering that he was wrong. They fostered his literary talent by giving him pennies for his written work; they educated him to an unusually advanced level in literature and the sciences. They formed him as a preacher, though the doctrines he went on to preach were hardly the ones they had in mind. But one of Ruskin's greatest gifts, perhaps his single greatest, was innate rather than fostered: his gift for sight – for minute examination, for seeing things as they truly were. And if there is one image from his early years that matches his precocious sermon in predictive force, it is that of the small Ruskin staring rapt at the colours of a carpet, or the knots in floorboards, or the bricks in a wall. Long before he loved art, he loved the visible world.

Ruskin's hand-lettered title page to The Iteriad, *1831*

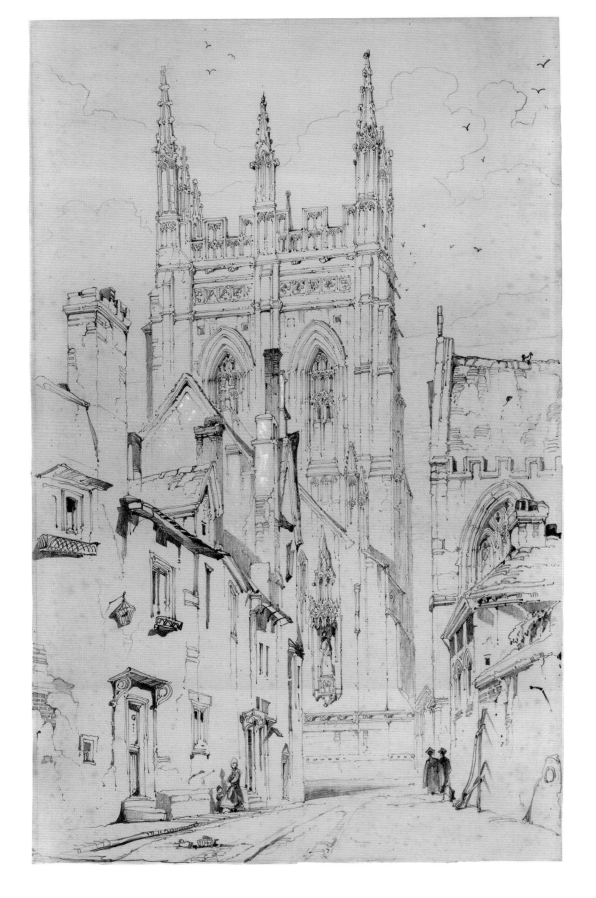

I already disliked growing older, – never expected to be wiser, and formed no more plans for the future than a little black silkworm does in the middle of its first mulberry leaf. – *Praeterita*, 118.

THE NATIONAL BACKGROUND

A few details of events in the early 1830s.

George IV died in 1830, and William IV began his short reign. The Manchester and Liverpool Railway opened in the same year. In Parliament, the Whigs came into power under Lord Grey. A terrible cholera epidemic spread through the country, and continued into 1832, by which time more than 30,000 people had been killed by the disease. In 1831, a series of riots – the so-called 'Swing' riots – broke out in rural areas, in protest at the increasing mechanization of agriculture.

Historians frequently cite the year 1832 as the birth-date of modern Britain. It was the year of the Great Reform Bill, which, briefly put, took some of the power away from the landed gentry and passed it into the hands of the rising commercial and manufacturing interest. (This process would continue throughout the century.) The franchise was greatly enlarged and representation in Parliament restructured, so as to shift the balance of electoral power away from underpopulated rural areas and towards the new cities.

The temper of the age was growing more humane, at least in some respects. In the following year, 1833, slavery was abolished throughout the British Empire, and the Factory Act put limits to child labour. 1833 was also the beginning of the Oxford Movement in the Anglican Church – idealistic men with keen minds and keener consciences began to worry about the legitimacy of their beliefs, and to turn away from Canterbury and towards Rome. (An Act of Roman Catholic Emancipation had been passed in 1829.) In the scientific sphere, one of the great events of the early decade was the publication in 1830 of Sir Charles Lyell's *Principles of Geology* – the book that Charles Darwin took with him on the HMS Beagle voyage, and which shaped his thinking on the matter of evolution.

RUSKIN AT HOME AND TRAVELLING

As a sheltered boy, leading what he later described (not without fondness) as a kind of monastic life in the London suburbs, John Ruskin would have known of these things mainly through the disapproving conversation of his parents. As Tories, with a sentimental weakness for aristocrats (by our lights, and by the lights of Ruskin himself as he grew older, they were snobs, albeit of a rather naïve and well-intentioned kind) the older Ruskins would no doubt have been distressed by the spirit of Reform. As Protestants from an Evangelical background, they would have been alarmed at the revival of what they saw as Romish ways. It was one of the great dreads of Margaret's later life that her son, steeped as he was in the arts of Italy, might go over to Rome.

Still, if Ruskin was over-protected by his strict but adoring parents, he was not starved of stimulation or knowledge.

Cameo portrait of Ruskin by C. R. Franz, Rome, 1840. In Praeterita, *Ruskin recalled: 'We bought, according to custom, some coquillage of Gods and Graces, but the cameo cutters were also skilled in mortal portraiture, and papa and mama, still expectant of my future greatness, resolved to have me carved in cameo. I had always been content enough with my front face in the glass, and had never thought of contriving vision of the profile. The cameo finished, I saw at a glance to be well cut, but the image it gave of me was not to my mind... I should now describe it as a George the Third's penny, with a halfpennyworth of George the Fourth, the pride of Amurath the Fifth, and the temper of eight little Lucifers in a swept lodging'*

Opposite: Merton College and Magpie Lane, Oxford, c.1838. Ruskin was already a good draughtsman when he entered Oxford University, and his architectural studies were much admired. His older friend at Christ Church, Charles Newton, asked him to make a drawing for the Oxford Society for the Preservation of Gothic Architecture (of which Ruskin was a founder member in 1839), but 'had to point out to me that my black dots and Proutesque breaks were no manner of use to him, and that I must be content to draw steady lines in their exact place and proportion'

THE WORLDS OF JOHN RUSKIN

Since he was still being schooled at home, John was free to continue accompanying his father on trips around the country. And since many of his father's customers were wealthy, he saw a good deal of the nation's grander houses, and the art collections they often displayed. The habit of sketch-making and note-taking was already well ingrained in him, and he learned early how to convert a rented hotel bedroom or a guestroom into a serviceable study. And his home schooling was becoming at once more rigorous and more varied. In 1831 he seems to have begun studying Hebrew with his mother, though there is little evidence that he ever mastered the language. He also began drawing lessons with a Mr. Charles Runciman, on whom he later looked back with disapproval. 'Mr. Runciman's memory sustains disgrace in my mind in that he gave no impulse or even indulgence to the extraordinary gift I had for drawing delicately with the pen point.' Following his unabated fascination for geology, John also compiled a *Dictionary of Minerals*.

The year of the Great Reform Bill, 1832, was momentous in Ruskin's young life for very different reasons. One was that he managed to complete *The Iteriad*, which stretched to 2,000 lines – a creditable work, but not an astonishing one. Far more significant than this poetic work was his earliest revelation of the power of art, and of one artist in particular. He was given a copy of Samuel Rogers' topographical poem *Italy*, with illustrations by J. M. W. Turner. As he put it:

> ...on my thirteenth (?) birthday, 8th February 1832, my father's partner,
> Mr. Henry Telford, gave me Rogers' *Italy*, and determined the main tenor of
> my life.' [The question mark introduced by Ruskin after the date is explained
> a few lines later: 'I have told this story so often that I begin to doubt its
> time.']

In the following year, 1833, the Ruskins made their first major trip to the continent. They had been planning it, with great, almost child-like excitement, for at least two years. It was to be Ruskin's first exposure to some of the places and sights which would later be sacred to him, including Chamonix, though it was on their next Continental tour, two years later, that the true force of these visions took hold of him. At a summer dinner party in Paris, he met the girl who would soon be his first love, Adèle Domecq; at this time there were no intimations of the amorous woes ahead for him. On 21 September: the family were back in Herne Hill; Ruskin settled down to writing a poetic account of the summer tour, taking Rogers as his model.

Realising the limitations of the education he had so far received, in 1834 his parents sent John to a school run by the evangelical Reverend Thomas Dale in Camberwell, just a short walk from Herne Hill. Dale was a severe master, and Ruskin did not greatly enjoy his hours there. He felt more kindly disposed to the private tutor, Mr Rowbotham, who now began to coach him two evenings a week – particularly on French grammar, and on Euclid and algebra. Mr Rowbotham took him as far as quadratics, '...but there I stopped, virtually, for ever.'

In September, his first prose work 'Enquiries on the Causes of the Colour of the Rhine' was published in J. C. Loudon's *Magazine of Natural History*: a very

Above, a typical opening from Rogers' Italy, 1830. Below, two vignettes from Ruskin's account of his first trip to the Continent in 1833, which he laid out in imitation of Rogers' book: an English family at Calais; and (bottom) a traveller contemplating the Alps

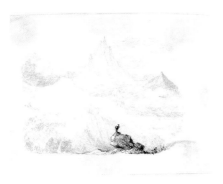

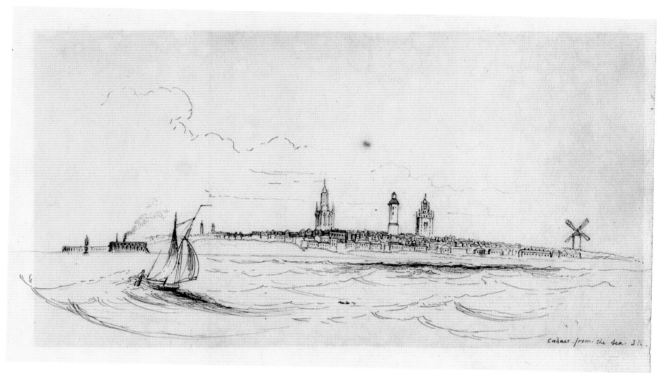

Calais from the sea, 1835. This drawing probably dates from June 1835, but Ruskin never forgot the impression his first visit to Calais made on him as a boy of fourteen, two years earlier: 'Stand on the pier and look round you. The sky is a French sky, it is a very turquoise, the sea is a French sea in everything but its want of motion, the air is French air, none of your English boisterous sea puffs which blow the dust in your eyes when you wish to be particularly clear sighted'

Part of St Mark's Church and Entrance to Doge's Palace, Venice, 1835. Ruskin saw Venice for the first time on the 1835 tour. This is one of the few drawings known to have been made during the family's week there in October; appropriately it includes part of the Doge's Palace, which he would later call 'the central building of the world'

reputable place for a very young 'scientist' (to use a word that had only been coined in recent months).

In March 1835 John began his first exercises in oil painting, but this, and all of his other studies, was suddenly disrupted by a severe attack of pleurisy. He was taken out of Dale's school for a while. By the early summer he was sufficiently well to accompany his parents on their second major continental tour, which began on 2 June. It was when the family arrived at Abbeville that Ruskin enjoyed what amounted to an epiphany. As he wrote, in a famous passage of his autobiography:

> ...there have been, in sum, three centres of my life's thought: Rouen, Geneva, and Pisa. All that I did at Venice was bye-work, because her history had been falsely written before, and not even by any of her own people understood; and because, in the world of painting, Tintoret was virtually unseen, Veronese unfelt, Carpaccio not so much as named, when I began to study them; something also was due to my love of gliding around in gondolas. But Rouen, Geneva and Pisa have been tutresses of all I know, and were mistresses of all I did, from the first moments I entered their gates.

> In this journey of 1835 I first saw Rouen and Venice – Pisa not until 1840; nor could I understand the power of any of those great scenes till much later. But for Abbeville, which is the preface and interpretation of Rouen, I was ready on that 5th of June, and felt that here was entrance for me into immediately healthy labour and joy.

In the same trip, he enjoyed his first, momentous view of the Alps.

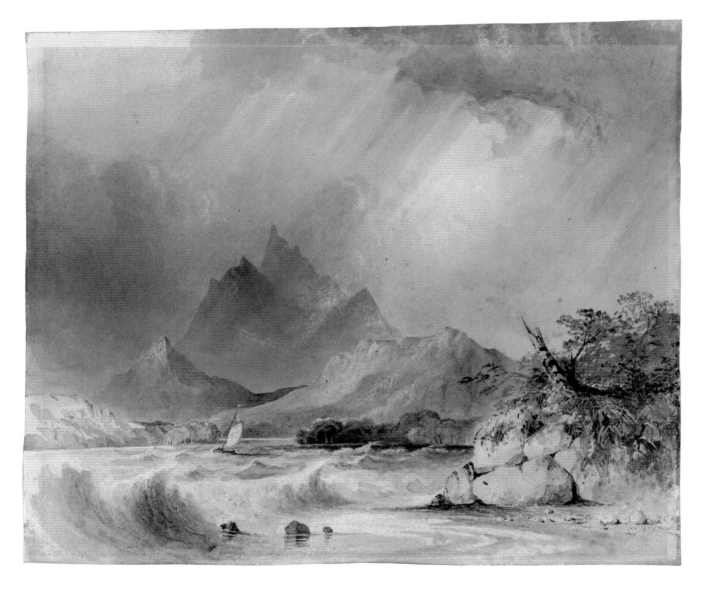

Mount Pilatus, Lake Lucerne, 1835-6. A rare example of Ruskin converting one of his 1835 Swiss pencil drawings into a watercolour in the fashionable style of the period, taken to a degree of completion unusual in his subsequent output. Quite apart from a deep-seated belief in absolute truth to nature, throughout his life Ruskin was never happy drawing without the subject in front of him

In the public sphere, the most significant event of the year was the publication of his poem 'Salzburg' in *Friendship's Offering*. He was taking the very first steps towards a writer's career. On 4 February 1836 he registered at King's College, London as an 'Occasional Student' of English Literature. Soon, though, he would have other things to occupy his attention.

It seems that Mr Domecq and the Ruskins may have discussed the advantages of an eventual marriage between their families; at any rate, there seemed to be general approval for the idea that John might begin to court one of the four Domecq daughters when they came to stay at Herne Hill: '[Adèle-]Clotide, a graceful oval-faced blonde of fifteen; Cécile, a dark, finely-browed, beautifully-featured girl of thirteen Elise, again fair, round-faced like an English girl, a treasure of good nature

and good sense; Caroline, a delicately quaint little thing of eleven.' Almost at once, Ruskin was smitten by Adèle-Clotide – or, as she was usually called, Adèle.

'Anything more comic in the externals of it, anything more tragic in the essence, could not have been invented by the skilfullest designer in either kind', he later wrote. Not greatly accomplished at charming even his school-mates at Dale's, Ruskin was hopelessly at sea with pretty girls, especially pretty girls with Parisian dresses and sophistication. Every attempt he made to impress Adèle was doomed; he appeared gawky, pedantic, ridiculous. He resorted to composing a dashing tale of romance, and had it published in *Friendship's Offering*. Result: 'Adèle laughed over it in rippling ecstasies of derision...'

In his old age, Ruskin was able to make this awful, humiliating episode into a wry comedy:

> The entirely inscrutable thing to me, looking back on myself, is my total want of all reason, will, or design in the business. I had neither the resolution to win Adèle, the courage to do without her, the sense to consider what was at last to come of it all, or the grace to think how disagreeable I was making myself at the time to everybody about me. There was really no more capacity nor intelligence in me than in a just fledged owlet, or just open-eyed puppy, disconsolate at the existence of the moon.

But it would be hard to overstate his degree of emotional distress at this failure in love. He was never to know any protracted happiness in love, and from time to time would admit to confidants, such as Charles Eliot Norton, that his inability to find and win an appropriate woman was one of his life's deepest sorrows. It was fortunate for him that he did at least possess a nascent gift for friendship, and was soon to have a chance to exercise it.

OXFORD

Those fortunate enough to have been educated at a distinguished university – or even a not so distinguished one – sometimes look back on their three or four undergraduate years as an unequalled golden age of exciting intellectual challenge and rapid personal development, unprecedented freedoms, fervent friendships and, for the very lucky, early love. For the less intellectually ambitious, it can at least offer a pleasant holiday between the drudgery of school and the tedium of routine adult work. Ruskin's experiences were unlike either of these. By and large, Oxford left him unenchanted, and though he did not actively dislike his time there, he certainly did not blossom.

The friends he began to make included two lasting ones: Henry Acland, a medical student who went on to become Regius Professor of Medicine at Oxford, remained close to Ruskin for the rest of their lives, and often took Ruskin's side in controversies; and Edward Clayton, later the addressee of Ruskin's *Letters to a College Friend*. Such contacts apart, perhaps his principal gain from his years at the University was the development of a certain social polish that he had previously lacked. After some initial rough-housing and banter, he rubbed along surprisingly well with the rich and hearty young bloods of Christ Church.

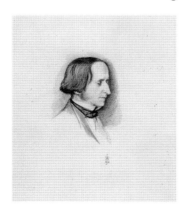

Henry Acland, 1853, by John Everett Millais Drawn on the ill-fated holiday in Glenfinlas, when Acland joined Ruskin, his wife Effie and the painter Millais; Ruskin reported to his father that Millais had thought Acland's head noble and worth drawing

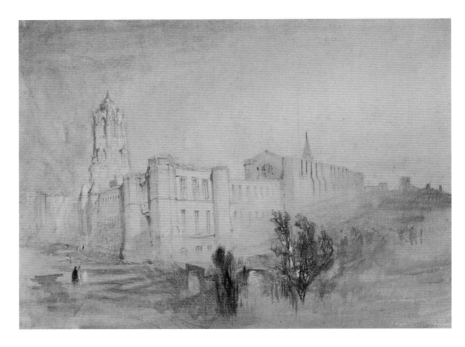

Christ Church, Oxford, 1842, one of Ruskin's most Turnerian works, as reproduced in the magisterial Library Edition of Ruskin's complete works, published in 1903-12. Ruskin offered this drawing to the Dean of Christ Church, Thomas Gaisford, in gratitude for allowing him to break off his studies because of illness. Ruskin wrote 'it has at least the merit of being perfectly faithful to every part of the principal subject – though some liberties have been taken with the accessories. I much regret that I should be unable to produce a better drawing of so impressive a subject' and continued 'it is taken from a point of view which I think new' although the debt to of Turner's own view of the subject, which he owned, is palpable

Ruskin matriculated at Christ Church in October 1836 as a Gentleman Commoner; his father paid his fees and 'Caution' money. The ranks of Gentleman Commoners were usually occupied by young men of old and landed families. The son of a wine dealer was to be mixing with the sons of Lords.

> My father did not like the word 'commoner,' – all the less, because our relationships in general were not uncommon. Also, though himself satisfying his pride enough in being the head of the sherry trade, he felt and saw in his son powers which had not their full scope in the sherry trade. His ideal of my future, – now entirely formed in conviction of my genius, – was that I should enter at college into the best society, take all the prizes every year, and a double first to finish with; marry Lady Clara Vere de Vere; write poetry as good as Byron's, only pious; preach sermons as good as Bossuet's, only Protestant; be made, at forty, Bishop of Winchester, and at fifty, Primate of England.

While waiting to go up, he chanced upon a mocking article about Turner's recent paintings by the Rev. John Eagles, published in *Blackwood's Magazine*. It roused 'black anger' in Ruskin, who wrote a lively refutation of Eagles' essay. This piece was not published in Ruskin's lifetime, since Turner advised him by letter not to, but it was the small seed from which all of *Modern Painters* grew.

Ruskin entered residence at Christ Church on 17 January 1837. The single most remarkable – some might say lamentable – aspect of his undergraduate career is that his mother accompanied him, apparently fearful for his health. Many, perhaps most people, would consider this rather an unhealthy arrangement, but Ruskin denies that it troubled him:

> I count it is just a little to my credit that I was not ashamed, but pleased, that my mother came to Oxford with me to take such care of me as she could. Through all three years of residence, during term time, she had lodging in the

Margaret Ruskin's lodgings in 'Mr. Adams' pretty house of sixteenth-century woodwork', c. 1836. This is another drawing reproduced in the Library Edition of Ruskin's works

1830-40: STUDIES AND FIRST LOVE

High Street (first in Mr. Adams's pretty house of sixteenth century wood-work), and my father lived alone all through the week at Herne Hill, parting with wife and son at once for the son's sake. On the Saturday, he came down to us, and I went with him and my mother, in the old domestic way, to St. Peter's, for the Sunday morning service; otherwise, they never appeared with me in public, lest my companions should laugh at me, or anyone else ask malicious questions concerning vintner papa and his old-fashioned wife.

The fear was obviously well-founded, and yet:

> None of the men, through my whole college career, ever said one word in deprecation of them, or in sarcasm at my habitually spending my evenings with my mother...

WORK

Ruskin was not particularly stimulated by his academic work; nor was he particularly impressed by most of the dons. One shining exception was Dr William Buckland, the pioneering geologist and magnificent British eccentric. Today, those who remember Buckland tend to do so not because of his considerable intellectual achievements but for his many colourful oddities and appetite for all manner of things. This is the man who, to prove its efficacy as a fertiliser, took quantities of bird droppings and wrote the world 'guano' on a college lawn, where it remained spelled out in flourishing grass for many terms afterwards. The man who boasted of having eaten every animal, and said that the two most disgusting flavours were those of mole and bluebottle. The man who debunked a 'miraculous' manifestation of martyr's blood in an Italian church by tasting the supposedly sacred fluid and pronouncing that it was bat urine, a flavour with which he was familiar. Ruskin was very fond of him:

Dr. Buckland lecturing at the Ashmolean, 1822, contemporary print

> Dr Buckland was extremely like Sydney Smith in his staple of character; no rival with him in wit, but like him in humour, common sense, and benevolently cheerful doctrine of Divinity. At his breakfast-table I met the leading scientific men of the day, from Herschel downwards, and often intelligent and courteous foreigners, – with whom my stutter of French, refined by Adèle into some precision of accent, was sometimes useful. Every one was at ease and amused at that breakfast-table, – the menu and service of it usually in themselves interesting. I have always regretted a day of unlucky engagement on which I missed a delicate toast of mice; and remembered, with delight, being waited upon one hot summer morning by two graceful and polite little Carolina lizards, who kept off the flies.

It was in Buckland's company that he met Charles Darwin for the first time, at a dinner on 21 April 1837.

His daily routine was not unduly demanding:

> I never missed chapel; and in winter got an hour's reading before it. Breakfast at nine, – half-an-hour allowed for it to a second, for Captain Marryat with my roll and butter. College lectures till one. Lunch, with a little talk to anybody who cared to come in, or share their own commons with me. At two, Buckland or other professor's lecture. Walk till five, hall dinner, wine either given or accepted, and quiet chat over it with the reading men, or a frolic with

Right, comparative chimneys, from Ruskin's 1838 articles in J. C. Loudon's Architectural Magazine *entitled 'The Poetry of Architecture'*

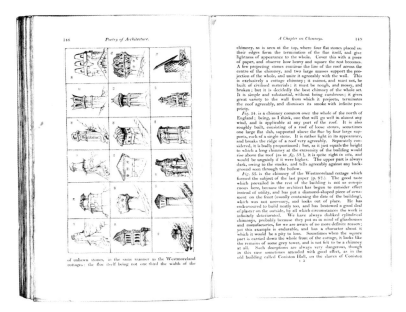

Coniston Old Hall and its chimneys, also from 'The Poetry of Architecture'. An early visit to Coniston in 1830 was marred by rain, but seven years later Ruskin had good enough weather to make a drawing from a position on the east side of Coniston Water, close to the house and estate of Brantwood which he was to purchase from W. J. Linton in 1871. In this woodcut he shows the distinctive profile of Coniston Old Hall, on the opposite edge of the lake beneath the mass of the great hill known as the Old Man

those of my own table; but I always got round to the High Street to my mother's tea at seven, and amused myself till Tom rang in, and I got with a run to Canterbury gate, and settled to a steady bit of final reading till ten. I can't make out more than six hours' real work in the day, but that was constantly and unflinchingly given.' ['Tom', as Ruskin himself explains in a footnote, is the great bell of Oxford, in Christ Church's western tower.]

In May of 1837, he was appointed to the high-toned Christ Church Society, to the delight of his parents; with whom, in June and July, he toured in Yorkshire, Derbyshire and the Lake District. Later in the year, he published a series of well-received articles on 'The Poetry of Architecture' in *The Architectural Magazine*, (1837-8) using the pseudonym 'Kata Phusin' – 'According to Nature.' It was the most substantial of his early pieces, and was later published as a small book, though he did not return to the subject of architecture for several years.

His second year at Oxford was fairly uneventful. In March 1838 he managed to pass the set of examinations known as 'Little Go' or 'Smalls', though with no great distinction. He entered, unsuccessfully, for the Newdigate Prize in poetry; and in the summer he once again toured in Scotland, the Lakes, and the north-east of England. The great event of the next academic year for Ruskin was winning (it was his third attempt, and he had worked extremely hard at the piece) the Newdigate Prize for his poem 'Salsette and Elephanta', which he read out in the Sheldonian Theatre on 12 June. The Newdigate was a greatly respected prize, and established the winner as man of great promise.

The Domecq girls visited the Ruskins again for Christmas. John's parents knew that Adèle was already engaged to a wealthy nobleman, the Baron Du Quesne (she would marry him the following year), but managed to keep the news from Ruskin until the end of their stay.

In his diary for 28 December, he wrote: 'I have lost her'.

1830-40: STUDIES AND FIRST LOVE

J. M. W. Turner, Winchelsea, *1828.*
In Praeterita, *Ruskin summed up the unique*
experience of the Turner collector: 'the pleasure of
one's own first painting everyone can understand.
The pleasure of a new Turner to me, nobody
ever will, and it's no use talking of it'

On the 8 February 1840, Ruskin came of age. His parents gave him a generous annual income of £200, and Turner's watercolour *Winchelsea*. In April he became a Fellow of the Royal Geological Society. However much his heart may have ached for Adèle, in every other respect things appeared to going swimmingly: he was a Prizeman, a published author, and a strong candidate for a First.

ILLNESS

In April, he was quite suddenly afflicted with a serious illness; possibly consumption.

> One evening, after Gordon had left me, about ten o'clock, a short tickling cough surprised me, because preceded by a curious sensation in the throat, and followed by a curious taste in the mouth, which I presently perceived to be that of blood. It must have been on a Saturday or Sunday evening, for my father, as well as my mother, was in the High Street lodgings. I walked round to them and told them what had happened.

> My mother, an entirely skilled physician in all forms of consumptive disease, was not frightened, but sent round to the Deanery to ask leave for me to sleep out of my lodgings. Morning consultations ended in our going up to town, and town consultations in my being forbid any further reading under pressure, and in the Dean's giving me, with many growls, permission to put off taking my degree for a year. During the month or two following, passed at Herne Hill, my father's disappointment at the end of his hopes of my attaining distinction in Oxford was sorrowfully silenced by his anxiety for my life.

He made a slow convalescence throughout the summer, and then went on an extended continental journey with his parents, which lasted from September until June 1841.

Some of the friends who were reading the instalments of *Praeterita* as he wrote and published it in the 1880s were disappointed that Ruskin did not devote more pages to undergraduate experiences. But Ruskin was unrepentant:

> 'And is there to be no more Oxford?', asks Froude, a little reproachfully, in a recent letter concerning these memoranda; for he was at Oriel while I was at Christ Church, and does not think that I have given an exhaustive view either of the studies or the manners of the University in our day.

> No, dear friend. I have no space in this story to describe the advantages I never used; nor does my own failure give me the right to blame, even were there any use in blaming, a system now passed away. Oxford taught me as much Greek and Latin as she could; and though I think she might also have told me that fritillaries grow in Iffley meadow, it was better that she left me to find them for myself, than that she should have told me, as nowadays she would, that the painting on them was only to amuse the midges. For the rest, the whole time I was there, my mind was simply in the state of a squash before 'tis a peascod, – and remained so yet a year or two afterwards, I grieve to say; – so that for any account of my real life, the gossip hitherto given to its codling or cocoon condition has brought us but a little way.

But his vocation had already been found; and the 'year or two' was all that it would take him to slough off the cocoon.

RUSKIN AND ART: ONE
TURNER AND NATURE

Ruskin's accomplishments as an art critic are so far-reaching and various as to be close to incomparable. One way of coming near to their significance is to follow the example of the American scholar John Rosenberg, who suggested that Ruskin's huge, five-volume work *Modern Painters* might be seen as the last great statement of English Romanticism, just as the *Lyrical Ballads* of Wordsworth and Coleridge can be seen as its first. Ruskin, he proposed, revolutionised general perceptions of art very much as the earlier writers had revolutionised perceptions of poetry. The word 'Nature' is as important to Ruskin as it was to Wordsworth, though the two writers often intend very different things by the term. For the young Ruskin, 'nature' was in large measure synonymous with 'truth': the merit of paintings could be judged by their degree of fidelity to the natural, visible world. But this standard of measurement is more complex than it might at first appear, partly because Ruskin also believed that the natural world was an embodiment of divine will. Fidelity to appearance is thus a matter of ethics as well as of optics.

How far Ruskin remained consistent in his views on art— or almost anything— is a matter of considerable debate. It has been said, with some justice, that by a careful selection of passages from across his 250 or so books, one could probably make the case for any number of contradictory expositions of Ruskin's Doctrine of Art. This is exasperating for those who look to critics for a grand theory, but heartening for those who can enjoy or even be inspired by the sight of Ruskin in the process of being led by his own sheer honesty to abandon cherished beliefs in the light of fresh experience. For all of these many returns of Ruskin's mind upon itself, there do in fact seem to be a small number of consistent threads in the Ruskinian tapestry— deeper lessons that remain constant no matter the changes in surface argument.

Comparative illustrations from Modern Painters IV, *showing the contrast between 'simple topography' (above) and 'Turnerian topography' (below) in the depiction of the Pass of Faido. Ruskin had visited the Pass in 1845 specifically to gauge the degree of Turner's fidelity to topographical truth. He wrote to his father: 'The Stones, road and bridge are all true, but the mountains, compared with Turner's colossal conception, look pigmy & poor. Nevertheless Turner has given their actual, not their apparent size.'* Modern Painters *argues strongly that in its evocation of the experienced reality of the Pass, which is reached only after arduous climbing through grandiose scenery, 'Turnerian topography' is closer to Nature than mere 'simple topography', though in the event Ruskin himself had been unable to resist some artistic rearrangement of the scene*

Sir Kenneth Clark, for example, confidently identified eight themes that remain fairly constant across the decades. Among these eight are the conviction that art is not made or apprehended by some form of superfluous faculty or talent such as 'taste', but involves the whole being, physical, mental and spiritual; that great artists have always been impelled to teach important and eternal truths; and that beauty in art is always founded in its resemblance to a living organism, especially in the way that parts may collaborate on making a glorious total effect. Ruskin called this collaboration the 'Law of Help'.

The artist whose work first prompted Ruskin to think along these lines was Joseph Mallord William Turner (1775-1851). In 1836, *Blackwood's Magazine* published a rude attack on the great man's recent display of paintings at the Royal Academy: *Juliet and her Nurse*, *Rome from Mount Aventine* and *Mercury and Argus*. It charged Turner with infidelity to Nature, and drove the 17-year-old Ruskin to rage. How could they not see that Turner's bold innovations brought him far closer to Nature than any previous painter? Ruskin's father showed the letter to Turner, who prudently suggested that it should not be sent; but it was the germ of *Modern Painters*, the first volume of which was published in 1843, bearing the pugnacious sub-title: '*...their superiority in the art of Landscape Painting to all the Ancient Masters.*'

It was a brilliant performance – better appreciated, at the time, by writers than by

the artistic establishment (Turner himself was a little embarrassed by its fervent praise) – yet it had at least one obvious defect. Ruskin's knowledge of the 'Ancient Masters' was not, however generously judged, all that great at the age of 24. This obvious lack was one of the motives which took him travelling to Italy, where his encounters with the likes of Tintoretto and Fra Angelico overwhelmed him. As he wrote to his father from Florence about a visit to Santa Maria Novella: 'There is the Madonna of Cimabue, which all Florence followed with trumpets to the church;... there is the great crucifixion of Giotto; there, finally, are three perfectly preserved works of Fra Angelico, the centre one of which is as near heaven as human hand or mind will ever or can ever go.' The rapture of his discovery was so intense that in the product of his research, *Modern Painters II*, Turner and Nature are relegated to the side-lines. It is worth noting a temperamental similarity at work here, however. His earlier writings had attacked the prevailing, orthodox wisdom about Turner; his new book praised many of the artists who were most neglected by contemporary connoisseurs, and damned those who were most esteemed. Once again, Ruskin was writing against the grain of received opinion.

1840-50: THE AUTHOR OF MODERN PAINTERS

Photogravure after 'The Author of Modern Painters', 1843, by George Richmond. This celebrated image of Ruskin was a large watercolour, commissioned by his father and exhibited at the Royal Academy in 1843, but subsequently destroyed by fire. In Praeterita, Ruskin described how, 'with amused interest in my youthful enthusiasm [for Turner], and real affection for my father, he [Richmond] painted a charming water-colour of me sitting at a picturesque desk in the open air, in a crimson waistcoat and white trousers, with a magnificent port-crayon in my hand, and Mont Blanc, conventionalised to Raphaelesque grace, in the distance'

*Opposite: Bridge at Terni, 1841.
One of the most beautiful drawings from Ruskin's tour of 1840-41. They stayed at Terni, famous for its chasm and waterfall, in April 1841, shortly after leaving Rome. 'Pleasant walk up towards the falls, but sun too hot to admit of any distance... Sat for an hour on some limestone rocks on a wild hillside looking over a lovely valley. Terni itself very Italian and picturesque — more of the real arched tower and rich roof than we have had for some time'*

In the spring and summer of 1840, the first months of his legal maturity, Ruskin used his enforced leisure to spend more time looking and thinking about paintings, and particularly about Turner. It was in this year that he finally met his idol for the first time, at the home of the art dealer Thomas Griffith. In his diary for 22 June, he wrote:

> Introduced to-day to the man who beyond all doubt is the greatest of the age; greatest in every faculty of the imagination, in every branch of scenic knowledge; at once the painter and poet of the day, J. M. W. Turner. Everybody had described him to me as coarse, boorish, unintellectual, vulgar. This I knew to be impossible. I found in him a somewhat eccentric, keen-mannered, matter-of-fact, English-minded — gentleman: good-natured, evidently, bad-tempered evidently, hating humbug of all sorts, shrewd, perhaps a little selfish, highly intellectual, the powers of the mind not brought out with any delight in their manifestation, or intention of display, but flashing out occasionally in a word or a look.

This moment of excitement aside, his life was deliberately placid. He was taken to see the Queen's physician, Sir James Clark, who banned him from all but the lightest forms of study unless he wanted to die before taking his degree, and recommended a stay in warmer climates. The family immediately planned a winter in Italy, and set off on 25 September 1840.

Their journey was to last ten months, and they did not return to Herne Hill until 29 June 1841. Mindful of John's delicacy, they travelled at a leisurely, undemanding pace through France, taking six weeks from Calais to Nice, before proceeding into Italy — initially Genoa, Lucca, Pisa, Florence, Siena; then, at the end of November, Rome (which Ruskin found not merely distasteful but frightening) and Naples. This was, of course, pretty much the route of the classical Grand Tour taken by young English aristocrats in the eighteenth century, before the Napoleonic wars had disrupted European travel. This first journey of his maturity set a pattern for much of the rest of Ruskin's life. From now until the onset of his illness in 1888, he was seldom resident in England for very long — usually only a matter of months — and seldom failed to make a summer journey to France, Switzerland or Italy — usually returning to places he already knew. Though this was an age of bold independent travel, Ruskin was never tempted to range further afield; and he always travelled in comfort and style.

For a brief period, the family took rooms in the same apartment building as the aristocratic Tollemache family, but were not on visiting terms. Ruskin became smitten with one of their daughters, Georgina, and would surreptitiously follow her through the streets. The infatuation did not blossom into romance, but in later years Georgina became a valued friend and confidante. Ruskin also met Keats's friend, the painter Joseph Severn, and George Richmond, also a painter (and a follower of William Blake). This was the beginning of two warm, life-long friendships. Italy was opening Ruskin's eyes to new possibilities, but one painter still dominated him. On 3 December, he wrote to Edward Clayton that Turner

> ...is the epitome of all art, the concentration of all power; there is nothing that ever artist was celebrated for, that he cannot do better than the most celebrated. He seems to have seen everything, remembered everything,

Casa Contarini Fasan and other palaces on the Grand Canal, May 1841; later copied by Samuel Prout, whose style it reflects

Title page of the first edition of The King of the Golden River *(1851), by Richard Doyle*

spiritualized everything in the visible world; there is nothing he has not done, nothing that he dares not do; when he dies, there will be more of nature and her mysteries forgotten in one sob, than will be learnt again by the eyes of a generation.

On 6 May, 1841, the family arrived in Venice. Ruskin's shaky health began to improve significantly, perhaps in response to his profound delight in the city's beauty. 'Thank God I am here!... it is the Paradise of cities... I am happier than I have been these five years – so happy – happier than in all probability I ever shall be again in my life.' Yet he was still anxious about his future prospects: he wrote to Dale that he was 'obliged, for the present, to give up thought of the University or anything else', and complained that 'hard mental labour of any kind hurts me instantly.'

They returned to England in June, and Ruskin spent a quiet month at home. It was at this time that the Ruskins entertained John Gray and his family. Gray, a solicitor and a distant cousin of John James, had a thirteen-year old daughter called Euphemia, or Effie, who seemed to be rather interested in this brilliant if sickly young man, almost a decade her senior, who told her tales of his continental tours and showed her his souvenirs. She asked him to write her a fairy story, and he agreed.

His parents now allowed him to travel on his own for the first time, and he set off for Wales with his friend Richard Fell. En route, though, he agreed to spend six weeks in Leamington, under the care of Dr Henry Jephson, taking his famous salt-water cure – dismissed by most orthodox physicians as mere quackery. Curiously, it appeared to do him some good: less, perhaps, because of any genuinely curative power in Jephson's liquids than because of the austere regime the medical gentleman imposed:

> Salt water from the Wells in the morning, and iron, visibly glittering in deposit at bottom of glass, twice a day. Breakfast at eight, with herb tea – dandelion, I think; dinner at one, supper at six, both of meat, bread and water, only: fish, meat or fowl, as I chose, but only one dish of the meat chosen, and no vegetables nor fruit. Walk, forenoon and afternoon, and early to bed.

Partly out of boredom, Ruskin now wrote the fairy story that he had promised as a present for Effie. *The King of the Golden River* was Ruskin's only work of fiction; it was also Britain's first literary fairy tale – the first, that is, to have been wholly invented rather than adapted from folk traditions. It was published nine years later, with illustrations by Richard Doyle, and became enduringly popular. In the twentieth century, the Canadian critic Northrop Frye noticed that this fable contains a simple version of the social views propounded in *Unto This Last*.

The only other notable event of the later year was a visit to his old tutor, the Rev Walter Lucas Brown, at his new home in Wendlebury, north of Oxford, to discuss the question of whether, like a number of his college contemporaries, he should enter the church. Ruskin had grave doubts about this path; and

soon abandoned all idea of Holy Orders. By 16 November he was back at Herne Hill.

In April 1842, Ruskin returned to Oxford to take Schools. He was too far out of touch with his studies to be competent to take the full set of papers for the Honours degree, so he sat for the less ambitious 'Pass' degree. He excelled in some papers, performed poorly in others, and was awarded the distinctly strange degree of an Honorary Double Fourth – the highest grade that the examiners felt they could award him under the circumstances.

Partly in celebration, John James took the family on a trip across France to Chamonix. Ruskin rode in a fine carriage of his own design: 'front and side pockets for books and picked up stones; and hung very low, with a fixed side step, which he could get off and on while the horses were at the trot; and at any rise or fall of the road, relieve them, and get his own walk, without troubling the driver to think of him.'

163 Denmark Hill, undated, by Arthur Severn

On their return to England, the Ruskin family moved to a large, three-storey house at 163 Denmark Hill, where they would spend much of the next thirty years. Ruskin made his study on the first floor, immediately above the breakfast room, so that he could look up from his writing to a pleasant view of open fields stretching off to a distant horizon. It was in this bright, agreeable room that the greater part of his work was written, starting with the first volume of *Modern Painters* – a vindication of Turner. He had no idea that the book would grow so much in the writing, take so many strange by-ways, and not be fully completed for almost eighteen years.

He composed this first volume swiftly, and sent the text to Byron's publishers, John Murray, who turned it down, probably unread. The firm of Smith, Elder and Co accepted it, but, after consultation with the author, changed the title from *Turner and the Ancients* to *Modern Painters: Their Superiority in the Art of Landscape Painting to the Ancient Masters, proved by examples of the True, the Beautiful, and the Intellectual, from the works of Modern Artists, especially from those of J. M. W. Turner, Esq., RA.*

Modern Painters appeared in the first week of May 1843, an anonymous publication, credited simply to 'a Graduate of Oxford'. It was not an overnight success, either critically or commercially, but before long it was provoking admiration and even astonishment among the reading classes. When they started to appear, the published reviews were for the most part highly favourable (one dissenting voice was that of John Eagles, who in the October *Blackwood's* declared that Ruskin was 'extremely unintelligible' and his praise of Turner 'nonsensical'), though it is a few remarkable private responses which have become famous. Charlotte Brontë famously wrote of it that 'this book seems to give me eyes': it is worth reading this remark in its original context, a letter to the publisher she shared with Ruskin:

> Hitherto I have only had instinct to guide me in judging of art; I feel now as if I had been walking blindfold – this book seems to give me eyes. I do wish I

had pictures within reach by which to test the new sense. Who can read these glowing descriptions of Turner's works without longing to see them?... I like this author's style much; there is both energy and beauty in it. I like himself, too, because he is such a hearty admirer. He does not give himself half-measure of praise or vituperation. He eulogizes, he reverences with his whole soul.

George Eliot was yet more fervent:

I venerate him as one of the great teachers of the day. The grand doctrines of truth and sincerity in art, and the nobleness and solemnity of our human life, which he teaches with the enthusiasm of a Hebrew prophet, must be stirring up minds in a promising way.

In December, Effie and her brother George came to stay at Denmark Hill again. She made herself very pleasant, playing the piano for Ruskin and raising his spirits with her unexpectedly grown-up wit. Shortly afterwards, she wrote to tell him that she always thought of him when he went out. For his part, Ruskin found that her cheerful presence greatly sweetened the long winter evenings. He was not smitten, but he was certainly attracted.

On New Year's Day 1844, his father presented him with Turner's *The Slave Ship* (1840), which he had bought for the reasonable price of 250 guineas. The long passage in *Modern Painters I* which describes this work was already quite well-known, and in subsequent decades became renowned as one of Ruskin's most eloquent prose-poems.

... Purple and blue, the lurid shadows of the hollow breakers are cast upon the mist of night, which gathers cold and low, advancing like the shadow of death upon the guilty ship as it labours amidst the lightning of the sea, its thin masts written upon the sky in lines of blood, girded with condemnation in that fearful hue which signs the sky in horror, and mixes its flaming flood with the sunlight, and, cast far among the desolate heave of the sepulchral waves, incarnadines the multitudinous sea.

Modern Painters had already sold well enough to go into a second edition, which appeared with revisions, and a new Preface, on 30 March 1844. The identity of 'a Graduate of Oxford' was now becoming quite well known, and Ruskin found himself greatly in demand for lunches and dinners. 'Ruskin' was becoming a name that commanded considerable attention and respect.

In May, he went on another continental trip with his parents, mainly to Chamonix and the Simplon. In the Alps, he happened to meet the distinguished Scottish geologist James Forbes, an encounter which re-awakened his lifelong interest in rocks. He also spent a good deal of time studying Dante in Cary's translation. Dante came to be one of the most important writers in his life: the Italian poet is second only to Shakespeare as the writer most often mentioned in his books.

On his way back to England, he stopped off in Paris, where he visited the Louvre mainly to look at work by Titian, Tintoretto, Perugino and Veronese. But he felt frustration at only being able to see the works out of their proper context in Italian churches.

The Slave Ship, 'Slavers throwing overboard the Dead and Dying — Typhoon coming on', by J. M. W. Turner, 1840. Ruskin later said: 'If I were reduced to rest Turner's immortality upon any single work, I should choose this.' He sold it in 1872, and by 1899 it was in the Museum of Fine Arts, Boston; but America did not feel the painting lived up to Ruskin's famous descriptions, and his reputation there suffered greatly

The Glacier des Bois, 1843-4. The previous year, Ruskin had written to his old tutor, Walter Lucas Brown: 'Chamonix is such a place! There is no sky like its sky. They may talk of Italy as they like. There is no blue of any firmament visible to mortal eye, comparable to the intensity and purity and depth of an Alpine heaven seen from 6000 feet up. The very evaporation from the snow gives it a crystalline, unfathomable depth never elsewhere seen.' In this watercolour, an example of Ruskin's self-conscious (even 'morbid') imitation of Turner, Ruskin attempts to convey the exhilaration of the place as much as its topography, following what he understood as Turner's method: 'bringing together a mass of various impressions which may all work together as a great whole' (letter to Brown, November 1843). The drawing was intended as a vignette illustration to poetry that Ruskin published in a sentimental periodical, Friendship's Offering

FIRST TRAVELS ALONE

At the start of April, Ruskin set off for his first unaccompanied (save by his valet John Hobbs, always called George to avoid confusion) travels to France, Switzerland and Italy. The seven-month trip was, in its way, an assertion of independence. His mother, anxious about his spiritual fragility and worried that he

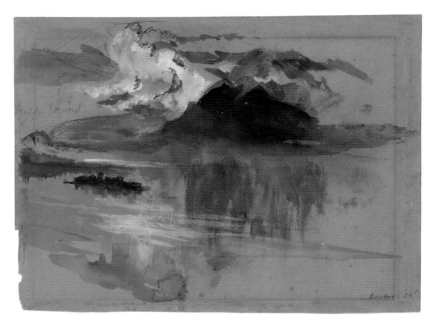

Mountains and lake, Baveno, 1845. On his long summer tour to Italy in 1845, Ruskin spent much of August in the cool of the Italian Alps. He was struck by the 'heavenly richness & majesty of the landscape above Baveno' in the Val d'Ossola, and on the day after making this drawing wrote to his father that 'There is no place like this – at all – it is delicious beyond imagination. I feel far more in Italy than I did at Florence, and the effects on the lake and mountains are so lovely that they make me quite miserable – because I can't do them.' This is an example of the freer, more expressive style adopted by Ruskin in drawings made quickly to capture effects of nature, and wholly for his own pleasure and benefit

Tomb of Ilaria del Caretto, Lucca Cathedral, 1874. This sublime piece of early Renaissance sculpture, carved in 1400 by Jacopo della Quercia, was one of Ruskin's most important discoveries during his tour of 1845; as he wrote forty years later, it 'became at once, and has ever since remained, my ideal of Christian sculpture.' It was not until many years later that he felt able to draw the sculpture

Opposite: Palazzo Miniscalchi, Verona, 1845. This drawing records the famous external frescoes that were already attracting the unwelcome attentions of restorers; they have now almost completely disappeared

might drift towards Catholicism, secretly slipped a copy of Bunyan's *Grace Abounding* into his baggage. By the end of the month he was in Genoa, and at the start of May in Lucca, where he was struck with rapture by Jacopo della Quercia's tomb of Ilaria di Caretto. He wrote about it yearningly:

> She is lying on a simple pillow, with a hound at her feet. Her dress is of the simplest middle age character, folding closely over her bosom, and tight to the arms, clasped about the neck. Round her head is a circular fillet, with three star shaped flowers. From under this the hair falls like that of the Magdalene, its undulations just felt as it touches the cheek, and no more. The arms are not folded, nor the hands clasped nor raised. Her arms are laid softly at length upon her body, and the hands cross as they fall. The drapery flows over the feet and half hides the hound. It is impossible to tell you the perfect sweetness of the lips & the closed eyes, nor the solemnity of the seal of death which is set upon the whole figure. The sculpture, as art, is in every way perfect – truth itself, but truth selected with inconceivable refinement of feeling. The cast of the drapery, for severe natural simplicity & perfect grace, I never saw equalled, nor the fall of the hands – you expect every instant, or rather you seem to see every instant, the last sinking into death. There is no decoration nor work about it, not even enough for protection – you may stand beside it leaning on the pillow, and watching the twilight fade over the sweet, dead lips and arched eyes in their sealed close.'

In later years, it would become one of the female forms he associated with that of his lost beloved, Rose La Touche.

From Lucca, he went on to Pisa, Florence, and Verona. By 10 September he was back in Venice, and horrified by what was happening to it – the 'scraping' of St Mark's, the white-washing of the Doge's Palace, the disfigurement of bridges by gas-pipes and many other modern 'improvements'. His distress at these developments was largely displaced, however, by the overwhelming delight of his first

Detail from Tintoretto's 'Crucifixion', in the Scuola di San Rocco, Venice, 1845. This superb drawing recording the overwhelming impression of his first encounter with Tintoretto is one of Ruskin's most concentrated and expressive Old Master copies, also reflecting the gloomy interior of the Scuola and the darkened condition of the paintings

encounter with Tintoretto – or, as Ruskin calls him, Tintoret – in the Scuola di San Rocco on 24 September:

> I have had a draught of pictures today enough to drown me. I never was so utterly crushed to the earth before any human intellect as I was today, before Tintoret. Just be so good as to take my list of painters, & put him in the school of Art at the top, top, top of everything, with a great black line underneath him to stop him off from everybody – and put him in the school of Intellect, next after Michael Angelo. He took it so entirely out of me today that I could do nothing at last but lie on a bench & laugh...

In *Praeterita*, he said that

> Tintoret swept me away at once into the 'mare maggiore' of the schools of painting which crowned the power and perished in the fall of Venice; so forcing me into the study of the history of Venice itself...

The drama of Ruskin's words – 'drown', 'crushed to the earth', 'swept me away' – is an index of how powerful these encounters of 1845 were for him. One effect of this overwhelming experience was to de-rail the second volume of *Modern*

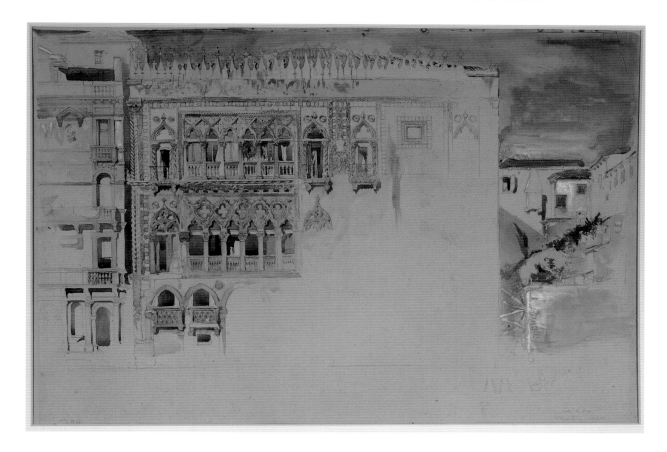

Ca d'Oro, Venice, 1845.
Ruskin was horrified in 1845 to find
restoration under way on many of the
older churches and palaces which to
him were the glories of the city.
'What an unhappy day I spent yesterday,'
he wrote to his father on 23 September,
'before the Ca d'Oro, vainly attempting
to draw it while the workmen were
hammering it down before my face.'
This might well be that drawing, as it
is dated 1845 and clearly shows
some of the irregularity and decay
on the building's façade, which was
in the process of being 'restored'

Painters from the course he had assumed it would follow. Another was to set him on the path that would lead to *The Stones of Venice* – he saw, now, that he needed to explain art in terms of its relation to society. His experience of 'restoration' stung him into the work on *The Seven Lamps of Architecture*; and his contemporary discovery of such so-called 'primitive' painters as Fra Angelico and Benozzo Gozzoli was almost as great a revelation as the work of Tintoretto. He had, to put it mildly, a great deal to think about.

His tour lasted until the end of October. By 5 November he was back in England. From November until March 1846, Ruskin was thoroughly immersed in writing the next volume of *Modern Painters*, drawing together all the teeming thoughts, feelings and impressions of his seven-month solo tour. He handed over the manuscript towards the end of the month, then went on a new European trip with his family – even though he was beginning to feel more and more uneasy about their relations; in particular, a gulf was evidently opening up between him and his father. The new volume was published on 24 April, when the family was in Geneva. It was well received, again, and added to his already substantial reputation as an art critic.

Yet from this point on, roughly from 1846 to 1856, he would largely turn his attention away from painting – even from Turner's paintings – and towards

architecture. His studies, his travels, his drawings and paintings, and above all his writings of this decade were all directed towards deepening his knowledge of architectural history, elaborating a vision of what was good and bad in buildings, and persuading others of the importance of architecture both in earlier periods and the present day.

The family came back to England on 8 October.

MARRIAGE

By now, Ruskin's family and friends alike had both decided that this increasingly famous young man was in want of a suitable wife. Lady Davy, the widow of Sir Humphry, tried to contrive an affair between Ruskin and Charlotte Lockhart, the daughter of Scott's biographer; but Ruskin was still not greatly gifted in the arts of courtship, and at their first meeting, he simply drowned Charlotte out from nervousness. He then hit upon the eccentric idea of impressing Charlotte by writing a dazzlingly learned review of Lord Lindsay's *Sketches of the History of Christian Art* in the *Quarterly Review*; and in March 1847 went to the Salutation Inn near Lake Windermere to compose it.

Perhaps the tactic was not as strange as it looks. It may be that he was already in love with Effie Gray by this point, or at least strongly drawn by her, and that, both disliking the prospect of their son marrying beneath him, and hankering for an advantageous connection with 'the elegant and high-bred', John James and Margaret were doing their best to force Ruskin into Charlotte's arms. It may also be that Ruskin was simply playing along, and delaying until Charlotte announced her (predictable) engagement to his (notional) rival, a Mr. James Hope.

In the mean time, Effie – now fifteen, the age Adèle had been when the boy Ruskin had fallen for her – came to stay at Denmark Hill from late April until 15 June; it must have been an awkward time for all. Effie was most impressed by how greatly Ruskin was in demand: 'He is just gone to breakfast with Rogers the poet, he then lunches at the Dean's Dr Buckland, he then goes to Sir Stratford Canning's and dines at Mr Ellis's'. Ruskin was signally failing to pursue Charlotte as his parents wished; and Effie began to flirt with him. He would wait outside her room before dinner every evening to escort her down – a practice which annoyed John James and Margaret intensely. By the time she left, they had declared their love for each other.

In the summer Ruskin went back to Oxford, and then for further treatment by Dr Jephson at Leamington Spa. Then he went on to Scotland, crossing the border on 18 August. He made no attempt to visit Effie now, probably because he had promised his parents that he would not do so. He was in a very poor mental state. On 25 August he wrote to his father that he was 'utterly downhearted... I am afraid of something seizing me in this state of depression.'

His parents, worried by all this, gradually and reluctantly came around to the idea that it might be best for him to be allowed to see Effie and even, little as they relished the idea, to marry her if he were so inclined. Ruskin went to Bowerswell and stayed for a week; it was not a wholly satisfactory visit. He was seeing Effie

Effie, c. 1850.
This may have been drawn in Venice, after Effie had had a miniature made. Ruskin seems to have thought he could do better, but Effie was not convinced, finding 'my throat too thick and my eyes not enough fire in them'

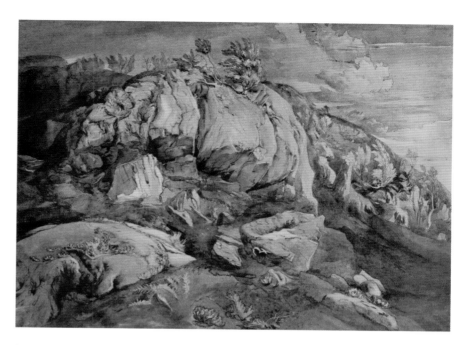

Study of thistles, Crossmount, 1847, as reproduced in the Library Edition. This was one of the drawings of natural forms that Ruskin completed in Scotland during his trip in August 1847

in her own surroundings for the first time, and learned to his dismay that she had other potential suitors – indeed, that there was an 'understanding' with a young man (one William Macleod) who was in India.

He wrote to a friend that 'I love Miss Gray very much and therefore cannot tell what to think of her – only this I know that in many respects she is unfitted to be my wife unless she also loved me exceedingly.' He proposed by letter and, by 21 October, had been accepted. Between this point and the wedding, five months later, he showered her with letters.

1848, the year well known to historians as the year of Revolutions across Europe, is for Ruskin scholars the year of his ill-starred marriage. On Monday 10 April, at four in the afternoon, he married Effie Gray in the drawing room of her family home in Perth, and they spent their wedding night in Blair Atholl. (Their wedding day coincided with a major Chartist demonstration in London.)

Perhaps the single most notorious element in Ruskin folklore is his failure to consummate their marriage, either on the wedding night or for the next six years. In a letter to her father, written several years later, on 7 March 1854, Effie wrote

> I had never been told the duties of married persons to each other and knew little or nothing about their relations in the closest union on earth. For days John talked about this relation to me but avowed no intention of making me his Wife. He alleged various reasons, Hatred to children, religious motives, a desire to preserve my beauty, and finally this last year told me his true reason (and this to me is as villainous as all the rest), that he had imagined women were quite different to what he saw I was, and that the reason he did not make me his Wife was because he was disgusted with my person the first evening April 10th....

Ruskin's legal deposition about these matters only deepens the mystery:

> It may be thought strange that I could abstain from a woman who to most people was so attractive. But though her face was beautiful, her person was not formed to excite passion. On the contrary, there were certain circumstances in her person which completely checked it. I do not think either, that there could be anything in my own person particularly attractive to her: but believed that she loved me, as I loved her, with little mingling of desire.

Gossip has long since supplied an answer to the question of what it was about Effie that so distressed Ruskin: since the only naked women he had encountered were those in statues and paintings, he did not know about pubic hair. This legend is so firmly entrenched in semi-educated folklore that it is often the single tale by which Ruskin is popularly remembered. Yet not only does it lack an unequivocal source; it is also highly unlikely. However naïve he might have been about the nature of women in general, Ruskin had almost certainly seen pornographic images during his time as an undergraduate, and knew that women had pubic hair. What he may not have known about was menstruation, and some biographers have speculated that Effie may have had her period on their wedding day; but this, too, seems an inadequate explanation for his sustained coolness towards her. The doctors who examined her at the time of the annulment reported both that she was a virgin and that she was 'naturally and properly formed.' Very much so: in later years, she gave birth to eight babies.

To their friends and acquaintances, though, the obvious problem of their marriage was not what failed to go on in the marital bed, but the fact that Effie – quite reasonably – resented the constant fussing and fretting of Ruskin's parents over their precious son.

In August, four months after their marriage, the couple set off for an eleven-week tour of Northern France, mainly in Normandy. Ruskin made an intense study of Gothic architecture. Shortly after their return to London, and after settling into

Avranches, with the Mont St Michel in the distance, 1848. This is one of the large drawings completed during the Ruskins' honeymoon

the house that John James had rented for them at 31 Park Street, Ruskin set
about turning his recent studies into a short book: *The Seven Lamps of
Architecture*. Among his motives for writing the book was an anxiety about the
dangers of ill-considered architectural restoration; Ruskin was concerned both to

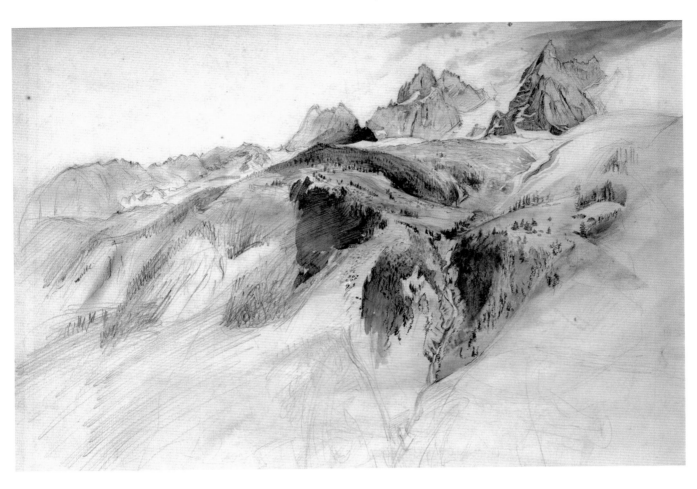

Aiguille Charmoz, Chamonix, 1849.
As well as studies taken purely for geological
information, Ruskin made larger drawings of the
Chamonix region, testing his artistic powers:
this was drawn from the window of the Hôtel
de l'Union, during his trip in late 1849 with
his parents but without Effie. The drawings of
1849 especially are among his finest, although
he wrote at the end of his stay in that year
that 'really my Chamouni work has been
most disappointing to me... I can't do it
yet, but I have the imagination of it
in me, and will do it, some day'

restrict the extent of such restoration and to preserve a memory of what might
be lost. Meanwhile, Effie, an outgoing girl, fretted at their lack of a social life,
and sometimes tried to invite people to come and meet him. One of those
she invited, F. J. Furnivall, left a charming account of how the newly-wed Ruskin
appeared on first encounter:

> I sprang up at once to take the outstrecht hand, and then and there began a
> friendship which was for many years the chief joy of my life. Ruskin was a tall,
> slight fellow, whose piercing frank blue eye lookt through you and drew you
> to him. A fair man, with rough light hair and reddish whiskers, in a dark blue
> frock coat with velvet collar, bright Oxford blue stock, black trousers and
> patent slippers... The only blemish in his face was the lower lip, which pro-
> truded somewhat... But you ceast to notice this as soon as he began to talk.
> I never met any man whose charm of manner at all approach Ruskin's. Partly
> feminine it was, no doubt; but the delicacy, the sympathy, the gentleness and
> affectionateness of his way, the fresh and penetrating things he said, the boyish
> fun, the earnestness, the interest he showed in all deep matters, combined to
> make a whole which I have never seen equalled.

1840-50: THE AUTHOR OF MODERN PAINTERS

Furnivall's testimony is a valuable reminder, at a time in Ruskin's life when he can seem at his most selfish, inconsiderate and even inhumane, of just how attractive and inspiring he could nonetheless be to women and men alike.

In April, Ruskin set off for yet another continental tour with his parents; Effie was too ill to join them. *The Seven Lamps of Architecture* was published while they were away. It became immensely influential – compulsory reading for all young architects, and a key element in the Gothic Revival. Ruskin's seven lamps are: sacrifice, truth, power, beauty, life, memory and obedience. Effie, at home, had been fretting about wanting to travel herself, and was particularly anxious to see Venice, about which her husband had said so much. Ruskin was barely back from Switzerland when he agreed to take her, and they set off again in September.

MR & MRS RUSKIN IN VENICE

On 22 March 1848, Venice had revolted against Austrian rule and declared itself a republic again. Early in 1849, the Austrians set out to reconquer it. They were victorious, and Venice surrendered on 22 August 1849, but only after a five-month siege and a non-stop artillery bombardment that was said by some to have been without precedent in the history of warfare.

The Ruskins arrived in the city in November, and booked in to the Hotel Danieli – the most expensive in town. They were to stay in Venice until 9 March 1850. The members of their party – which included Ruskin's servant John Hobbs, and Effie's companion Charlotte Ker – were almost the only foreign visitors to the city, which was not merely under Austrian martial law but bitterly impoverished – for the poorer, to the point of starvation – and suffering from the after-effects of bombardment and a cholera epidemic. Nature seemed to add to the misery, for it was also a terribly cold winter.

Distant view of Venice by moonlight, 1849-50. Although the bulk of Ruskin's drawings in Venice were architectural studies for The Stones of Venice, *he was also alive to the city's more atmospheric beauties*

St Mark's Square, Venice, Daguerreotype, c.1845. Ruskin was an early enthusiast for the Daguerreotype, and in 1845 was delighted to purchase a whole series of them from a French photographer in Venice, including perhaps this one: 'exquisitely bright small plates, (about four inches square), which contained, under a lens, the Grand Canal or St. Mark's Place, as if a magician had reduced the reality to be carried away into an enchanted land.' On later visits to Italy, and in France and Switzerland, he had plates made under his direction, by his man-servants John Hobbs and Frederick Crawley

Undaunted by this, Ruskin engaged an Italian manservant called Domenico, and then threw himself into work with an energy and dedication that was remarkable even by his own standards. His first impulse was to visit all the major buildings and make sure that they had not been too badly damaged by the bombardments or the occupying army. Effie – quite a lively prose stylist – wrote home about her strange husband's activities in a spirit of gentle mockery:

> Mr Ruskin is busy all day till dinner time and from tea till bed time. We hardly ever see him excepting at dinner, for he has found that the short time we are able to remain is quite insufficient for the quantity of work before him. He sketches and writes notes, takes Daguerrotypes and measures of every palace, house, well or any thing else that bears on the subject in hand, so you may fancy how much he has to arrange and think about. I cannot help teasing him now and then about his sixty doors and hundreds of windows, stair-cases, balconies and other details he is occupied in every day.

And:

> John excites the liveliest astonishment to all and sundry in Venice and I do not think they have made up their minds yet whether he is very mad or very wise. [Perhaps the same was true of Effie?] Nothing interrupts him and whether the Square is crowded or empty he is either seen with a black cloth over his head taking Daguerrotypes or climbing about the capitals covered with dust, or else with cobwebs exactly as if he had just arrived from taking a voyage with the old woman on her broomstick. Then when he comes down he stands very meekly to be brushed down by Domenico.

Above and opposite: Preparatory drawings for The Stones of Venice. *Opposite, an example of a Venice 'worksheet' (1850), a larger study meticu-lously drawn and measured on the spot; 206 numbered worksheets survive, of which 78 are in the Ruskin Library. Ruskin would write up his notes in large diaries, carefully cross-referred with the worksheets and other material, including individual drawings (such as the Study of a gable, No. 14, 1849, above). In due course he also started to collect notes and sketches on particular themes, using smaller notebooks (see pp. 56-7)*

They spent little time in each other's company. Not that Effie now minded very much: she was enjoying herself in her own ways. She went to many balls and parties, often escorted by a dashing Austrian first lieutenant, Charles Paulizza. There is no suggestion that this grew into an affair, however much the Lieutenant might have wished it. Ruskin was entirely free of jealousy, and he, too, sometimes enjoyed the company of both Paulizza and a resident Englishman who became a good friend, Rawdon Brown. For a brief time, they enjoyed such happiness as was possible for an ill-matched pair.

Lower portion of window on other sheet
The finish & bristleness of lion heads
very fine. For the rest after doge palace
Now note. great roll. faced at a and b
and its proper joined at c. semi separate
ie ⌣⌣ . at e.
which the small roll of the
great arch foliation is central
a separate order. faced only where
smallest arches join the trefoil circle
fz is a truer contour than f.
and the cusp of this smaller
trefoil has a fillet
and the central 4 foil a fillet
only on the outer sides of
its cusps.
get xy. if I can.

joint ———— joint
all cut I
think in two
masonry pieces

fz

side shaft
rich eye —
dotting line
central real eye

Fig 1

octagonal
line section
of central
shaft

but side
shape
with
cornices leaves and

central shaft
section

octagonal

central shaft
head. octagonal.
as well as shaft
above. at d.
leaves on abacus.

Fig 3.

Fig 2

Fig 4.

No 148. Traceries Front.
p 80. M. 2

Some pages from the thematic notebooks that Ruskin compiled in Venice, 1849-50. The first, House Book I, (above) was prepared by Effie with headings, as was the slightly later Door Book. Other books came later as material accumulated: the Bit book (right); the second House book (spreads below); the Palaces book (spreads opposite, above); and the Gothic book (spreads opposite, below). Ruskin carefully went through these as he wrote The Stones of Venice, *crossing out material as he used it*

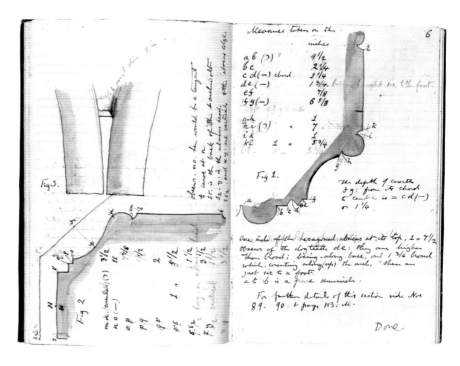

RUSKIN AND ARCHITECTURE

Even if Ruskin had never written so much as a sentence on painting, drawing or sculpture, he would still be regarded as one of the nineteenth century's most profound critics, on the strength of his architectural studies. It could even be argued that Ruskin's books on architecture are of greater and more enduring significance than his books on painting, since their arguments told so deeply in the practical worlds of building, design and restoration. Among other achievements, Ruskin gave fresh direction and intelligence to the Gothic Revival; introduced searching ways of thinking about and loving the buildings of the middle ages; fought against the prevailing fashion for insensitive restoration of old edifices and argued instead for respectful conservation; prompted the foundation of the National Trust and other movements; and inspired many of the outstanding architects of the following century, above all Frank Lloyd Wright, to think about 'organic' buildings.

Indeed, Ruskin's career as a mature writer begins with the publication of 'The Poetry of Architecture' in the *Architectural Magazine* (1836-7); these essays, signed Kata Phusin – 'According to Nature' – proposed that buildings should be designed so as to be in harmony with their local environs, and should, wherever possible, be constructed from local materials. His work on *Modern Painters* took him away from the theme for a few years, but in the winter of 1848, after a research trip around Northern France with his new wife, he set about trying to show that 'certain right states of temper and moral feeling were the magic process by which all good architecture has been produced.'

Cover of the original edition of The Seven Lamps of Architecture, *showing the interconnection of the Seven Lamps. The design is based on the 13th century inlaid floor panels of San Miniato (which may have been traced for Ruskin by his servant 'George'), as an example of the type of 'pure architectural decoration' in which organic form is 'abstracted to outline'*

He called the resulting book *The Seven Lamps of Architecture* (1849), the 'lamps' or principles in question being Sacrifice, Truth, Power, Beauty, Life, Memory and Obedience. Only two of these principles – Power and Beauty – were staples of architectural writing before Ruskin's time. Ruskin insisted that the spatial dimensions of buildings were also moral dimensions; as in his studies of painting, ethics and aesthetics were inseparable. There was also a religious aspect to the book. The Catholic architect Pugin, one of the most brilliant advocates of the Gothic style in architecture (Ruskin claimed never to have read him, but he must have been well aware of what Pugin had said), had persuaded himself and others that a necessary condition of a return to Gothic architecture in Britain was for the country to cast off Protestantism and return to Rome. Some of the richness and complexity of Ruskin's work in architecture, throughout his career, is a conflict between his Protestant inheritance and his love for the fruits of the Catholic Middle Ages.

In later years, Ruskin turned violently against *Seven Lamps*, calling it a 'wretched rant of a book', and deploring its popularity with the reading public, but – quite apart from its considerable merits both as prose and as argument – it was the prelude to one of his four or five great masterpieces, *The Stones of Venice*. The battle between, as Rosenberg puts it, 'Ruskin's anxious conflict of attitudes between Catholic art and Catholic worship' continues in the pages of *Stones*, and in an appendix, 'Romanist Modern Art', Ruskin attacks Pugin directly and vehemently. Again, Ruskin came in old age to regret some of the sentiments he expressed in this work: 'I am struck, almost into silence, by wonder at my own pert little Protestant mind.' There is no need to dwell on these misgivings too

One of the plates from *The Seven Lamps of Architecture*, entitled: 'Traceries from Caen, Bayeux, Rouen and Beauvais.'

'...The more frequent and typical form is that of the double sub-arch, decorated with various piercings of the space between it and the superior arch; with a simple trefoil under a round arch, in the Abbaye aux Hommes, Caen (fig 1); with a very beautifully proportioned quatrefoil, in the triforium of Eu, and that of the choir of Lisieux; with quatrefoils, sixfoils, and septfoils, in the transept towers of Rouen (fig 2); with a trefoil awkwardly, and very small quatrefoil above, at Coutances (fig 3); then, with multiplications of the same figures, pointed or round, giving very clumsy shapes of the intermediate stone (fig 4, from one of the nave chapels of Rouen, fig 5, from one of the nave chapels of Bayeux), and finally, by thinning out the stony ribs, reaching conditions like that of the glorious typical form of the clerestory of the apse of Beauvais (fig 6). (In this plate, figures 4, 5, and 6 are glazed windows, but figure 2 is the open light of a belfry tower, and figures 1 and 3 are in triforia, the latter also occurring filled, on the central tower of Coutances.) Now it will be noticed that, during the whole of this process, the attention is kept fixed on the forms of the penetrations, that is to say, of the lights as seen from the interior, not of the intermediate stone. All the grace of the window is in the outline of its light; and I have drawn all these traceries as seen from within, in order to show the effect of the light thus treated, at first in far off and separate stars, and then gradually enlarging, approaching, until they come and stand over us, as it were, filling the whole space with their effulgence. And it is in this pause of the star, that we have the great, pure and perfect form of French Gothic; it was at the instant when the rudeness of the intermediate space had been finally conquered, when the light had expanded to its fullest, and yet had not lost its radiant unity, principality, and visible first causing of the whole, that we have the most exquisite feeling and most faultless judgments in the management alike of the tracery and decorations'

Plate III.

J. Ruskin.

R.P. Cuff.

Allen & Co. Sc.

Baden. Switzerland
First try of large subject 36.R.
catalogue J Ruskin . 1863
263

*Capital 36 of the Doge's Palace, 1849-52.
The second volume of* Stones of Venice *contains a
detailed study of the 36 capitals that support the
lower storey of the Doge's Palace, a typically
Ruskinian close reading of architectural detail. This
last capital of the series, which supports a large
sculpture of the Judgement of Solomon, shows
Justice on the left, in the centre Aristotle the law-
giver, and to the right a figure Ruskin never man-
aged to identify, teaching two boys to read. Ruskin
thought the capital both noble and graceful, but his
point is that it was an assertion by the government
of Venice that 'Justice only could be the foundation
of its stability, as these stones of Justice and
Judgment are the foundation of its halls of council'*

*Opposite: Baden, 1863. An example of Ruskin's
ability to understand architecture on a larger scale
and in its social context. His first visit to Baden
was in 1833; a diary entry for 13 September typi-
fies his combined early interests in geology and the
picturesque: 'Pretty place on the Limmat among
limestone rocks of distinct and thin strata, dipping
southwest about 30°, richly wooded in some parts
and bare and fantastic in others; meadows around
green and beautiful and town picturesque enough.'
He returned thirty years later, spending the last two
weeks of September 1863 at work on drawings for
the Swiss towns project. The inscription on this
watercolour – 'First try of large subject' – was
added by Ruskin at a later date, and refers to a
remarkable large composite view of the town,
made from five joined sheets of paper (Private
Collection). This kind of aerial view was much
favoured by Ruskin, but well reflects the vertiginous
Swiss landscape: working from a stone outcrop high
on the right bank of the river Limmat, he has typi-
cally started to work up just a few isolated parts of
the composition, including the Stadtturm, with its
corner turrets, and the Schloss Stein above*

long. *Stones* is magnificent, both for its evocation and analysis of particular build-
ings and for the brilliance of its overall argument that the rise and fall of a major
nation is given precise and inescapable articulation in its buildings. And its much-
reproduced chapter 'The Nature of Gothic', a meditation on labour, was the ear-
liest of Ruskin's piercing anatomies of social health and illness.

Unlike many men of letters, Ruskin actually had the chance to see his sermons
turned into stones, when his friend Henry Acland asked him to collaborate on
the design and decoration of the Oxford Museum. Here was the opportunity to
make a building in the true, rather than cod-Gothic style. (In 1872, he com-
plained in a letter to a friend about the disastrous influence of his eulogy of
Venetian Gothic: 'I have had indirect influence on nearly every cheap villa-builder
between this [address] and Bromley; and there is scarcely a public house near
the Crystal Palace but sells its gin and bitters under pseudo-Venetian capitals,
copied from the Church of the Madonna of Health.') The problem was that
builders were simply apeing or pastiching certain elements of the Gothic style;
true Venetian Gothic, Ruskin insisted, was founded on the involvement of the
whole community, and was an expression of that community's deepest aspira-
tions and faith. For various reasons, Ruskin grew discontented with the Oxford
Museum project, as with so much else in his life. He could hardly have foreseen
that his teachings would inspire later generations of architects in strange and
wonderful ways.

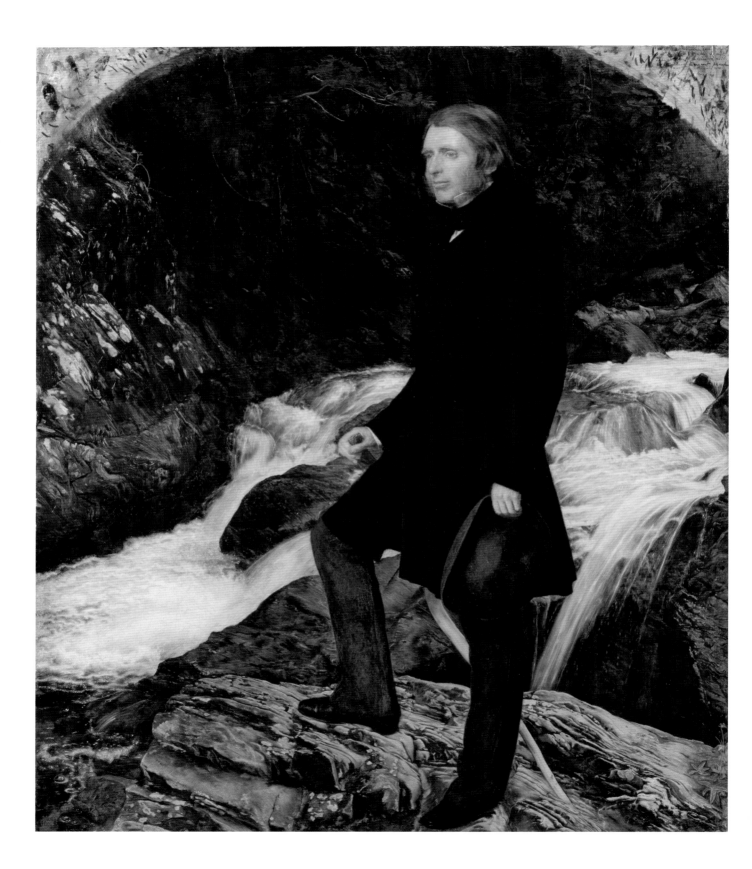

1850-1860: ARCHITECTURE AND ADULTERY

After the economic and social crises of the 1840s, the early to mid 1850s were increasingly triumphant ones for the British middle classes, though the decade would end with a shocking slump. One index of their growing prosperity was a rise of some 27 per cent in the servant population, to about 1.05 million. Despite the rush of capital into industrial ventures, there was still an immense amount available for investment in luxury goods, including art and architecture. The Gothic Revival was just one of many movements fuelled by this great surplus, and the Gothic style was now being deployed in buildings as varied as railway stations and suburban houses. And all those new suburban houses had lots of empty walls that required filling with pictures. One does not have to be a vulgar materialist to grasp the significance of this development for a major art critic: a nation with more time to enjoy art and more disposable income to spend on it was in urgent need of an authoritative voice. As one of his biographers, Wolfgang Kemp, puts it: 'Ruskin's career was closely bound up with the movements of the middle class and of surplus capital...'

THE STONES OF VENICE

Effie and John left Venice on 9 March 1850. In early April they stopped in Paris, and met the Domecq family, including Adèle – now the Baroness Du Quesne. Effie said that she thought her 'much the plainest of the whole lot'; she was not, perhaps, the most impartial of judges. By 20 April they were back in Denmark Hill, and they spent most of the summer and winter of 1850-51 in London. Ruskin did not like to work at their new house in Park Street, so he would usually go every morning to Denmark Hill, where he began months of hard, solitary labour on *Stones of Venice*, writing in his old room until six every evening. He kept up this diligent regime until March 1851.

As a minor concession to Effie, Ruskin agreed to attend a number of parties in the evenings, though he did not greatly relish the business of socializing. He did, however, greatly enjoy quieter and more intimate evenings with Thomas Carlyle – who would eventually come to be a father figure, especially after the death of John James – and the poet Coventry Patmore. Despite her obvious and largely unfeigned gaiety in public, Effie was often sad, and privately began to share the opinion of others that both her spirits and her physical well-being might improve were she to become a mother. She wrote to Brown, in Venice:

> I quite think with you that if I had children my health might be quite restored. Simpson and several of the best medical men have said so to me and your gracious permission to me against your prejudices amuses me not a little, but you would require to win over John too, for he hates children and does not wish any children to interfere with his plans of studies. I often think I would be a much happier, better, person, if I was more like the rest of my sex in this respect.

Increasingly uncomfortable in the disapproving presence of the Ruskin family, she spent two months of the summer back home at Bowerswell, and returned to Park Street in October. Ruskin now instructed her to refuse all his invitations for the next few months, to allow him to concentrate exclusively on *Stones*.

Opposite: Ruskin at Glenfinlas, by Millais, 1853-54. Ruskin, wearing his blue stock and holding his familiar wide-awake hat, stands by the gneiss rocks that he himself drew (see p. 69). Conceived, painted and finished under increasingly trying circumstances, the painting never pleased Ruskin or his family: 'As for the wonderment of the painting... there can be of course no question,' Ruskin wrote to Millais. 'On the whole the thing is right and what can one say more – always excepting the yellow flower and the over-large spark in the right eye, which I continue to reprobate – as having the effect of making me slightly squint... BUT my father and mother say the likeness is perfect – but that I look bored – pale – and a little too yellow. Certainly after standing looking at the rows of chimnies in Gower Street for three hours – on one leg – it is no wonder...'

THE WORLDS OF JOHN RUSKIN

On 3 March 1851 Ruskin published the first volume of *The Stones of Venice*. He was thirty-two, and with this triumphant sequel to his work in *Modern Painters*, clearly the author of what were going to be two of the dominant literary works of the age. *Stones* opens with a magnificent flourish, which has justly become famous:

> Since first the dominion of men was asserted over the ocean, three thrones, of mark beyond all others, have been set upon its sands: the thrones of Tyre, Venice, and England. Of the First of these great powers only the memory remains; of the Second, the ruin; the Third, which inherits their greatness, if it forget their example, may be led through prouder eminence to less pitied destruction.

Powerful as this overture is, its sentiments are not particularly original. To compare Britain with Venice was something of a staple of political speeches at that time; and in 1849, Disraeli ended one of his thunderous declamations with the warning that '... I see no reason why you should form an exception to that which the page of history has mournfully recorded; that you too should not fade like the Tyrian dye and moulder like the Venetian palaces ...' But the use Ruskin went on to make of the comparison was indeed quite novel, notably in his insistence on the superiority of medieval Venice to its Renaissance successor.

At almost exactly the same time he launched *Stones*, Ruskin published a pamphlet, a small chipping from the greater work: *Notes on the Construction of Sheepfolds*, which argued for the unification of all Protestant Christian communions. It was said that a number of farmers bought it under the mistaken impression that it was an agricultural handbook, though the story probably has more charm than verity.

He relaxed briefly from his strenuous regime of composition for a few weeks in the spring. In April, he and Effie went to Cambridge, where Ruskin noted the ugliness (as he saw it) of King's College chapel, and then on to Yorkshire and Derbyshire. He took up his pen again to begin Volume II of *Stones* on 1 May 1851: the same day that the Great Exhibition opened just a few miles away. He wrote in his diary: 'Denmark Hill. Morning. All London is astir, and some part of all the world. I am sitting in my quiet room, hearing the birds sing, and about to enter on the true beginning of the second part of my Venetian work. May God help me to finish it to His glory, and to man's good.' As one might expect, he despised the huge glass structure at which tourists were already goggling in their thousands; Effie, with less fastidious tastes, had a season ticket to the Exhibition. It is not a bad indication of their unsuitability for each other, and their growing estrangement.

His contempt for the Crystal Palace was only one of the ways in which Ruskin went against the majority opinion of that month. The *Times* had recently fired off two attacks on the work of Holman Hunt and Millais, first at the Royal Academy show in 1850 and even more fiercely for this summer's show. At the suggestion of Coventry Patmore, Ruskin went to the Royal Academy to inspect their work, found far more to admire than to deplore, and wrote eloquent letters to the *Times* praising these self-styled 'Pre-Raphaelites'. The second letter prophesied that they might well 'lay in England the foundations of a school of art nobler than the world has seen for three hundred years.'

Opposite: drawings for Plate XII of The Stones of Venice II, *'Linear and Surface Gothic'. The three volumes of* The Stones of Venice *are illustrated entirely with Ruskin's own drawings, often made by putting together studies like these in a kind of collage. This is one of the most elaborate. The window openings at the top are from Rouen and Salisbury cathedrals; the canopies and mouldings below from St. Wulfran, Abbeville and the Can Grande tomb in Verona. The drawing illustrates one of the main points of the most influential chapter of Volume II, 'The Nature of Gothic' – the difference between the two 'vast schools' of the style, exemplified by the simple strength of the Veronese tomb on the right, and the wayward, repetitious linearity of the Abbeville gable on the left – and explores its ethical dimension. 'The late French Gothic is very beautiful,' Ruskin concludes, 'but the Italian Gothic is the nobler style'*

Plate 12.

Fig 2

Fig 4

Fig 5

Fig 6

Part of Stones of Venice 2 Pl. xii

Doge's Palace, Venice: 25th Capital, 'Month of March', probably drawn at the time of writing The Stones of Venice. *Ruskin greatly admired the original fourteenth-century sculpted capitals of the Doge's Palace, for their naturalistic decoration and for the mixture of graceful and grotesque carving, and wrote about them in Volume II (1853) of* Stones. *On this capital, facing the Piazzetta, he correctly identified (from a series depicting the months) the figure of March, 'sitting triumphantly in a rich dress'. He later gave plaster casts of the capitals to the South Kensington (now Victoria and Albert) Museum*

Hunt and Millais, deeply gratified, wrote to thank him. Ruskin and Effie visited Millais at his house in Gower Street, and the three soon became close friends. Ruskin adapted his *Times* letters into a pamphlet, *Pre-Raphaelitism*, and, despite the tangled webs of passion, remorse and rage that ultimately came of this association between the still-young critic and the young painters, he would from now on be known as the doughty supporter of Millais & Co as well as of Turner. (At the same time Ruskin was being so certain in his unconventional artistic views, his religious doubts were growing more troublesome. In May, he wrote to Henry Acland: 'You speak of the Flimsiness of your own faith. Mine, which was never strong, is being beaten into mere gold leaf.')

With *Stones* duly set on its way and the Pre-Raphaelites duly boosted, Effie and John set off for a second long stay in Venice, where they arrived on September 1st, and learned almost at once that Paulizza had died just a few weeks earlier, in July. The couple moved into lodgings at the Casa Wetzlar – today, the Gritti Palace Hotel – and Ruskin hurled himself into work with renewed, almost phenomenal

energy. Effie, who had no mission of her own, enjoyed being back in Venetian society, but was still unhappy about her strange new family. In October, she wrote to her parents about the chilliness of the Ruskins, saying 'I do not grow fonder of them as I grow older.' A few weeks later, she told them that 'every time John is with them without me his mind is poisoned.' Her health, no doubt as a consequence of her anxieties and discontents, began to suffer.

For Ruskin, work proceeded without undue interruption until three days after Christmas, when he learned by letter of Turner's death (on 19 December). Turner, he discovered, had made him an executor of his will. His mind began to turn on the question of an adequate memorial to Britain's greatest painter, and for a while he mused that there should be a Turner Gallery 'in the form of a labyrinth'.

His musings continued into the New Year, 1852. For a while, Ruskin contemplated writing a *Life* of Turner, but soon concluded that 'Biography is not in my way.' He returned to his Venetian labours, and permitted himself and Effie only a few distractions. An unusually light-hearted one came in February, when they attended the Carnival. A more sombre one came in March. Ruskin sketched out his earliest essays in social criticism – three letters on the Corn Laws and economic problems, intended for publication in the *Times*. But John James strongly disapproved of the radical strain in his son's arguments, and suppressed these letters. It was the beginning of a new kind of tension between father and son that would grow deeper over the next few years.

On May 16th, Ruskin and Effie moved to rooms overlooking St Mark's Square for the last few weeks of their stay. They finally left Venice in the last week of June and were back in England by 12 July. John James had leased a new house for them, just a short walk away from Denmark Hill: 30, Herne Hill. Effie found it all 'inconceivably cockney after Venice'. She was gloomy, and her health was, again, very poor. Apparently indifferent to his wife's dark moods, Ruskin picked up his former routine of going to his parents' house every day to write the next two volumes of *Stones*. He worked, if anything, harder than ever, and took only a very few breaks from his demanding task. Effie spent September to November in Bowerswell; her health continued to decline, and she was deeply unhappy with her cruelly inattentive husband. Anyone privy to their story might have guessed that a crisis was imminent.

The Order of Release, by Millais, 1853

Early in 1853, Effie sat for Millais as the heroine of a picture which was eventually titled 'The Order of Release'. Millais completed it at the end of March, and it was a great success at the Royal Academy that summer. It may have been at this time that the two friends began to grow infatuated with each other – or, at least, Millais began to be smitten with Effie; but, if so, Ruskin does not seem to have noticed. In May, the Ruskins took an apartment at 6, Charles Street, near Berkeley Square, for the season, and they made a good show of covering up their growing discontent with each other by often going out together.

THE SCOTTISH SUMMER

If Ruskin suspected that illicit love was blossoming between his wife and his friend, he did nothing to prevent it. It seems possible that he might even have half-

Ruskin's sketch of the cottage where he, Effie and Millais stayed at Glenfinlas, sharing with the schoolmaster and the school, though they had use of the garden. In the accompanying letter to his father, Ruskin sketched some of the Glenfinlas vegetation, lamenting 'I have lost all power of sketching fact. I must either do a thing thoroughly – grass and leaves – or I can't do it at all.'
Opposite is the finished drawing that he made of the gneiss rocks at Glenfinlas, a little upstream from the spot where he stood for Millais' portrait

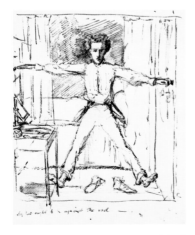

Millais, self-portrait from the sketchbook he used at Glenfinlas

consciously promoted an affair, since Effie was proving such a dreary nuisance; after all, he could hardly have contrived a better way of advancing the nascent affair than by arranging for all three of them to spend a summer holiday together. After the London season, they took a trip north with Millais and Millais's brother. Their first stop was Wallington, Northumberland, which they reached by 22 June – having travelled, despite Ruskin's principled dislike of rail travel, by train.

They travelled on, via Edinburgh, to the Highlands: Brig o'Turk in Glenfinlas, in the Trossachs. After a few days at the Inn, they put up at the local schoolmaster's house. Millais began to work on a portrait of Ruskin: it went very slowly, and more slowly still as Millais grew ill and unhappy – increasingly smitten with Effie. During their Scottish trip, Ruskin's reputation was consolidated by the publication of *Stones* Volume II on 28 July, and Volume III on 2 October. The long trip ended in late October; by this time, almost inevitably, Millais was hopelessly in love with Effie, and in a state of near-hysteria.

Ruskin had accepted an invitation to lecture in Edinburgh, and on the 1, 4, 15 and 18 November he delivered his 'Lectures on Architecture and Painting' (published in April 1854). These were well received, and very popular: a thousand people attended, and the hall was so crammed that some fainted and had to be carried out. He was lionised by Edinburgh's intellectual classes – most gratifying to his sense of Scottish identity and pride. Two days after the final lecture he wrote to his parents that he had finally begun work on *Modern Painters III*. But, though he

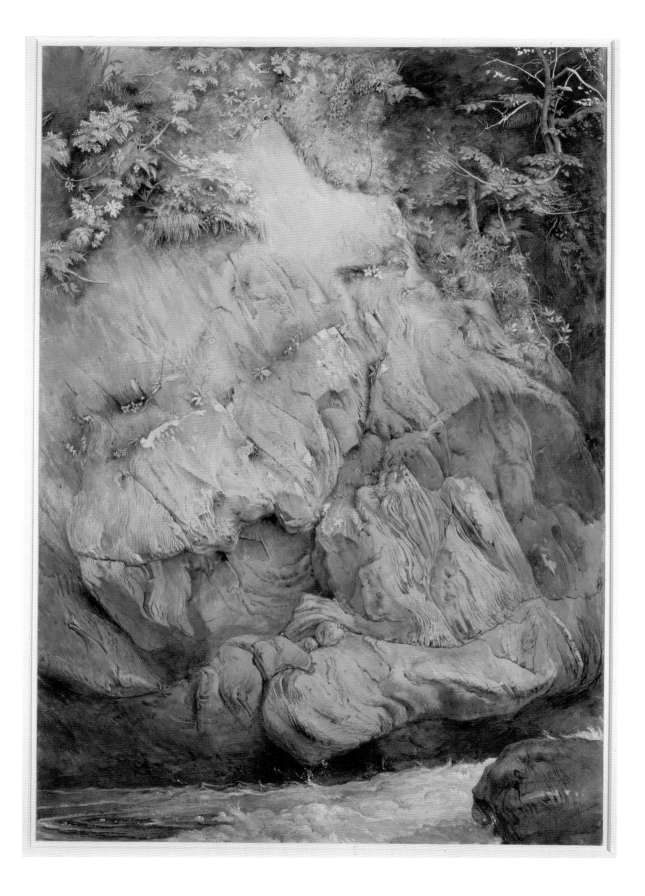

Diagram used to illustrate the second of Ruskin's 1853 lectures in Edinburgh. It shows how a pointed arch can be both practical – having sufficient depth to incorporate a sash window – and decorative, especially if that decoration draws on natural forms for inspiration: 'It is the glory of Gothic architecture that it can do anything.' Both Effie and Millais also worked on the diagram.

did not foresee its long afterlife, he was already the author of a short text which would go on to have a more substantial influence on the world than anything in the five volumes of *Modern Painters*.

THE NATURE OF GOTHIC

Volume Two of *Stones* contained a chapter entitled 'The Nature of Gothic'. The significance of this essay was far-reaching and dramatic. It was, for example, an inspiration to the best British architects of the Gothic Revival: Butterfield, Waterhouse, Street. But it also encouraged less talented men towards the thoughtless grafting of some superficial trappings and stylistic details of Gothic architecture on to buildings which had no other Gothic dimension – and particularly not what Ruskin saw as its spiritual well-springs. It was this type of bogus Gothic against which he would later thunder in his Bradford lecture, 'Traffic'.

But the real potency of 'The Nature of Gothic' lay not in its aesthetic arguments but in its ethical outrage:

> The great cry that arises from all our manufacturing cities, louder than any furnace blast, is all in very deed for this, – that we manufacture everything there except men; we blanch cotton, and strengthen steel, and refine sugar, and shape pottery; but to brighten, to strengthen, to refine, or to form a single living spirit, never enters into our estimate of advantages.

Or, again:

> We have much studied, and much perfected, of late, the great civilized invention of the division of labour; only we give it a false name. It is not, truly speaking, the labour that is divided; but the men: – Divided into mere segments of men – broken into small fragments and crumbs of life; so that all the piece of intelligence that is left in a man is not enough to make a pin, or a nail, but exhausts itself in making the point or the head of the nail.

'Gothic' soon took on a separate life from the rest of *Stones*. A few months later, in 1854, the philanthropist F. J. Furnivall asked Ruskin for permission to reprint the chapter as a pamphlet, which might be given free of charge to all students of his newly founded Working Men's College in London. Ruskin agreed, and so began a long relationship with that College. Thirty-eight years later, William Morris re-issued it as a handsome volume from his Kelmscott Press. Morris had first read it when it was brand new.

ENTER MORRIS

William Morris – by general agreement the most profound, appealing and heroic of British Socialists, as well as a poet, designer, printer and many other things – always professed his undying gratitude to the 'Tory' Ruskin, and, for all his dislike of masters, nonetheless referred to him as 'Master'. They did not know each other well, and met only a few times – Ruskin was much closer to their mutual friend Edward Burne-Jones – but their mutual regard was warm and enduring. Ruskin despised Socialism, as he understood it, yet it can be argued that Morris (who would eventually became a full-blooded socialist some three decades later, in the 1880s) did more than many avowed Ruskinians to make the Master's hopes into realities. One of Morris's contemporaries at Oxford, where he was an undergraduate at Exeter College from January 1853 until he took his pass degree in the autumn of 1855 and his BA in 1856 (and where he met Burne-Jones) recalled the importance of Ruskin's writings for idealistic young men:

> It was when... Burne-Jones and he [Morris] got at Ruskin, that strong direction was given to a true vocation... Morris would often read Ruskin aloud. He had a mighty singing voice, and chanted rather than read those weltering oceans of eloquence as they have never been given before or since, it is most certain. The description of the Slave Ship, or of Turner's skies, with the burden 'Has Claude given this?' were declaimed by him in a manner that made them seem as if they had been written for no end but that he should hurl them in thunder on the head of the base criminal who had never seen what Turner saw in the sky.

The Nature of Gothic, first page of the Kelmscott Press edition printed by William Morris (using his own 'Golden' typeface) in 1891

THE WORLDS OF JOHN RUSKIN

Morris had already read the two volumes of *Modern Painters* before coming up to Oxford; it was the newly published second volume of *Stones* that struck like lightning – and not for Morris alone. As Fiona McCarthy notes, *Stones* 'was an Oxford book, the Oxford book of that whole period...' Morris called it 'a revelation.' In his reading of this book we can find the roots of virtually his entire career in art and politics, including his establishment of a Society for the Protection of Ancient Buildings. Reading it was a turning point in Morris's life.

In his introduction to the Kelmscott edition, Morris explained that 'the lesson... Ruskin teaches us, is that art is the expression of man's pleasure in his labour.' Morris went on to proclaim that it was 'One of the very few necessary utterances of the century. To some of us when we first read it, now many years ago, it seemed to point out a new road on which the world should travel.' As Clive Wilmer has justly pointed out, though Morris does not give it, the name of that road is Socialism.

Back in London for the new year, 1854, Ruskin began proper work on *Modern Painters III,* and continued to sit for Millais's portrait. But his marriage was crumbling by the day. Effie was isolated and wretched at Herne Hill, and Ruskin often spoke to her harshly. She wrote a series of increasingly despairing letters back to her family. Eventually she was driven to make the most humiliating confession: on 7 March, she finally wrote to her father: 'I have therefore simply to tell you that I do not think I am John Ruskin's Wife at all!'

Mr Gray resolved to come to London and confront the Ruskin family. They arrived in London on the 14 April and, on the 25th, took Effie back to Scotland with them. Ruskin saw the party off at King's Cross, to all appearances unaware that this was a final break with his wife. On the same day, he was served with a citation to Court in a suit for the annulment of their marriage. If this shocked or wounded him, he seems to have recovered with almost indecent haste.

On 9 May, he left for the continent with his parents, as planned. By the 24th they were at Chartres. They moved on to Switzerland, where Ruskin contemplated the mountains with a sense of recovered serenity, and spent many hours drawing. These few weeks had a pervasive influence on the next two volumes of *Modern*

Panorama of Thun, 1854. Murray's Handbook described Thun as 'a very curious old town [which] contains within its walls nothing especially worthy of notice.' Ruskin always liked the place, partly for its associations with Turner (the lake at Thun was 'a quite favourite subject of Turner's; his first sketch of it from Nature used to hang in my mother's room') but also for its simplicity. Ruskin was always happy in Thun, and the visit in 1854 was no exception. 'I have had a lovely walk this afternoon through the streets of Thun in the balmy air, all the people at their windows, looking happy and quaint, and full of interest,' he wrote in his diary. There are nearly twenty known drawings of the Swiss town, many of which, like this example, are given a distinctive blue tonality, and concentrate on the varied interlocking roofs

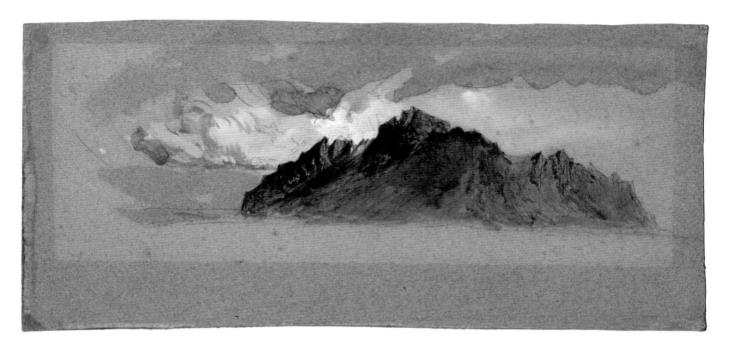

Mount Pilatus, probably drawn in 1854, when Ruskin escaped from his divorce proceedings to the Alps. He had a particular fondness for the range of low mountains overlooking Lake Lucerne, centring on Mount Pilatus, and drew them many times: 'wherever you see it, its form is always beautiful'

Painters. On 10 July, in Chamonix, he wrote: 'Thank God, here once more, and feeling it more deeply than ever. I have been up to my stone upon the Breven, all unchanged, and happy.'

During their absence, the law was moving with uncommon alacrity. On 15 July, the 'pretended marriage' was declared a 'nullity' since 'the said John Ruskin was incapable of consummating the same by reason of incurable impotency'. Many men would have found this public statement of their shortcomings a humiliation, but Ruskin was intensely happy. On 13 August he wrote 'How little I thought God would bring me here again just now – and I am here, stronger in health, higher in hope, deeper in peace than I have been for years.'

The family returned to London on 2 October, and Ruskin applied himself steadily to writing, though he also went out a good deal more than had previously been his habit. In December, the Glenfinlas portrait, finally completed, was hung at Denmark Hill. Ruskin wrote a civil note to Millais, who replied that he found it surprising that Ruskin should wish their friendship to continue.

All that autumn and winter, Ruskin, after discussing the matter with Furnivall, found a new preoccupation: lecturing on art at the Working Men's College in Red Lion Square. On 2 November he began a series of weekly lectures on drawing which he continued, at intervals, for the next five years. From this humble beginning came all manner of – mostly happy – consequences. Some of Ruskin's students went on to work for him in a variety of ways in later life; others made successful careers as fine craftsmen (though this was not Ruskin's primary ambition for graduates of the College).

This regular contact with intelligent, thoughtful, decent working men gradually

changed Ruskin's idea of his ideal audience; and one of his last great works was to be a series of letters addressed, precisely, to the Working Men of England. Some of those workers heeded him. Well into the twentieth century, earnest men and women of the working classes would try to improve themselves by reading Ruskin, or reading about him; and Ruskin's influence on the fields of working-class education and adult education was immense.

His friendships in other spheres were developing in unexpected ways, too. He met Rossetti's mistress, Elizabeth Siddall, at about this time, and declared that her pictures were even better than Rossetti's. He promptly bought them all. Ruskin was a great boon to the couple's finances: he agreed to give Elizabeth £150 a year, and agreed to pay Gabriel a fixed sum every year in return for whatever drawings he was willing to hand over. Ruskin's relations with Millais continued to be unexpectedly warm, at least on his side, and it was only after Millais failed to respond to another letter praising the excellence of the Glenfinlas portrait that Ruskin put an end to the friendship.

Towards the end of the year, he spent about a month in Oxford with Acland, who wanted Ruskin's help with an ambitious new project – a museum, complete with laboratories and exhibition halls, which would be a centre of science teaching. (Known for many years simply as the Oxford Museum, it is now called the Museum of Natural History.) The scheme was not popular in Oxford, as many of the more traditional dons believed that the University should continue to provide an exclusively classical or mathematical education, fit for gentlemen, rather than a scientific one. Acland asked Ruskin for commentary and advice both on the over-all structure of the new building and its decorative details. Ruskin was greatly taken by the idea, partly because it gave him a timely opportunity to put some of the claims he had made in 'The Nature of Gothic' to a practical test. It was also a chance for Britain to affirm its spiritual well-being by creating its own Gothic architecture.

Work gathered pace in the New Year, 1855, when Ruskin began to collaborate with Benjamin Woodward on designs for the building. Ruskin took charge of the sculptural schemes. This considerable task aside, it was a relatively uneventful peri-od, save for the marriage of Effie and Millais in July. His principal literary effort of the year – apart from continued attention to *Modern Painters* – was the first of his 'Academy Notes' – reports on the June exhibition at London's Royal Academy. With a quite remarkable degree of disinterestedness, he pronounced that Millais's *The Rescue* was 'the only great picture exhibited this year.'

The following year, 1856, was the year of *Modern Painters III*, in January, with Volume IV following in April. (In the following month, he also published a far more modest work, *The Harbours of England*.) In May, he went on another European tour with his parents: this one was to last four months, and most of the time was spent in Switzerland. He was tired, and did far less work than usual. On the steamer from Vevey to Geneva, he met his most important American friend and disciple, the Harvard art historian Charles Eliot Norton – or more exactly, re-met him, as Norton had paid a brief visit to Denmark Hill the previous October. In *Praeterita* he calls Norton 'a man of the highest natural gifts, in their kind;

John Ruskin with William Bell Scott and Dante Gabriel Rossetti, 1863, by William Downey. Among the most celebrated images of Ruskin is a group of informal photographs taken on 29 June 1863 by the photographer William Downey. They were made in the back garden of Dante Gabriel Rossetti's new house in Cheyne Walk, London, and also include the artist William Bell Scott. It seems that Ruskin was not expecting to be photo-graphed, which would account for his somewhat severe and flustered appearance, and for the fact that he was displeased when the images were publicly circulated

Opposite: Design for window, Oxford University Museum, c.1857-58. This quick sketch is a rather fanciful idea of a window whose upper part is formed by a pair of stylised birds

"Ruskin"
an idea by him for a Window at Oxford Museum

Fribourg, 1854-6. (Ruskin's inscribed date of 1859 is probably wrong.) Fribourg was one of the places most often visited by Ruskin, in the years when he was planning an illustrated history of Swiss towns, never seriously begun. In Modern Painters IV (1856) he wrote that it had kept 'much of the aspect it had in the fourteenth and fifteenth centuries,' and was therefore 'the only mediaeval mountain town of importance left'

observant and critical rather than imaginative, but with an all-pervading sympathy and sensibility, absolutely free from envy, ambition, or covetousness.'

The family were back in England at the end of September. Ruskin spent some time pursuing friendships with writers and painters. In October he called on Morris and Burne-Jones; in November, he wrote to Browning praising his wife's long poem *Aurora Leigh*: 'the greatest poem in the English language... not surpassed by Shakespeare's sonnets.' But he had a major task in mind all this time. On 13 December, he finally wrote to the Prime Minister, Palmerston, offering to catalogue the archive of Turner's drawings and sketches as unpaid curator. ('Unpaid' meant not only that he would give his time for free but that he would not seek recompense for the considerable expense of materials, including frames and mounts.) The offer was formally accepted the following February, and he began his preliminary work at once.

1850-1860: ARCHITECTURE AND ADULTERY

His first set of intensive labours on the Turner bequest lasted until June. His attention was so narrowly fixed on this task as to allow him little time or energy to notice what was going on in the larger world. The years 1857-59 were disrupted by a world-wide economic crisis, the first of its kind, and many of Ruskin's contemporaries were ruined. On a more parochial note, those members of the middle class who were untouched by the collapsing markets were increasingly looking to Ruskin as a guide. It was the year of the foundation of the 'Alpine Club' in London. British tourists, copies of *Modern Painters IV* in hand, begin to flock to the Alps, with effects that, in later years, Ruskin came to deplore. His words were helping to kill the thing he loved.

In June, he published *The Elements of Drawing* – a text adapted from classes he had been giving at the Working Men's College. On the 10th and 13th of July he gave lectures in the Manchester Athenaeum on 'The Political Economy of Art'. (They were published later in the year, and republished in 1880 under the title *A Joy Forever*). Proceeds from the lectures went to the Working Men's College. He spent a pleasant summer holiday with his parents in the Highlands, where they travelled as far north as Cromarty; then it was time for the true labour to begin.

In October he set about the Herculean task of 'arranging' the Turner materials. He eventually discovered 'upwards of 19,000 pieces of paper drawn upon by Turner'. With the assistance of two pupils from the Working Men's College, George Allen and William Ward, he worked 'all the autumn and winter of 1857, every day, all day long, and often far into the night' at the Turner bequest. It has often been reported that it was at this time he consented to the burning of a number of erotic – or, to some eyes, pornographic – drawings by the Master; but more recent research has shown that this is not so: the drawings survive.

He delivered his report to the Trustees in March 1858. In *Modern Painters V*, he would explain that, though the physical effort had done him no harm,

> ...the excitement involved in seeing unfolded the whole career of Turner's mind during his life, joined with much sorrow at the state in which nearly all his most precious work had been left, and with great anxiety, and heavy sense of responsibility besides, was very trying: and I have never in my life felt so exhausted as when I locked the last box, and gave the keys to Mr Wornum, in May 1858.

In poor spirits, he set off almost at once for a restorative trip to the Continent.

RUSKIN'S 'UNCONVERSION'

It was during this journey that he experienced a decisive loss of his Evangelical faith – an event sometimes referred to as his 'un-conversion' – while in Turin. He gave two, rather different accounts of the event. One Sunday morning, he attended a dismal Protestant service:

> The assembled congregation numbered in all some three or four and twenty, of whom fifteen or sixteen were gray-haired women. Their solitary and clerk-less preacher, a somewhat stunted figure in a plain black coat, with a cracked voice, after leading them through the languid forms of prayer which are all that in truth are possible to people whose present life is dull and its terrestrial

Different ways of depicting trees, c.1855-56. A typical comparative illustration, engraved as Plate 27 of Modern Painters IV *(1856), entitled 'The Aspen, under Idealization', intended to show the superiority of Turner's tree-drawing. From top left: Giottesque; Modern or Blottesque; Purist; Constablesque; Turneresque; Hardingesque*

future unchangeable, put his utmost zeal into a consolatory discourse on the wickedness of the wide world, more especially of the plain of Piedmont and city of Turin, and on the exclusive favour with God, enjoyed by the between nineteen and twenty-four elect members of his congregation, in the streets of Admah and Zeboim.

Myself neither cheered nor greatly alarmed by this doctrine, I walked back into the condemned city, and up into the gallery where Paul Veronese's Solomon and the Queen of Sheba glowed in full afternoon light. The gallery windows being open, there came in with the warm air, floating swells and falls of military music, from the courtyard before the palace, which seemed to me more devotional, in their perfect art, tune, and discipline, than anything I remembered of evangelical hymns. And as the perfect colour and sound gradually asserted their power on me, they seemed finally to fasten me in the old article of Jewish faith, that things done delightfully and rightly, were always done by the help and in the Spirit of God.

Of course that hour's meditation in the gallery of Turin only concluded the courses of thought which had been leading me to such end through many years. There was no sudden conversion possible to me, either by preacher, picture, or dulcimer. But that day, my evangelical beliefs were put away, to be debated of no more.

Thus *Praeterita*, Vol. III Ch. I. Ruskin gave a shorter narrative of this experience in *Fors*, April 1877:

I was still in the bonds of my old Evangelical faith; and, in 1858, it was with me, Protestantism or nothing: the crisis of the whole turn of my thoughts being one Sunday morning, at Turin, when, from before Veronese's Queen of Sheba, and under quite overwhelmed sense of his God-given power, I went away to a Waldensian chapel, where a little squeaking idiot was preaching to an audience of seventeen old women and three louts, that they were the only children of God in Turin; and that all the people in the world out of sight of Monte Viso, would be damned. I came out of the chapel, in sum of twenty years of thought, a conclusively un-converted man.

Back in England in the middle of September, he returned to work on *Modern Painters* V. It was probably at about this time that he had his first brief meeting with Rose La Touche, barely ten years old, but soon to play a fateful, not to say dreadful part in his life. Her parents had written to him asking for drawing lessons, in such charming terms that he invited the family to visit Denmark Hill. But he was too busy to give Rose lessons himself, and there was no hint as yet of the unspeakable agonies ahead for them both. That tragic chronicle did not truly begin for another eighteen months or so, in April 1860.

Meanwhile, he was growing ever more vexed with the progress of the Oxford Museum. The building was costing more than had been calculated; and neither the University authorities nor the stone-cutters were happy with his demands for natural forms on the façade. In December he wrote an angry letter to his close friend Lady Trevelyan: 'I've done with architecture and won't be answerable for any more of it. I can't get the architects to understand its first principles & I'm sick of them.' Early in January 1859, he went to Oxford again to assess the state

Sketch of head from Veronese's Solomon and the Queen of Sheba, 1858.
The unusual technique of this sketch probably indicates that Ruskin was trying to record the brush strokes used by Veronese

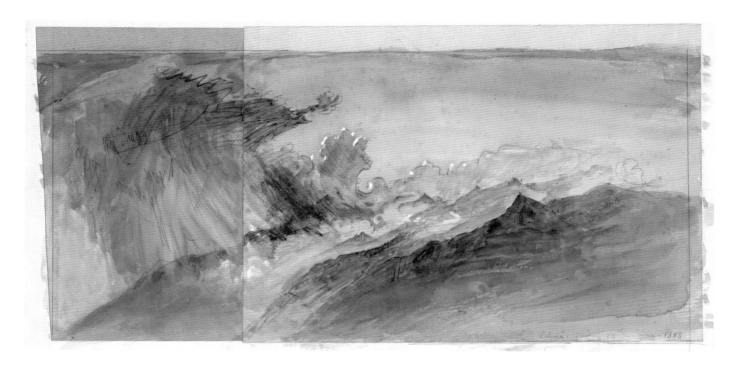

Storm Clouds, Mont Cenis, close to Turin, 1858. In Praeterita, *Ruskin remembered making drawings of 'one lurid thunderstorm on the Rosa Alps, another on the Cenis, and a dream or two of mist on the Viso'. In* Modern Painters V *(1860), he reproduced a similarly dramatic drawing in which he imagined the clouds taking the shape of 'Medusa serpents writhing about the central peak'*

of the Museum. He approved of some aspects, but thought that all the decoration in colour was 'vile'.

Later that same month, Miss Margaret Alexis Bell, the headmistress of a progressive girls' school in Cheshire, Winnington Hall, paid a visit to Denmark Hill. She and Ruskin met again, shortly after his fortieth birthday, when he lectured on 'The Unity of Art' in Manchester. (Ruskin also met the novelist and biographer Mrs Gaskell during this northern trip.) He was impressed by Miss Bell's ideas, and visited her school for the first time on 9-15 March. The impression made on him by the Headmistress and her girls — the 'birds', as he would soon be calling them — filled him with delight, and over the next decade (until 1868), he would visit Winnington regularly and engage in lively correspondence with the children. It would be hard to overstate the emotional importance that Winnington came to have for him in his forties, both as a refuge from his parents and as kind of Eden in its own right.

On 10 May, he published *The Two Paths*; and then, ten days later, he travelled to Germany with his parents. This was to be their final tour together. They returned to London in October, but Ruskin left almost immediately for a few weeks at Winnington. He was in the final throes of completing *Modern Painters V*, and he soon had his 'birds' busy assembling its Index. One long task was finally reaching completion; a new one was about to be launched.

Winnington Hall in the 1860s

RUSKIN AND SOCIETY

I desire, in closing the series of introductory papers, to leave this one great fact clearly stated. THERE IS NO WEALTH BUT LIFE. Life, including all its powers of love, of joy, and of admiration. That country is the richest which nourishes the greatest number of noble and happy human beings; that man is richest who, having perfected the functions of his own life to the utmost, has also the widest helpful influence, both personal, and by means of his possessions, over the lives of others. – *Unto This Last* (1860).

'Justitia': Burne-Jones's design for the cover of
Munera Pulveris, c. 1864

Interior of St George's Museum, founded by
Ruskin at Walkley, near Sheffield: one of his
practical attempts to influence society

For many readers, as we have seen, Ruskin's significance as a social critic vastly exceeds any of his other virtues, and his very short book *Unto This Last*, which can be read in a couple of hours, has greater value than such mammoth productions as *Modern Painters* or *The Stones of Venice*; the word 'value', of course, is one of the terms that Ruskin puts under close scrutiny in *Unto This Last*. Ruskin himself once said that it was his best book, 'the one that will stand (if anything stand) surest and longest of all works of mine'. It was, again, the book which most inspired the first generation of British Labour politicians, and Tolstoy, and Mahatma Gandhi. In its pages, we can see the earliest articulation of policies which shaped the creation of the post-war Welfare State, and of other institutions and practices which have mitigated certain forms of poverty, squalor and ignorance since Ruskin's day: green belts, free education, public libraries, town planning and so on.

In its own day, the short book drew very different responses: 'utter imbecility', spluttered one reviewer; 'intolerable twaddle', another; the world 'was not going to be preached to death by a mad governess'. (Note the slur on Ruskin's masculinity here.) Howls of outrage and contempt greeted every new instalment of the work as it appeared in Thackeray's *Cornhill Magazine*, until Thackeray was forced to cancel the run prematurely. Ruskin's friend and mentor Thomas Carlyle was one of the very few who read the work with excitement and admiration. Otherwise, the man who had been the darling of the thoughtful middle classes suddenly became one of its leading hate figures.

No wonder that the year 1860 is often taken as a turning point in Ruskin's fortunes: *Modern Painters* was complete, his work as an art critic appeared done, and he was noisily and unexpectedly launched on his new career of social prophet. In fact, the transition was not nearly so dramatic as most of Ruskin's contemporaries believed. In the last volume of *Modern Painters V*, he wrote that 'Government and co-operation are in all things and eternally the laws of life. Anarchy and competition eternally and in all things, the laws of death.' No one turned a hair at this, as it seemed to be talking only about snowflakes and other nice things; but when he repeated exactly the same words in *Unto This Last*, the true implications of what he was saying suddenly dawned. Ruskin was attacking one of the most sacred principles of Political Economy, competition in a free market.

For acute readers, the alarm bells should have sounded much earlier, for even in *The Seven Lamps of Architecture* there are passages about building as a reflection of social conditions, and in *The Stones of Venice*, the chapter entitled 'The Nature of Gothic' outlined a theory of labour that in later years proved invaluable to early generations of socialists – even though, as one can hardly stress too often, Ruskin was a self-declared Tory, and regarded socialism as he understood it with as much disdain as many a frightened burgher regarded his own 'wild' writings. Ruskin's

St George and the Dragon, after Carpaccio, 1872. A specific part of Ruskin's interest, stirred by Burne-Jones, in the sixteenth-century Venetian painter Carpaccio, centred on the cycle of paintings in the Scuola di San Giorgio degli Schiavoni. In these depictions of the life of St. George, Ruskin found an embodiment of 'knightly and Christian purity and courage,' which led to the nomination of his idealistic social and artistic community as the Guild of St. George

social views, in brief, develop from his attempts to understand art; they are not a dramatic break with his earlier preoccupations but grow naturally — perhaps inevitably? — from them. A corrupt, venal society cannot create great art, and nineteenth century Britain seemed to Ruskin among the most venal of all time.

Despite the waverings in his faith throughout his middle years, Ruskin remained a Christian, and a large part of his message to Britain concerns the gap between its avowed Christian beliefs and its actual Mammonist conduct. The title of *Unto This Last* alludes to the Bible, and some of the book's key arguments are conducted in parables. It is the work of a moral thinker, not a trained economist, and the questions it asks are so embarrassingly simple that few of us are accustomed to pondering them, let alone answering them. Powerful old wine in an elegant new bottle, then; and the subsequent vessels for this wine include the likes of *Munera Pulveris* (1863), *Time and Tide* (1867) and *Fors Clavigera*, as well as his many practical schemes for social reform and redemption. In his own mythology, Ruskin became a kind of new St George, fighting the Dragon of capitalism. He could not slay the beast, but he went an astonishingly long way in taming it.

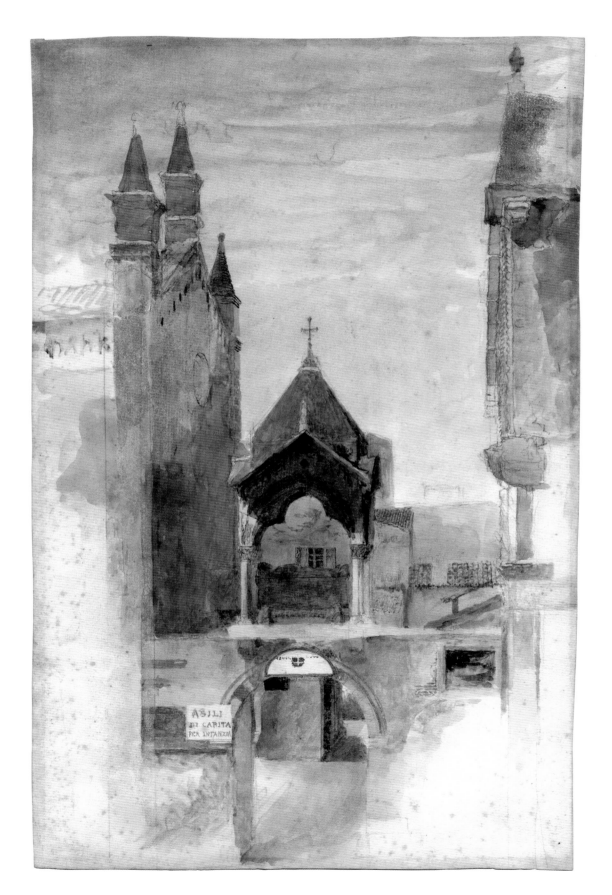

1860-70: THE PROPHET AND HIS SORROWS

If Ruskin's biographers tend to consider 1860 as the watershed in Ruskin's life as a writer, the moment at which his attention shifted from questions of art to questions of society, they are only following Ruskin's own lead. His claim should be treated, however, with more than a degree of caution; he continued to write about art for the rest of his healthy life, and it is important to grasp that his social commentaries are not a radically new departure for him, but developed so organically from his work on art and architecture that it is tempting, with the benefit of hindsight, to think of them as an inevitable growth. Yet the year 1860 really was a landmark in Ruskin's life, as it saw the long-delayed completion of his largest work on art and aesthetics, *Modern Painters*, and the first publication of his short but astonishingly influential attack on laissez-faire capitalism, *Unto This Last*.

ROSE LA TOUCHE: ONE

It was also the year in which his interest in Rose La Touche first blossomed into obsession, and so marks the beginning of one of the most wretched of all tales of thwarted love. His passion for the unattainable Rose poisoned his happiness for the next seventeen years, until her death in 1875. (One hastens to add that this strange non-affair also tormented poor Rose, though she may well already have been doomed to unhappiness by her parents, no matter which suitors came her way.) She continued to haunt him after his death – quite literally so, Ruskin came to believe, for spirit mediums told him that she would appear by his side at séances – and the intensity of his feelings for her probably brought on the repeated mental breakdowns of his later years.

He could still find happiness in work, and other pleasures – his frequent visits to Winnington School throughout the 1860s were a reliable source of refreshment and delight, without which he might have been in a far worse way; even his disapproving parents had grudgingly to admit that the place was obviously good for his health – but from this point on it is generally safe to assume that, unless Ruskin reports otherwise, his spirits are low, or worse than low. From the age of forty onwards, he was at heart a man of sorrows.

* * * * *

In the early months of 1860, writing at considerable speed, he finally – seventeen years after publishing its first volume – managed to complete *Modern Painters V*; at any rate, to stop and take leave of it, for most readers have found its finale abrupt and inconclusive. Ruskin was aware of this weakness: 'Looking back over what I have written, I find that I have only now the power of ending this work, – it being time that it should end, but not of "concluding" it; for it has led me into fields of infinite inquiry, where it is only possible to break off with such imperfect result as may, at any given moment, have been attained.' The huge book had become a burden that he was anxious to shed. It was eventually published on 14 June. The critic Clive Wilmer has written searchingly on the question of Ruskin's chronic inability to bring any of his books to a satisfactory conclusion, and has noted that inhibitions of this kind are sometimes said to be a symptom of bipolar disorders. This corroborates an earlier suggestion by Ruskin's twentieth-century biographer R. H. Wilenski.

Opposite: Castelbarco Tomb, Verona, probably 1869. A colourful and detailed rendering of a subject that had fascinated Ruskin since early youth. The effigy of Count Guglielmo da Castelbarco (1320) sits beneath a stone canopy over the cemetery gate adjoining the church of Santa Anastasia in Verona. Ruskin thought it 'the most perfect Gothic sepulchral monument in the world', and 'my most beloved throughout all the length and breadth of Italy'

THE WORLDS OF JOHN RUSKIN

There is a mild irony in the fact that the declared theme of this abandoned work was the law of organic unity, and its importance in pictorial composition. But, as so often, the book's range was vast. It includes his studies of mountains, clouds and plants; his Venetian work; and, of course, a great deal on Turner. Towards its conclusion came the superb and, in later years, much-excerpted chapter 'The Two Boyhoods', contrasting the dazzling world of Venetian splendour into which Giorgione had been born with the squalid London scenes that filled the eyes of Turner when he was very young. It might have been the first chapter of the Turner biography that John James was so much hoping that his son would eventually write. There was also much tacit autobiography in the book, and his first extended exercises in decoding the recondite meanings of mythology. Here, one might say, be Dragons. The Dragon would come to be a potent embodiment of all that was evil in the modern world; he founded the Guild of St George in an attempt to slay it.

Its final pages included a sonorous lament. The 19th century had '...caused every one of its great men, whose hearts were kindest, and whose spirits most perceptive of the work of God, to die without hope; Scott, Keats, Byron, Shelley, Turner. Great England, of the Iron-heart now, not the Lion-heart; for these souls of her children an account may perhaps be one day required of her.' It is hard to resist the guess that he felt one more name should be added to that list of casualties: Ruskin.

UNTO THIS LAST

On 17 May 1860 he left England until September. He arrived at Chamonix on 26th June, and set about work on *Unto This Last*. 'At Chamouni I gave up my art-work and wrote this little book – the beginning of the days of reprobation.'

He composed the piece swiftly, and on 1 July he sent the first instalment to Smith, Elder and Co. *Unto This Last* was published as a series of four essays in Thackeray's popular *Cornhill Magazine* from August until November – until, that is to say, the angry protests of readers persuaded Thackeray to cut it short. (The text was published in book form in 1862.)

It was a ferocious and dazzlingly sardonic attack on the economics of Adam Smith, Ricardo and Mill; Ruskin tore into classical definitions of national prosperity and declared that the 'wealth' of which such thinkers wrote was actually 'illth'. He coined a memorable maxim to sum up his position:

THERE IS NO WEALTH BUT LIFE.

Self-portrait, c. 1861; reproduced by Collingwood in his biography of Ruskin, where he describes its 'unique value and interest' as 'a good likeness of a face whose most noteworthy expressions no artist or photographer has quite succeeded in catching'

His arguments were widely derided. *The Saturday Review* spoke of 'constant eruptions of windy hysterics', 'utter imbecility', 'intolerable twaddle' and said that the author was 'a perfect paragon of blubbering'. The *Westminster Review* mocked his style of 'motley patched with apocalyptic spangles.' Apart from Carlyle, almost everyone else seemed to agree that Ruskin had gone soft in the head.

Rose La Touche, 1861.
In Praeterita Ruskin recalls his first meeting with
Rose: 'So presently the drawing-room door opened,
and Rosie came in, quietly taking stock of me with
her blue eyes as she walked across the room;
gave me her hand, as a good dog gives its paw,
and then stood a little back... neither tall nor short
for her age; a little stiff in her way of standing.
The eyes rather deep blue at that time, and fuller
and softer than afterwards. Lips perfectly lovely in
profile; a little too wide, and hard in edge, seen in
front; the rest of the features what a fair, well-
bred Irish girl's usually are; the hair, perhaps,
more graceful in short curl round the forehead,
and softer than one sees often, in the
close-bound tresses above the neck'

The background to *Unto This Last* was the first act of the tragedy of Ruskin and Rose La Touche. As early as April, he was writing reports to the girls at Winnington that 'I've got a dear little one... whom I'm really very fond of... who writes for me – the prettiest little poems you ever heard – and is full of play besides.' The amorous infection had begun, and by the summer the image of Rose was taking hold of his imagination more and more firmly. This was one of the main causes of the downcast moods he would write of in letters to friends.

By September back in Denmark Hill with his parents again, he reported feeling lonely and dispirited. The depression deepened, and he found it hard to work, though he was briefly cheered by Carlyle's hearty – if curiously scatological – approval of *Unto This Last*: 'You go down thro' these Dismal-Science people, like a Treble-x of Senna, Glauber and Aloes [that is, powerful laxatives], like a fit of British Cholera, threatening to be fatal! I have read your paper with exhilaration, exultation, often with laughter, with bravissimo! Such a thing flung suddenly into half a million dull British heads on the same day, will do a great deal of good. I marvel in parts at the lynx-eyed sharpness of your logic, at the pincer-grip (red-hot pincers) you take of certain bloated cheeks and blown-up bellies...'

On New Year's Eve he wrote to Margaret Bell that 'I have been much depressed and unable to attend to anything myself.' This complaint sounds through his correspondence for months, and years, to come.

On 25 January 1861, Mrs La Touche and Rose took tea at Denmark Hill. Shortly afterwards, he dined at their town house, and a friendship with the family developed to the point where they would drop in on Ruskin whenever they came to London. In the middle of March, on one of his stays in Winnington, he wrote to his father that 'Rosie's my only pet.' Rose took occasional drawing lessons with him, and gave him the nick-name 'St Crumpet'. (Or, sometimes 'Archigosaurus'; the discovery of dinosaur remains was a great topic of conversation at this time.) Ruskin called Mrs La Touche 'Lacerta': 'Lizard' – 'the grace and wisdom of the serpent, without its poison'. He was not always so admiring of reptiles.

In the spring the La Touches went on a European tour, and Rose, now 13 years old, wrote him a long, affectionate letter which he later reproduced in *Praeterita*. The family returned from their trip at the end of April and cheered him during their brief stay in London, but by the second week in May they went back to Ireland. Ruskin plunged into gloom again; uncertain whether to go to France or Ireland that summer, he ended up doing both. On 13 May he wrote to Mrs Browning that 'I am ill and can't work at things.' To Georgiana Burne-Jones, he wrote of Rose: 'Do I want to keep her from growing up? Of course I do.' And his romantic misery was compounded by a sense of religious crisis. He wrote to Norton; 'I looked for another world, and find there is only this, and that is past for me.'

There were many reasons for his depression. However bracing the support of Carlyle and others, the wrathful attacks on *Unto This Last* had damaged his formerly impregnable self-confidence. His discovery of Turner's erotic engravings had shaken his hero-worship, and his convictions about the morality of great art. He was also becoming persuaded that his father's ambitions for him were at odds

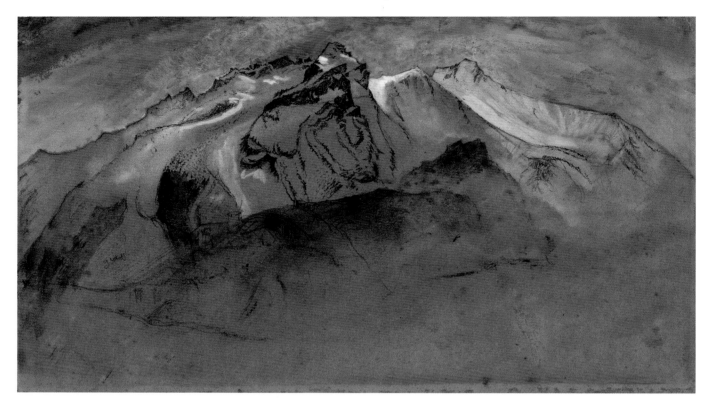

Mountains at the head of Lake Annecy, 1862-63.
In June 1863 Ruskin gave a lecture to the Royal Institution, on 'Forms of the Stratified Alps of Savoy.' This watercolour reflects his description of them as 'true sculptured edifices'

with his true nature – that they were more an encumbrance than an encouragement.

He arrived in Ireland in late August and stayed at the La Touches' house and park in Harristown, until 6 September. After a brief visit to various friends, and to his parents, he set off for the continent, travelling to Geneva, then to Lucerne. His state of mind was worse than ever – anxious, downcast and strangely lethargic. In later years, he wrote that these were months in which he 'lived [i.e. lived solely] for the love of Rosa'. They corresponded regularly, until in October she fell ill from some form of the nervous disorder that was to plague her for the rest of her life. At Christmas, she wrote him a letter of exceptional sincerity and beauty – the 'star- letter', he called it in later life, since it refers at one point to the Star which guided the Magi to Bethlehem – in which she expressed her affection for him very sweetly.

He arrived back in London on New Year's Eve, still in very poor spirits, and then spent the first four months of the year mainly at home. On 16 January 1862 he wrote to Norton:

> Am I not in a curiously unnatural state of mind... that at forty-three, instead of being able to settle to my middle-aged life like a middle-aged creature, I have more instincts of youth about me than when I was young, and am miserable because I cannot climb, run, or wrestle, sing, or flirt – as I was when a youngster because I couldn't sit writing metaphysics all day long. Wrong at both ends of life...

1860-1870: THE PROPHET AND HIS SORROWS

To ease his sense of misery and distract his mind, he began to work hard at the Turner Bequest, but even this was not enough to pull him entirely free of his gloom. Bad news broke in on his labours: in February, Lizzie Siddall died from an overdose of laudanum – it was almost certainly suicide. And when the La Touches visited London again, he found to his dismay that Rose was 'getting horrid' and doing him 'more harm than good': 'Rosie's got too old to be made a pet of any more.' On Valentine's Day, her fourteenth birthday, he gave her a thirteenth-century psalter. The La Touches seemed to be favouring his attentions for a while, and even made him the surprising offer of a small house on their estate – an offer that was soon withdrawn.

Then, in April, came the worst blow to date. The La Touches took Rose away; he would not see her again until 1866. He later write to his friend Mrs Cowper (the former Georgiana Tollemache) that her parents 'took the child away from me practically – four years ago – and since that day of April 1862, I have never had one happy hour, all my work has been wrecked.' On 15 May he left for the continent, paying for the expenses of his companions, Edward and Georgiana ('Georgie') Burne-Jones: they travelled via Paris and Lucerne to Milan. The trip would have a huge effect on Edward's development as a painter: the combination of Italian Renaissance painting and Ruskin's instruction was an invaluable boon.

In Milan, he started work on the first of the 'Essays on Political Economy', which were printed in *Fraser's Magazine*, edited by J. A. Froude, in June (the series continued into 1863); these pieces, which continued the lines of argument launched in *Unto This Last*, would eventually be published in book form as *Munera Pulveris* in 1872. Again, his father strongly disapproved. So did his readers. Like Thackeray before him, Froude was forced to stop printing the series after receiving a flood of angry letters.

The work in Milan exhausted him, and he spent the remainder of the summer in

Edward Burne-Jones, Study after Tintoretto's 'Meeting of the Virgin and St Elizabeth', 1862. Leaving Ruskin in Milan to work on copies after Luini, the Burne-Joneses moved on to Venice in June 1862. A duty to Ruskin was fulfilled through a number of copies – though not as many as he would have liked – after Venetian Old Masters. Although only on a small scale, this watercolour manages to capture the compositional strength of one of Tintoretto's paintings in the Scuola di San Rocco

Thun, probably 1862. Ruskin gave this watercolour to Edward and Georgie Burne-Jones, who later gave it to their son Philip, also a painter and Ruskin's godson

THE WORLDS OF JOHN RUSKIN

Ruskin's device, as used on binding of the Library Edition of his works

Laufenburg, under the Bridge, 1863. Ruskin delighted in the happy survival of the old covered bridges in the least spoiled Swiss towns, especially the 'really magnificent' bridge at Laufenburg, which he later commented that the modern visitor would almost certainly miss, 'travelling on the railroad past the spot where he might have got a glimpse of it just when he is getting the lunch-basket out from under the seat.' In The Elements of Drawing *he wrote: 'Now, this kind of bridge, sympathising with the spirit of the river, and marking the nature of the thing it has to deal with and conquer, is the ideal of a bridge, and all endeavours to do the thing in a grand engineer's manner, with a level roadway and equal arches, are barbarous'*

Mornex, near Geneva. He set himself to a calming regime of walks, gardening, geological study and bridge-building. For the first time in many months, he felt a measure of contentment, and he considered settling in Switzerland for good – safely far away from the wounding words of his new enemies. Even this hard-won contentment was fragile, though. On 16 November he wrote to Margaret Bell that 'I am all but crushed here'. He returned to England for a few weeks in November and December – he gave a talk to the Working Men's Club – but was back in Mornex by Christmas, and made more definite plans for emigrating to the country.

Once again, the early months of the new year, 1863, were poisoned by gloom – the prelude to a year which was, by his standards, unproductive, though it was in this year that he seems to have adopted the maxim, or memento mori, or injunction, TODAY TODAY TODAY as his personal motto. He came back to Britain for a few months in the summer, and by 5 June he was lecturing at the Royal Institution on 'The Alps of Savoy'.

On 8 September he began his journey back to Switzerland. His plans to settle there were thwarted, mainly because the locals set an outrageous price on the land he wanted to buy, since – with peasant or bourgeois logic – they could not see any other appeal in the land, they assumed that he must have discovered some unsuspected treasure there: gold, perhaps, or at the very least some kind of rich mine. This put paid to one of his more agreeable dreams; and in October he heard that Rose had fallen ill, after her first communion had brought on an attack of hysteria. It set him thinking again about the ways in which his strange upbringing – on the one hand excessively strict, on the other pampered – had left him unfit for normal adult life.

A few days before Christmas, he sent his parents a harsh letter, fiercely condemning the way in which they had raised him:

> Men ought to be severely disciplined and exercised in the sternest way in daily life – they should learn to live on stone beds and eat black soup, but they should never have their hearts broken – a noble heart, once broken,

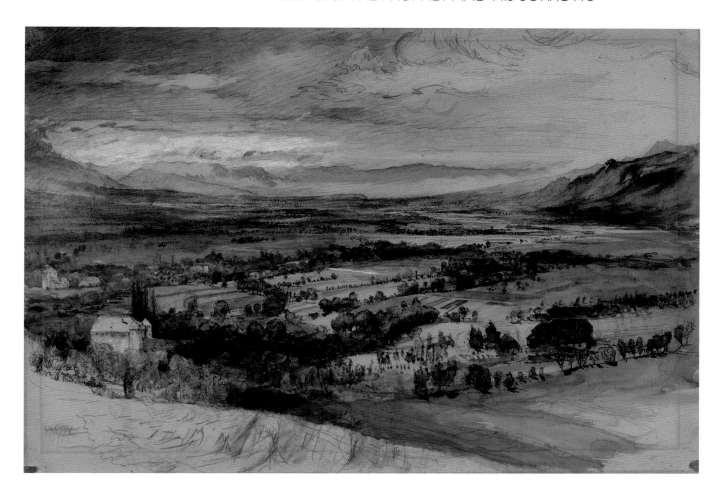

'View from the Brezon, looking towards Geneva', 1862. The full inscription accompanying this expansive panorama is 'View from the base of Brezon above Bonneville, looking towards Geneva. The Jura in the distance; Salève on the left.' When looking for a house in 1862, Ruskin went so far as to enter into correspondence with the Commune of Bonneville for the purchase of 'the whole of the top of the Brezon,' commanding this and other views. In his notes of 1878 on one of Turner's Bonneville subjects, Ruskin referred to the 'grand old keep' in the foreground, by then demolished, but on which he had also 'cast longing eyes,' and thought of buying. He wrote to his mother of 'its unspoiled, unrestored, arched gateway between two round towers, and gothic-windowed keep,' but was disappointed to find the building in poor condition, and 'gave up all mediaeval ideas'

never mends, – the best you can do is rivet it with iron and plaster the cracks over, – the blood never flows rightly again. The two terrific mistakes which Mama and you involuntarily fell into were the exact reverse in both ways – you fed me effeminately and luxuriously to the extent that I actually now could not travel in rough countries without taking a cook with me! – but you thwarted me in all the earnest fire and passion of life. About Turner you indeed never knew how much you thwarted me – for I thought it my duty to be thwarted – it was the religion that led me all wrong there – for if I had courage & knowledge enough to insist on having my own way resolutely, you would now have me in happy health, loving you twice as much (for, depend upon it, love taking much of its own way, a fair share, is in generous people all the brighter for it), and full of energy for the future – and of power of self-denial: now, my power of duty has been exhausted in vain, and I am forced for life's sake to indulge myself in all sorts of selfish ways, just when a man ought to be knit for the duties of middle life by the good success of his youthful life. No life ought to have phantoms to lay.

The timing of this rebellion was unfortunate. His father had only a few months to live.

THE WORLDS OF JOHN RUSKIN

John James Ruskin in old age, c. 1863

Despite the bitterness of his outburst, Ruskin returned to his parents at the beginning of 1864, and spent the better part of the next two years, to the spring of 1866, living under the old family roof. It was at this time, tentatively at first, that he began to take an interest in Spiritualism – another sign of his drift away from the religious certainties of his childhood, which would bear strange fruit in later years, after the death of Rose. But the thought of death was very much in the air: John James Ruskin, by now a frail old man, was taken ill in late February, and died of uremic poisoning on the night of 2/3rd March 1864, at the age of seventy-eight. Ruskin held his father in his arms for the last day and night.

Shortly after the death, Ruskin had this unconventional but moving inscription cut on his father's tombstone:

> He was an entirely honest merchant
> and his mercy is, to all who keep it, dear and helpful.
> His son, whom he loved to the uttermost
> and taught to speak truth, says this of him.

Ruskin wrote about his bereavement to Acland on 9 March, saying that he had experienced the loss of a father 'who would have sacrificed his life for his son, and yet forced his son to sacrifice his life to him, and sacrifice it in vain. It is an exquisite piece of tragedy altogether – very much like Lear, in a ludicrous commercial way – Cordelia remaining unchanged, and her friends writing to her afterwards – wasn't she sorry for the pain she had given her father by not speaking when she should.' Yet whatever the extent of his sorrow and anger, Ruskin also felt a sense of release. He would no longer have to struggle against his father as well as his nation. In April, Ruskin's cousin Joan, or Joanna, Agnew, came to live at Denmark Hill and to take care of Ruskin and his mother. She was to play a large role in the rest of Ruskin's life, particularly his old age.

John James left his son a very considerable fortune: more than £120,000 in cash, as well as property valued at over £10,000 and other assets; in present-day values, something like six million pounds. The money was an embarrassment to him, and through a combination of charitable acts, bad investments and simple improvidence he soon managed to rid himself of well over £20,000. By his last decade, he had given away much of his inheritance, though by that time his own works were selling in such numbers that he was rich again in his own right.

Ruskin carried on living at Denmark Hill in reasonable comfort and order, though one, perhaps unexpected result of his bereavement was that he found it difficult and at times impossible to engage in any form of intellectual work. From June onwards, he found some relief by visiting the British Museum several times a week to study the Egyptian antiquities – a new interest which was made visible to the reading public two years later in *The Ethics of the Dust.*

On 21 April he travelled to Bradford Town Hall to deliver the major lecture (some think it the most powerful he ever wrote): 'Traffic'. It was one of his most uncompromising confrontations with an audience – very nearly a bite into the hands that were poised to applaud him – and one of his greatest attacks on Victorian materialism.

1860-1870: THE PROPHET AND HIS SORROWS

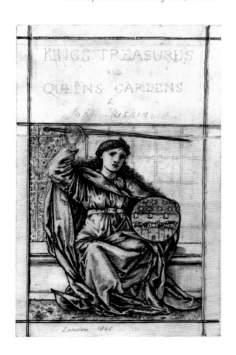

FUN.—March 29, 1876.

PLAYING WITH EDGED TOOLS.

AN UNDESERVED SNUB FOR SHEFFIELD.

MR. FUN CANNOT HELP THINKING THERE IS MUCH MORE GOOD IN ONE DAY'S HONEST LABOUR THAN IN
YEARS OF SUPERFINE, OFTEN SUPERFICIAL CRITICISM.

*Above: Ruskin the social critic, as seen by Punch in
1867. Here he is treating the 'honest labour' of
Sheffield – and its belching chimneys – with
disdain. The caption reads: 'Mr. Fun cannot
help thinking there is much more good in
one day's honest labour than in years of
superfine, often superficial criticism.'
Below, the suggested title page for* Sesame and
Lilies *by Edward Burne-Jones, c. 1864*

My good Yorkshire friends, you asked me down here among your hills that
I might talk to you about this Exchange you are going to build: but, earnestly
and seriously asking you to pardon me, I am going to do nothing of the kind.
I cannot talk, or at least can say very little, about this same Exchange. I must
talk of other things, though not willingly....

Continue to make that forbidden deity [riches] your principal one, and
soon no more art, no more science, no more pleasure will be possible.
Catastrophe will come; or, worse than catastrophe, slow mouldering and
withering into Hades...

"Traffic" was later published in *The Crown of Wild Olive*.

At the end of the year, he went to Manchester, where he lectured in consider-
ably less savage terms on books – 'Of Kings' Treasuries', at Rusholme Town
Hall – and on women's education – 'Of Queens' Gardens'. 'Of Kings' Treasuries'
proposed that public libraries should be founded in every major city in Britain.
The new year, 1865, was another relatively unproductive one in terms of
entirely new work, though in January Ruskin did begin to publish his series
Cestus of Aglaia – 'The Girdle of Grace' – on the laws of 'Art practice and
judgement' in the *Art Journal*. From the point of view of posterity, the great
event of the year came on 21 June, when he published *Sesame and Lilies* –
developed from the two Manchester lectures. This was, for a long time, by
far the most popular of all Ruskin's books, and it sold some 160,000 copies in
his lifetime alone. France knew the book, too, thanks to the young Marcel
Proust, who translated it as *Sésame et les Lys*. (According to the art historian
John Gage, there is also evidence that Monet had read the French edition of
The Elements of Drawing.)

In December, though the publication date is misleadingly given as 1866, Ruskin
published *The Ethics of the Dust*. Cast in the form of a dialogue with schoolchild-
ren – in fact, the pupils of the Winnington School – and heavily influenced by
Ruskin's immersion in Egyptology in the months after his father's death, this is an
imaginative primer of crystallography. It is a very curious book, one of the oddest
things Ruskin ever wrote, though Carlyle thought it marvellous.

ROSE AGAIN

At the very start of 1866, the awful tale of Ruskin's infatuation with Rose entered
a new phase. Some time shortly after 3 January, her 18th birthday, he proposed
marriage to her. She did not reply immediately, but on 2 February asked if he
would wait three years for her answer. He asked her whether she was aware
what age he would be in 1869 – that is, fifty – and she replied that she did. So
they agreed to put the question aside until she reached the age of majority. In
fact, her equivocal reply was to mark the beginning of almost a whole decade of
misery for them both.

By this time, Rose's religious attitudes had taken on such a morbid cast as to
amount to a kind of mania; she was afflicted by a variety of strange complaints,
including headaches, hysterical seizures and a kind of amnesia that would
temporarily wipe out all memory of the previous decade. Her parents,

understandably, opposed the idea of marriage to a man in his late forties, and took their child back to Ireland in April.

On 25 April, Ruskin began his customary summer tour. The trip was soured by the deaths of Ruskin's 'two best women friends of older power', Jane Carlyle and Lady Trevelyan. Mrs Carlyle had died suddenly on 21st April; Lady Trevelyan, one of Ruskin's touring party, on 13 May, in Neuchâtel. He returned to England on 12 July, ill and despondent. As autumn passed into winter, his gloom deepened, and was exacerbated by very bad weather. From this point on, tumult in the atmosphere and turmoil in his soul are recurrent themes in Ruskin's diaries, especially during the winter months. By the Christmas season he was as low as he had ever been. It was, he said, 'The worst Xmas I ever passed.'

The new year, 1867, began in much the same vein. In February, the La Touches came to London but this time forbade any contact between Ruskin and Rose. The only thing that rallied Ruskin's spirits was a letter from a retired craftsman, Thomas Dixon, who wrote to Ruskin asking him to elaborate on his political and economic views. He replied in a series of letters which were printed, from 1 March onwards, in the *Scotsman*, the *Leeds Mercury* and other journals, and in December gathered into book form with the title *Time and Tide, by Weare and Tyne* – a sequel to the work begun in *Unto This Last* and *The Crown of Wild Olive*. Ruskin found that the letter form suited him, and this exchange was probably what gave him the idea for *Fors Clavigera*, which he began four years later.

Further cause for satisfaction came on 23 May, when he was given an honorary Doctor of Law degree at Cambridge. The Public Orator singled out *The Crown of Wild Olive* for particular praise, a choice which pleased him very much. The next day, he delivered the Rede Lecture: his topic was 'The Relation of National Ethics

Neuchâtel: lake and cemetery, with Lady Trevelyan's grave, 1866.
Pauline Trevelyan was a geologist, artist and above all patron of Pre-Raphaelite artists, who had been involved in the Oxford Museum project. Ruskin returned to Neuchâtel in late June to make this drawing of her grave, of which he later made a copy as a gift for her husband

The Walls of Lucerne, 1866. One of Ruskin's most famous watercolours, The Walls of Lucerne typifies what is most appealing to modern eyes about his best work, combining small patches of precise detail and high colour with whole areas of paper left untouched or carrying only the beginnings of form. This is a view from the Schweizerhof, Ruskin's favoured hotel in Lucerne, of the wall linking the Dachliturm, in the centre, with the Allenwindenturm beyond

to National Arts'. On 28 June, he set off for a holiday in the Lakes, returning to Denmark Hill at the end of August, but leaving again almost immediately for a rest cure in Norwood, under a Dr Powell. He had heard rumours that Rose might be marrying another suitor, but she sent him a single rose, which reassured him.

Meanwhile, another member of his extended family was having romantic problems with the Irish folk: Joanna Agnew had been courted by Percy La Touche, and then engaged, but they quarrelled and, in September, the engagement was broken off. Once again, Ruskin's sufferings deepened as the days of the year grew shorter and darker. Of that Christmas Day, he later wrote that 'I went roaming about all Xmas day ... so giddy and wild that in looking back to it I can understand the worst things that men ever do.'

He wrote next to nothing for the first few months of the new year, 1868, though he did manage to see a good deal of his London friends, including the Burne-Joneses and the Patmores.

In May, the La Touches, determined that Ruskin should never marry Rose, contacted Effie Millais for information that might be used against him. They also consulted

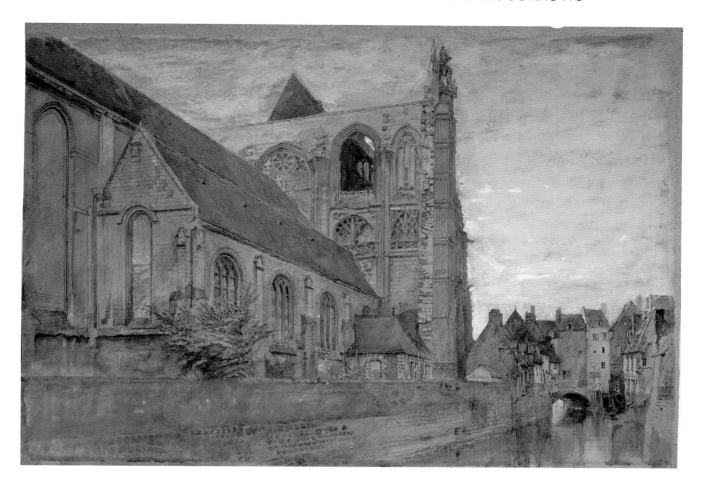

St Wulfran, Abbeville, 1868. Above, the church from the river; opposite, sculpture on the south porch. In Praeterita, *Ruskin wrote: 'My most intense happinesses have of course been among the mountains. but for cheerful, unalloyed, unwearying pleasure, the getting in sight of Abbeville on a fine summer afternoon, jumping out in the courtyard of the Hôtel de l'Europe, and rushing down the street to see St Wulfran again before the sun was off its towers, are things to cherish the past for, – to the end.' Elsewhere he called the town an 'entrance... into immediately healthy labour and joy', a place almost entirely unspoiled by the modern world, each of its fine old buildings 'keeping its place, and order, and recognized function, unfailing, unenlarging, for centuries.' St Wulfran's southern lateral door, with its tall pointed arch surmounted by an elaborately carved gable flanked by near life-size carvings of saints, Ruskin declared to be 'one of the most exquisite pieces of flamboyant Gothic in the world'*

lawyers, and managed to establish – to their own satisfaction at least – that were Ruskin and Rose to marry and have children, such offspring would render null and void the legal separation from Effie on the grounds of impotence; thus, these hypothetical children would be illegitimate. Ruskin travelled to Ireland in May, no doubt with the unrealistic hope that he might see Rose, and on the 13th he lectured to a large Dublin audience on 'The Mystery of Life and its Arts' – a text later added to editions of *Sesame and Lilies*. It was on that same day that he learned that Rose's parents had forbidden her to write to him.

At the end of the month he paid his last visit to Winnington; the school had lost its power to soothe him. By the time he arrived back in London in June, Mrs Cowper had received a letter from the La Touches, outlining their legal efforts. Ruskin despaired. He wrote in his diary 'All is over.' But he resolved to keep on working through his despair. He set off to France on 24 August, and spent two months in Abbeville. Norton visited him there, and they made a joint trip to Paris, where Ruskin met the American poet Longfellow – an encounter which pleased Ruskin very much.

Once they were back in England, Norton also arranged for him to meet Charles

THE WORLDS OF JOHN RUSKIN

Darwin again. 'Ruskin was full of questions which interested the elder naturalist,' Norton recalled, 'by the keenness of observation and the variety of scientific attainment which they indicated, and their animated talk afforded striking illustration of the many sympathies that underlay the divergence of their points of view.' This agreeable meeting did not, however, inhibit Ruskin from deriding Darwin's theories in such books as *The Eagle's Nest*.

Ruskin now knew that he had 'three dark months' until February 1869, when Rose was due to give her long-delayed reply to his proposal of marriage.

But no reply came. On 8 February 1869, he turned 50. 'How utterly sad these last birthdays have been, in 67 and 68. I am not much better to-day, but in better element of work.' Some of the work he had in mind was his research into Greek mythology. On 9 and 15 March he gave two lectures on the subject at University College, London, and the South Lambeth Art School. (From this point on, he devoted more and more attention to the subject of myth.) In June he published *The Queen of the Air*, an essay on the Greek myths of cloud and storm.

Verona, River Adige and Ponte Nuovo, 1869. In a letter to his mother he wrote: 'The only mischief of the place is its being too rich. Stones, flowers, mountains — all equally asking one to look at them — a history to every foot of ground'

His summer trip to Italy began on 27 April. His first major destination would be Verona, notionally to prepare studies of tombs for the Arundel Society. But he was distracted somewhat from this task by his passage through the Rhône valley, the state of which horrified him, and inspired him with ideas for an irrigation system which would turn the region into a 'Paradise'.

From Verona, where he met Longfellow again, he went on to Venice. He was, of course, still haunted by Rose. When he came across Carpaccio's paintings of scenes from the life of St Ursula, he made an intuitive connection between the saint and his absent beloved. St Ursula, the legend ran, had pledged herself to a heathen, provided that he would be baptized and allow her three years to make a pilgrimage to Jerusalem. This identification would grow stronger over the next decade, to the point of obsession and full-blown madness.

While travelling, he heard news of his appointment to the Slade Professorship of Fine Art at Oxford by a unanimous vote. At first he was uncertain whether it would be right for him to accept, as it seemed to mean giving up his work on social and economic matters. But he soon decided that the advantages of accepting the chair made any small acts of compromise worthwhile. He came back to London at the end of August and began to prepare diligently for his duties. From now on he would speak with the authority of England's most ancient university behind his words, as Professor Ruskin — or, simply, 'The Professor'.

RUSKIN AND ART: TWO
CRITICISM AS AUTOBIOGRAPHY

All great art is praise – The Laws of Fésole

There is nothing that I tell you with more
eager desire that you should believe...
than this, that you will never love art well,
till you love what she mirrors better.
— The Eagle's Nest

The third and fourth volumes of *Modern Painters* did not appear until 1856; a full,
momentous and often turbulent decade after the second volume. In the course of
that decade, Ruskin had rapidly become far and away the most powerful voice in
British art criticism - an eminence which he enjoyed until the end of the 1850s.
His sway over public taste was well caught by a spoof poem in *Punch*, supposedly
written by a disgruntled Academician:

> I takes and paints
> Hears no complaints,
> And sells before I'm dry
> Till savage Ruskin
> Sticks his tusk in,
> Then nobody will buy.

One way of telling Ruskin's life story in the years after the first two volumes of
Modern Painters is as a series of dramatic encounters with art and artists. Chief
among these would be: his public defence of the Pre-Raphaelites, his powerful
effect on their work, and his catastrophic friendship with Millais; his arduous
labours on the Turner bequest; his discovery of Veronese's sensuous work, and its
consequences for his 'un-conversion' from Evangelical protestantism; his appoint-
ment as Slade Professor of Fine Art at Oxford; his not wholly sane obsession
with Carpaccio's *St Ursula*; the humiliating Whistler libel trial, and so on. Such
a specialised view of his biography evidently leaves out a great many important
matters, or casts them in an eccentric light (his Carpaccio obsession, for instance,
cannot be understood in isolation from his doomed love for Rose La Touche).

Yet it remains a surprisingly adequate account for all that, since the experience of
art was so central to Ruskin's existence that critics have seen the five volumes of
Modern Painters as, in essence, a tacit or coded autobiography. Rather than
unfolding according to a master plan, they chart the shifts in Ruskin's mind as they
occured. Though he was still concerned with developing and advancing his ideas
about what constitutes greatness in art, his mood grews darker and darker in
Volumes III and IV (written in 1855, published 1856), and reached depths of
despair in certain passages of Volume V. He worried more and more at how
artists arrived at 'truth', and proposed that the distinction between great and
'mean' art must lie 'not in definable methods of handling, or styles of representa-
tion, or choices of subjects, but wholly in the nobleness of the end to which the
effort of the painter is addressed.' But such a statement prompts more questions
than it answers.

His growing concern with social evils – partly under the guidance of Carlyle –
found its way into the books, as did his anxiety about the inroads that the discov-
eries of modern science were making into religious faith. 'If only,' he wrote in a
letter of 1851, 'the geologists would let me alone, I could do very well, but those
dreadful hammers! I hear the chink of them at the end of every cadence of the
Bible verse.'

He grew more and more interested in pictorial symbolism: 'The greater and
more thoughtful the artists, the more they delight in symbolism, and the more
fearlessly they employ it.' This aspect of Ruskin's criticism was wholly against the
conventions of the time, and looks forward to the iconographical work of

Panofsky and others in the twentieth century. As Ruskin himself confessed, *Modern Painters* eventually encompassed such an uncontrollably large variety of subjects – 'fields of infinite inquiry' – that it could not be adequately concluded, only abandoned. A semblance of unity is lent to the finale by his return to the painter who inspired the seventeen-year-long project, Turner; but, as David Barrie has written, Ruskin's 'interpretation of him is radically different... Turner is no longer seen as a celebrant of the glories of God and nature, but as a faithless and desolate spirit.' Is this image of Turner also a displaced autobiographical portrait? Or an intimation of the greater sorrows which were in store for Ruskin after 1860? He never stopped writing about art altogether in those years of anguish, but his attention was increasingly devoted to other matters.

No single phrase can hope to sum up the burden of *Modern Painters*, but it would be foolish to pass by the subject without recalling one of one of Ruskin's most frequently cited and stirring declarations: his credo on the nobility of vision itself:

> The greatest thing a human soul ever does in this world is to see something, and tell what it saw in a plain way. Hundreds of people can talk for one who can think, but thousands of people can think for one who can see. To see clearly is poetry, prophecy, and religion, – all in one.

1870-80: THE PROFESSOR

ART CRITICISM.

Ruskin scattering the flowers of his criticism over the world of art (a grimy London), guided by the star of High Art. Cartoon by Frederick Waddy, published in One a Week, *25 May 1872*

Opposite: Compartment of external wall, Baptistery, Florence, 1872. This large drawing was integral to Ruskin's first lectures on sculpture at Oxford, for which the starting point was engraving, the art of line, and thus a 'prior art to that either of building or sculpture, and is an inseparable part of both, when rightly practised.' The Baptistery was 'one piece of large engraving. White substance, cut into, and filled with black, and dark green... the noblest type of intaglio ornamentation.' The patterns 'have no more to do wth the real make of the building than the diaper of a Harlequin's jacket has to do with his bones.' Of the drawing, Ruskin recalled working 'with the best care I could – never took more pains with a drawing'

The 1870s were the glory years of Ruskin's Oxford Professorship. His earliest lectures were a great success, and Ruskin derived considerable pleasure from seeing how he could hold and sway a large, admiring audience. They were also years of intense toil – he took his Oxford obligations with great earnestness, and prepared each lecture thoroughly – and though Ruskin was seldom happier than when absorbed in some fresh project, even his copious mind felt over-stretched by the many different subjects he now had to master and explain. He confided to his diary on 12 February 1872 that his 'head was too full of things and I don't know which to write first'. He was also increasingly engaged in many different practical projects for the improvement of the world, most of them his own inventions. Meanwhile, the sorry emotional background to all this toil, a nagging bass of misery behind all the public triumph, was his thwarted passion for Rose La Touche.

* * * * *

The year 1870 began ominously. On 7 January, Ruskin had a chance meeting with Rose at the Royal Academy. He tried to approach her, but she shunned him; and when he offered to return to her the bundle of her old letters which he always carried with him, she said, simply, 'No.' He marked the encounter by drawing a cross in his diary, as if a disaster too great for words had taken place. There followed a brief, bitter exchange of letters. Ruskin was furious with her, and threatened that he would inscribe her copy of his forthcoming book of lectures with the words

> To the woman
> Who bade me trust in God, and her
> And taught me
> The cruelty of Religion
> And the vanity of Trust....

For all his anger and pain, he continued to apply himself doggedly to preparing for his new post, and on 8 February – his fifty-first birthday – he began the first series of Slade Lectures on Art. (There would be seven series in all.) This inaugural series was published later in the year by Oxford's Clarendon Press.

Ruskin's first lecture drew such a huge crowd that it was transferred at the last minute from the Museum lecture theatre to the Sheldonian, where three decades earlier he had recited his Prize poem. His theme was 'That the art of any country is the exponent of its social and political virtues.' As the series continued, it became apparent that many of his listeners were female, and of mature years; it was not only bright young men who began to idolize him. Ruskin was initially nervous about this type of performance, but rapidly gained in confidence and verve. Most listeners thought him a spell-binding lecturer: imaginative, provocative, unexpectedly funny at times.

A few years later, the novelist W. H. Mallock – the nephew of Ruskin's old friend Froude – wrote a roman-à-clef entitled *The New Republic* (1877), in which the character of 'Mr Herbert' is obviously based on Ruskin. It was a caricature, but affectionate and deeply respectful: 'that singular voice of his, which would often hold all the theatre breathless, haunts me still... There was something strange and

Page from Ruskin's 'Coin Book,' the extensive catalogue of his collection of coins and casts, including many examples from the classical era. This is a coin from Syracuse, with the head of Persephone, 'the loveliest of all the copper heads'

aerial in its exquisite modulations that seemed as if it came from a disconsolate spirit, hovering over the waters of Babylon and remembering Zion.' Ruskin approved of the verbal portrait, and felt that Mallock had understood him better than almost anyone.

'The Professor' found his Oxford work more draining than he had anticipated, and by the end of April was in need of rest. With Joanna and others he set off for the Alps, and then Italy: Venice (where he resumed his relationship with Carpaccio), Florence, Pisa, Siena – where he met Charles Eliot Norton, and they encountered those fireflies which he recalls in the magnificent final paragraph of *Praeterita*. The trip, fairly short by Ruskin's standards, lasted two months; Ruskin then went back to Denmark Hill where he tried to concentrate on preparing his next set of Oxford lectures – which, instead of Italian Painting, were now to be devoted to Greek Art. But emotional distress kept breaking in.

He was back in England by the end of July and spent a good deal of time this summer at the British Museum, studying coins, and building up a collection of his own. He also applied himself to the study of conchology. His lecture series was on 'The Elements of Sculpture', and was later to be published as *Aratra Pentelici*.

In November, Joanna Agnew told Ruskin that she was engaged to Arthur Severn, son of his friend Joseph and also a painter. This seemed to pose a terrible threat not only to the smooth running of his domestic affairs, but also to his emotional stability, for his deep attachment to Joanna was partly due to her being yet another of those young girls whom he hoped would never grow up. A reasonably

Lion waterspout from the Fonte Branda, Siena, 1870. Given to Charles Norton in 1879 with the inscription 'You know where this is! Keep it for yourself. JR 1879'; ten years later his memory of seeing the fountain with Norton appeared in the last pages of Praeterita

1870-1880: THE PROFESSOR

Ruskin with Joan and Arthur Severn in Venice, June or July 1872. From left to right: Ruskin, Mrs. Hilliard (sister of Lady Trevelyan and mother of Ruskin's secretary Laurence), Joan, Arthur Severn, Constance Hilliard (daughter of Mrs. Hilliard) and the artist Albert Goodwin

successful compromise was reached when Ruskin gave the newlyweds the Herne Hill house, which meant that she was only a short walk away from Denmark Hill. The Severns – Arthur as well as Joanna – would be an increasingly important presence in his life, and eventually play the role of parents in his second childhood.

FORS CLAVIGERA

From January 1871 onwards, he began to publish *Fors Clavigera* – it appeared regularly each month until 1878, and then at irregular intervals until 1884: a period of thirteen years, roughly corresponding to his time as a Professor at Oxford. This series of pamphlet-length letters addressed 'To the Workmen and Labourers of England' was to grow into a huge book – 1,900 pages, or 650,000 words. As his first editors wrote: 'There is no other book in the world quite like it'; and it is hard, even after another century, to think of anything precisely comparable, though one can see vague anticipations of it in writers such as Coleridge and Carlyle. German scholars have suggested affinities between *Fors* and *Die Fackel* by the bitter Viennese satirist and cultural critic Karl Kraus; others have seen affinities between Ruskin's eclectic work and Ezra Pound's long poem-including-history *The Cantos*. Yet neither of these is more than a vague approximation. In *Fors* we can actually witness the ebbings and flowings, the abrupt transitions and reversals, the leaps and stumbles of an author's mind as nowhere else in literature.

Some of Ruskin's modern admirers believe *Fors* to be the third and last of his triad of giant masterpieces, after *Modern Painters* and *The Stones of Venice*. As such unconventional enterprises go, it was reasonably successful from the very beginning: the first edition of each new letter, 1,000 copies, would usually sell quickly and be supplemented by about another 3,000 copies. From 1882 onwards, the letters would also be re-issued in book form, twelve numbers to the volume. This suggests an average total sale of about 5,000 per letter – a very healthy sales figure, which puts *Fors* well ahead of, say, the *National Review* (about 1,000 copies)

103

and not too far behind the *Edinburgh Review* (about 7,000 copies). The prophet was being heeded, at least in some circles.

What does the mysterious title mean? A variety of things, each of which flows into the other. Ruskin proposed three translations for each of the two words. 'Fors' might signify force in the sense of physical strength, or fortitude (mental strength), or fortune – chance, luck, fate. 'Clavigera' is derived from the approximately corresponding trio of 'clava' (the club, an instrument or heraldic attribute of physical strength), 'clavis' (the key, or the instrument of patience) and 'clavus' (the nail, or attribute of fate).

George Allen's publishing colophon, with St George and the Dragon, designed by Walter Crane, c. 1894

From the very first issue of *Fors*, Ruskin set up one of his assistants, George Allen, as his private publisher. Allen, who had been one of Ruskin's students at the Working Men's College, distributed Ruskin's works from his home in Orpington, Kent, originally at a fixed price whether to book sellers or individual buyers. Gradually, the rights to all of Ruskin's old titles from Smith, Elder and Co were transferred to Allen, until by the end of 1873 he was responsible for all of Ruskin's publications. It was an unprecedented arrangement: Allen was a publisher who worked with just one author; Ruskin was the first British author with his own private imprint. Nor was it anything like a vanity operation. After a few initial hiccups, the company could eventually earn as much as £4,000 a year – more than John James had usually earned in the wine trade.

In February, Ruskin boarded at the Crown and Thistle in Abingdon, a few miles outside Oxford and was driven in to town by carriage most days. He planned to establish a School of Drawing, and gave the University an initial donation of £5,000 towards its first costs. A few days later, he took up residence in Corpus Christi, where he had just been awarded an honorary fellowship; he would spend roughly three months a year in Corpus until 1878. But improvement of the University's provision for the fine arts was only one of the many things on his mind. He was getting well into his stride with *Fors*, and soon wrote one of many blistering invectives against the mindless pursuit of material progress – in this case,

the building of a railway through a landscape of exceptional beauty:

> 1st May:
>
> There was a rocky valley between Buxton and Bakewell, once upon a time, divine as the vale of Tempe; you might have seen the Gods there morning and evening – Apollo and all the sweet Muses of the light – walking in fair procession on the lawns of it, and to and fro among the pinnacles of its crags. You cared neither for Gods nor grass, but for cash (which you did not know the way to get); you thought you could get it by what the *Times* calls 'Railroad Enterprise.' You Enterprised a railroad through the valley – you blasted its rocks away, heaped thousands of tons of shale into its lovely stream. The valley is gone, and the Gods with it; and now, every fool in Buxton can be in Bakewell in half an hour, and every fool in Bakewell in Buxton; which you think a lucrative process of exchange – you Fools Everywhere.'

Carlyle called this fifth letter 'a quasi-sacred consolation to me, which almost brings tears to my eyes! Every word of it is as if spoken, not out of my poor heart only, but out of the eternal skies; words winged with Empyrean wisdom, piercing as lightning.'

In June, Ruskin gave his only lecture of the year at Oxford: 'The Relations between Michael Angelo and Tintoret', which scandalised conventional taste by attacking Michelangelo's mannerist virtuosity. The University authorities were particularly annoyed, as the Ashmolean Museum had (and still has) a substantial collection of Michelangelo's drawings; once again, Ruskin's sense of aesthetic values was posing a threat to conventional market values.

In July, he took a holiday in Matlock, Derbyshire. Here, he fell seriously ill – 'within an ace of the grave' – and suffered first from a chill, then from inflammation of the

Matlock, Derbyshire, 1871. Possibly the view from near the hotel where Ruskin wrote Fors Clavigera, Letter 8. *The drawing was later bought from Ruskin by George Allen*

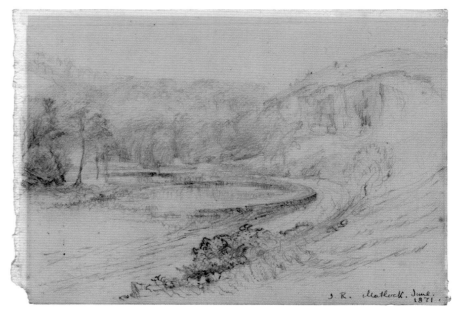

bowels; it seems almost certain that he also experienced a mental breakdown. Some biographers think that this was full-blown madness, the first of several terrible episodes which blighted the rest of his active life. Others consider that it was not until his vision of the Devil in February 1878 that Ruskin truly took leave of his senses for the first time. In either case, the gravity of his condition cannot be doubted.

By the end of the month, after careful treatment by Acland, the Severns and Mrs Cowper, he was adequately well again, though by no means happy. He learned from lawyers who had investigated the technicalities of the case that he was, indeed, legally entitled to marry again, and so made another proposal to Rose. She replied in terms which made him rage that she was insolent, foolish and self-centred.

Meanwhile, in the pages of *Fors*, he was outlining a project which might apply to England the same kind of regenerative or redemptive work that he had envisaged for the Rhône Valley in 1869.

> I am not rich (as people now estimate riches), and great part of what I have is already engaged in maintaining art-workmen... The tenth of whatever is left to me, estimated as accurately as I can (you shall see the accounts), I will make over to you in perpetuity, with the best security that English law can give, on Christmas Day of this year, with engagement to add the tithe of whatever I earn afterwards. Who else will help, with little or much? the object of such fund being, to begin, and gradually – no matter how slowly – to increase, the buying and securing of land in England, which shall not be built upon, but cultivated by Englishmen, with their own hands, and such help of force as they can find in wind and wave...

He thus announced the St George's Fund, which by 1877 was to develop into the Guild of St George. Ruskin was as good as his word, and maintained a policy of, as he put it, 'glass pockets' from this point on, making fully public the details of his personal income and expenditure. The St George's project was by far the most ambitious scheme he ever attempted: in effect, it was a plan to build what much later generations would call a 'counter-culture' – an alternative England of agrarian communes, governed along the lines of chivalry, justice and obedience. This was the lance with which the Dragon of Victorian avarice would be slain. In its grand form, the vision was – of course – never achieved, but it did bear some significant fruit, and continues to do so. The Guild of St George still exists, and acts, in the twenty-first century. It owns an excellent art gallery, in Sheffield, and land; the Master and Companions dedicate themselves to improving the condition of art education, craft and design, and the rural economy.

Ruskin found the early days of his struggle discouraging, though. He received fewer replies and pledges of funds than he had hoped, and the legal difficulties of establishing the scheme were to drag on for several years.

BRANTWOOD

Back in London, after his recovery, he heard about a property for sale in the Lake District: Brantwood, on the shore of Coniston Water. He bought it, sight unseen,

Rose La Touche, c. 1872-4. Inscribed 'Flos Florum Rosa': 'Rose, the flower of flowers'

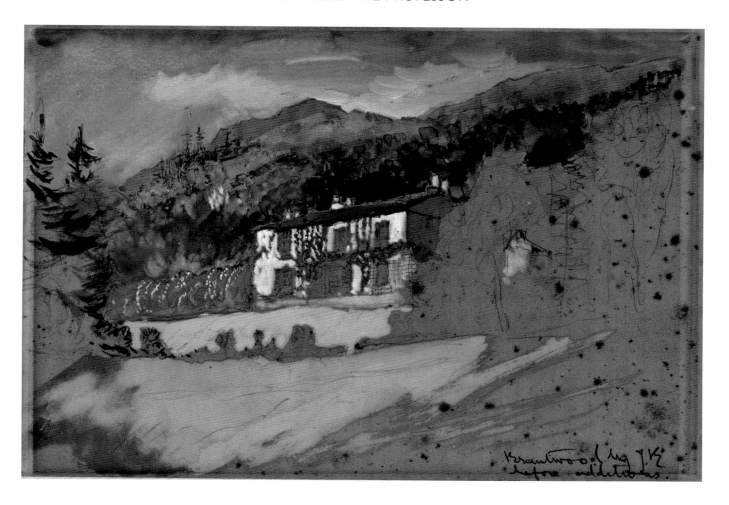

Brantwood seen from the edge of the lake, 21 September 1871. This drawing records Ruskin's first view of his new house. The later inscription, by Joan Severn, reads: 'Brantwood, by J R before additions'

from the radical writer and publisher W. J. Linton, and only went to inspect it in September. (He had a keen sense of what could be seen from the house; it is striking that he valued the house's view rather than its architecture or amenities.) He soon went up to visit his new purchase. On the whole, he was pleased: 'I've had a lovely day. The view from the house is finer than I expected, the house itself dilapidated and rather dismal....

> ...a small place here, with five acres of rock and moor, a streamlet, and I think on the whole the finest view I know in Cumberland or Lancashire, with the sunset visible...

> Here I have rocks, streams, fresh air, and, for the first time in my life, the rest of the purposed home.

From now on, Brantwood became his main residence when not at Oxford. Eventually, he would settle there for good, like a hermit in a cell. The beauty and order of the place brought him at least a measure of peace, when his demons permitted.

Morning Cloud at Coniston, 18 June 1877: the view from Brantwood over Coniston towards Coniston Old Hall and the mountain called The Old Man

Below: study of ivy on a rock at Coniston. Ruskin often drew ivy; in Praeterita *he recalled how in 1842 he had stopped to draw a stem of ivy 'carefully, as if it had been a bit of sculpture, liking it more and more as I drew. When it was done, I saw that I had virtually lost all my time since I was twelve years old, because no one had ever told me to draw what was really there! All my time, I mean, given to drawing as an art; I had never seen the beauty of anything, not even of a stone – how much less of a leaf'*

In November 1871, Convocation finally accepted Ruskin's offer of endowing a drawing mastership at Oxford. The other aspect of his generous gift was a collection of items that the students might study and copy. This was the birth of the Ruskin Drawing School and the Ruskin Art Collection; Alexander Macdonald was the first drawing master.

Margaret Ruskin died on 5 December, at the age of 91. His feelings, as at the death of his father, were mixed. The King and Queen of his private world were now both gone, leaving him as the undisputed monarch. It was a lonely state, as he told the readers of *Fors*: the loss of his parents left him 'without any root, or, in the depth of the word, any home.' Yet it was also a welcome state of independence.

On New Year's Day, 1872, he published *Munera Pulveris*, dedicated to Carlyle, and greatly revised from its earlier versions. His Oxford lectures for the new term were on the relations of science and art – a remarkable and challenging set of talks, later collected as *The Eagle's Nest*. One of its maxims is particularly worth stressing, since it indicates how far he was from being the simple 'worshipper of beauty' imagined by some of his friends and enemies alike: 'You will never love art well, until you love what she mirrors better.'

Besides his Oxford duties, there were many practical considerations on his mind. He had, for instance, dreamed up a charming project to keep at least some of London's distressingly filthy streets clean. He paid three street sweepers to do their best to clear the mud from a road in Seven Dials. These good intentions went to nothing, thanks to the overpowering amounts of mud on the appointed road and the unfortunate idleness of the chosen sweepers, so the project was soon abandoned. He was also preparing to move out of Denmark Hill – a task he accomplished at the end of March.

At the start of April, he travelled to Italy for three months with the Severns and others, and, once in Venice, soon became thoroughly absorbed once again in the

work of Carpaccio, especially *The Dream of St Ursula,* which he described lovingly in *Fors.* But he cut the journey short and came back to England on 27 July, so as to visit Rose, who, as he had learned, was seriously ill. Yet again, he proposed marriage. A turbulent few weeks ended with a fierce letter of rejection from her. On 8 September he recorded in his diary: 'When Jesus therefore had received the vinegar, he said 'It is finished'...' Below this, he wrote: 'Fallen and wicked and lost in all thought; must recover by work.'

On 13 September he moved permanently into Brantwood. (Three days later, he published *The Eagle's Nest.*) At the end of October, he travelled southwards again for a new term in Oxford, where he lectured both to the students and to the general public on metal and wood engraving – 'the first of the arts'. These talks were the early version of *Ariadne Florentina.* Work, the cure he had prescribed for himself in the Brantwood Diary, appeared to be having the desired effect on him. There was a rare note of cheer in his final diary entry for the year:

> Intensely dark and rainy morning; but I, on the whole, victorious, and ready for new work; and my possessions pleasant to me in my chosen or appoint- ed home; and my hand finding its Deed.

The coming year, 1873, was to be a time of relative calm and recuperation for Ruskin, at least to external appearances. When not in Oxford and lecturing, he spent the greater part of the year at Brantwood; there was no Italian trip that summer. One indication that the inveterate traveller might possibly be learning to appreciate the quiet pleasures of having now found his own home – by the way, it is striking how often his most recent book had used the word 'nest' as a metaphor for homes and dwelling places of all kinds, including cities like London – came in the latest instalment of *Fors,* dated 4 January, which included a recipe for Yorkshire Goose Pie.

Ruskin at Brantwood in 1873, by the Whitby photographer Frank Sutcliffe, who later wrote of 'the heavenly blue eyes of a dreamer and the strong nose of a warrior'

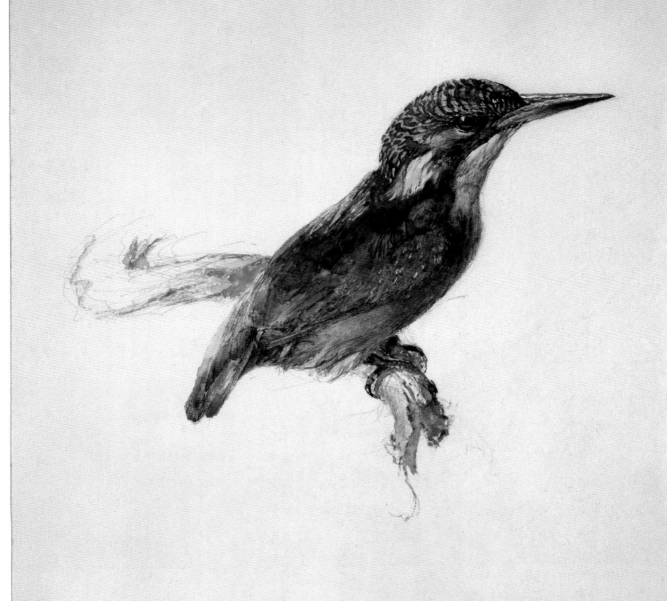

In Oxford, that March, he delivered a series of lectures on ornithology – the foundation of *Love's Meinie* (1873-1881), which was to be the first in an eventual trilogy of idiosyncratic and strangely erudite books on natural history which also included *Proserpina*, on flowers, and *Deucalion*, on geology. His days passed peacefully enough, though his nights were often troubled by nightmares about snakes, or by sexual dreams about Rose. Of one of these, he said that Rose 'gave herself to me – as sweetly in body as Cressid to Troilus.' In July he wrote to Norton that 'the deadly longing for the companionship of beautiful womanhood only increases in me – the want of it seems to poison everything.'

On 20 October, in Oxford, he delivered the first of ten lectures on Tuscan art, to be published in November 1874 as *Val D'Arno*. He returned to Herne Hill for the end of the year. Meanwhile, Rose La Touche's mental condition had continued to deteriorate, and early in 1874, her parents settled her in a hospital in Norwood, only a short distance away from Herne Hill. Joan Severn paid the invalid girl a number of compassionate visits. Ruskin's own mental health was significantly more robust, though by no means untroubled; in a letter to Norton, he outlined his growing obsession with St George and the Dragon.

It was perhaps with a private hunch that a *mens sana* might be arrived at by contriving to be *in corpore sano* that he launched the most famous, and most frequently derided of all his practical schemes. Noting that the young gentlemen of Oxford mainly exercised their bodies by playing team sports – most of which Ruskin thought childish, pointless or worse – he proposed that they should instead engage in 'Useful Muscular Work'. To be exact, that March he set a group of his undergraduate disciples, including Arnold Toynbee and his future editor Alexander Wedderburn, to work mending a road at Hinksey, near Oxford. Despite the evident social value of this work – the road was in a poor area, and often flooded with dangerously insanitary water – it was mocked from almost all

A Vineyard Walk, Lucca: lower stone-work of 12th-century tower, 1874
This is the campanile of the Romanesque church in Pozzuolo, just south west of Lucca: 'up to country church and drew well...' (Diary, 24 September 1874)

sides. Common sense considered it ludicrous for well-born youths to apply themselves to manual labour. But the young men themselves seem to have enjoyed the experience, if only for the opportunity it provided to meet the Professor on close terms.

At the end of the month, he set off on another Italian trip; this one would last seven months. He wrote regularly to Carlyle throughout this trip; since the death of John James, Carlyle had become more and more of a father figure. His first main stay was in Assisi, where he planned to study Giotto's frescoes, and where he lived for a while in the pleasing austerity of a sacristan's cell. His Christian faith, which had been enfeebled or, at times, all but extinguished for some sixteen years now, grew steadier and brighter again in these pious surroundings. To his surprise, he began to grow more fervent in his admiration for Cimabue's work than for that of Giotto. The older Ruskin would be a very different type of Christian from the young Ruskin; in some respects much closer to Catholicism than Protestantism, though he never crossed fully over to Rome.

SS. 40

Ruskin at work in Assisi: above, a letter to Joan describes the lower church, which 'has quantities of beautiful work in it; very little spoiled. But you can only see it between the hours of ¹/₂ past three and five, in entirely cloudless afternoons, lying on your back, and through an opera glass. The window at A. is the source of Light. The frescoes on the roof at BC, CD. The thing like a Punches show is Di Pa's working place — got up to by two ladders, — there being not one in Assisi long enough — I suffer [?] — to get up at once (is di Pa at his easel in this position — with his own shadow (which you can't see as it's in profile) falling exactly on the paper.' Below, a letter to Carlyle shows him with his books working at the sacristy table

1870–1880: THE PROFESSOR

In Lucca, he returned to the study of Ilaria di Caretto's tomb; then he went on to Florence.

Throughout September and October he was deluged by letters from Rose — some of them frighteningly distraught.

ENTER WILDE

On 17 October 1874, Oscar Wilde — formerly of Trinity College, Dublin — matriculated at Oxford. He was later to call his time there 'the most flower-like' of his life. His two great intellectual masters at the University would be Pater (he did not meet the author of *Studies in the History of the Renaissance* until his third year, but began to read him with rapture in his first term) and Ruskin — both prophets of art, but each with a very different gospel to expound. As Wilde's best biographer, Richard Ellmann, puts it: 'Ruskin was sublime, full of solemn reproof, and fanatical; Pater insidious, all vibration, but cautious.' (There was a gap of twenty years between them: Ruskin was 55 this year; Pater, his former disciple and now competitor, 35.) Wilde ultimately cast off both influences, but his early adulthood was dominated by their contradictory teachings.

Wilde made a point of attending Ruskin's lectures on Florentine art in the University Museum during the Michaelmas term, and, like other ardent young men of his generation, was altogether enthralled. The undergraduates would do for Ruskin what they did for almost no other lecturer: they applauded him. Sometimes they were so entranced that they even forgot to applaud — a higher compliment still.

During one of these lectures, Ruskin reminded his young men about his proposal that they should join his scheme of 'Useful Muscular Toil'. Though Wilde hated early rising, he overcame his sluggish habits for Ruskin's sake, and joined the exertions from November to the end of term. In later years, he liked to tell mildly comical tales of his road-making experiences, and used to brag that he had enjoyed the privilege of being allowed to fill 'Mr Ruskin's especial wheel-barrow', and being given lessons by the Master himself in how to roll it from place to place.

Ruskin grew fond of young Wilde, and asked him to call. After he graduated, Wilde wrote to Ruskin that 'The dearest memories of my Oxford days are my walks and talks with you... from you I learned nothing but what is good. How else could it be? There is in you something of prophet, of priest, and of poet, and to you the gods gave eloquence such as they have given to none other, so that your message might come to us with the fire of passion, and the marvel of music, making the deaf to hear, and the blind to see.'

Wilde also learned something of Ruskin's private misery, so that his admiration was mixed with sympathy. His journal entry for 25 April 1875 records a meeting with his friend William Hardinge, who explained to him that Ruskin had recently confided in him about Effie. 'True sorrow does a man good,' Ruskin had told him, 'false sorrow does one harm. I only loved but one woman and I still feel chivalrous towards her and the man who robbed her from me.'

THE WORLDS OF JOHN RUSKIN

Ruskin was back at Herne Hill on 23 October; Rose La Touche's parents, aware that Ruskin's presence was one of the few things that had any power to ease their daughter's anguish, had given their consent for the tormented couple to meet, and they finally managed to enjoy a number of relatively happy times together, despite Rose's persistent ill health. She was sent off to Dublin in 15 December.

Ruskin returned to Brantwood for the end of the year. He began the new year, 1875, in very poor health, afflicted by attacks of vertigo, temporary blindness, bad digestion and other complaints; and he was distressed by the weather – heavy rains, dense fogs, violent winds. His condition was so uncomfortable that he was driven to go down to Herne Hill in February, and to seek treatment from a homeopathic doctor. The attempted cure did him no good. (He may well have seen Rose for the last time this month.) His illness continued well into the year. In April he published the first part of *Proserpina*, and in May, the first two sections of his practical guide for travellers, *Mornings in Florence* (1875-7), the fruit of his researches the previous year.

THE DEATH OF ROSE

On 25 May, in Dublin, Rose La Touche, hopelessly insane, finally died; she was twenty-seven.

Ruskin learned of her death three days later.

'I have just heard that my poor little Rose is gone where the hawthorn blossoms go', he wrote to his friend Susan Beever. Elsewhere: 'That death is very bad for me, seal of a great fountain of sorrow which can never now ebb away; a dark lake in the fields of life as one looks back.'

The blow was devastating. He gave only one series of lectures at Oxford, and was excused his duties for the next two years. The summer was passed quietly at Brantwood. He did next to nothing for the rest of the year, though in October he exerted himself sufficiently to buy a cottage and land at Walkley, just outside Sheffield, which as he told readers of *Fors 56* would be 'the germ of a museum arranged first for workers in iron, and extended into illustration of the natural history of the neighbourhood... and more especially of the geology and flora of Derbyshire.' He spent most of that month visiting his friends the Cowpers at their house, Broadlands.

In December he returned to Broadlands and began to attend further spiritualist seances, this time in hope of making contact with Rose. A medium, someone who had never met the girl, described her appearance on a number of occasions. In his diary entry for 14 December, Ruskin recorded 'the most overwhelming evidence of the other state of the world that has ever come to me.' And a few weeks later he told Norton that Rose's ghost was often seen beside him, though he never witnessed it himself.

The conviction that spirit mediums might offer him his one means of recapturing some aspect of Rose sharpened his interest in the larger question of psychic phenomena. In early April 1876 he visited one of Britain's leading psychic researchers, F. W. H. Myers, at Trinity College, Cambridge. Later in the month he

Ruskin photographed by Lewis Carroll (Charles Lutwidge Dodgson), 6 March 1875. Joan Severn considered it 'the best photograph done of the Professor', adding 'he himself hates all portraits of himself'. This one was no exception. The weary, puffy expression reflects the strain of the months leading up to Rose's death

Rose La Touche on her deathbed, probably shortly after his last visit to her on 25 February 1875. She was 'out of her mind in the end; one evening in London she was raving violently till far into the night; they could not quiet her. At last they let me into her room. She was sitting up in bed; I got her to lie back on her pillow, and lay her head in my arms, as I knelt beside it... They left us, and she asked me if she should say a hymn. And I said yes, and she said "Jesus, lover of my soul," to the end, and then fell back tired and went to sleep. And I left her.' This little drawing (reproduced approximately life size) is now accepted as a portrait of Rose

went on a fortnight's tour – Grantham, Sheffield, Knaresborough – with the Severns. It was during this tour that he visited the Walkley museum and enjoyed a few hours of pleasant talk there with some working men. He began to collect materials for the museum and would continue to do so for the remainder of his active life.

Ruskin reading at Brantwood by Arthur Severn, probably June 1876, when Ruskin was beginning work on the Bibliotheca Pastorum. Collingwood, Ruskin's biographer, described evenings at Brantwood: Ruskin 'would pull the four candlesticks close to him at the drawing room table' and read aloud from a current favourite (often Walter Scott) 'while we sketched furtively in corners, Laurence Hilliard and I, and the ladies plied their needles.' The figures have been identified as (left to right) Sara Anderson (Ruskin's secretary, and later Kipling's), Laurence Hilliard, Ruskin's principal secretary and an artist, Joan Severn, and Ruskin

It was at around this time that he began to edit the *Bibliotheca Pastorum* (1876-85) or '*Shepherd's Library*' – that is, the St George's Guild library of standard work-texts that Ruskin believed essential for a good and useful life. His intention was that copies of each of these key documents would be owned by each member of the Guild. The first volume of the series was Xenophon's *Economist*, translated by Collingwood and Wedderburn. Ruskin's choices of other essential texts is fascinating and frequently unpredictable. Among the proposed titles were: the *Book of Moses* and the *Psalms of David*; the *Revelations of St John*; Hesiod's *Works and Days* (which Ruskin offered to translate); Virgil's first two *Georgics* and *Aeneid* book six, as translated by Gavin Douglas; Dante; Chaucer (not including the *Canterbury Tales*); Gotthelf's *Ulric the Farmer* (one of his childhood favourites); and Ruskin's biography, now seldom read, of the hero of the Second Sikh War, and evangelist, Sir Herbert Edwardes: *A Knight's Faith*.

On 24 August, he set off en route for Venice, where he booked rooms at the Grand Hotel. This Italian stay was to last almost a year. Here, he met a sympathetic local aristocrat, Count Alvise Zorzi, with whom he campaigned vigorously against insensitive 'restorations' to St Mark's. Their campaign was successful in halting restoration work until 1880. But Ruskin's deepest attention was focussed elsewhere.

He was now intent again upon Carpaccio's *Dream of St Ursula*. He wrote to one friend that the painting was 'now called in Venice "Il quadro di signor R"...' On 18 September he had it removed from its usual place so that he could copy it more easily. He wrote to Joan Severn:

> Fancy having St. Ursula right down on the floor in a good light and leave to lock myself in with her... There she lies, so real, that when the room's quite quiet, I get afraid of waking her! How little one believes things, really. Suppose there is a real St Ursula, di ma, taking care of somebody else, asleep, for me?

Copy by Ruskin after detail of Carpaccio's St Ursula's Dream, 1877

North West Porch of St Mark's, Venice, 1877. This watercolour, on which Ruskin worked during the whole of the spring of 1877, depicts the last unrestored portion of the façade of St. Mark's, and was used to publicise Ruskin's support of the campaign by Count Alvise Zorzi to prevent further unsympatehtic restoration, including the proposed replacement of the Byzantine mosaic

By now, his identification of the late Rose and Carpaccio's St Ursula was absolute. Between 23 December 1876 and 2 January 1877, he experienced a series of happy Rose-related coincidences – as he saw them – and considerably less happy, indeed tormenting, visions. With hindsight, this was another prelude to his later mental illness. He continued to work on and dream about Carpaccio's *Dream* for month after month; and he spent hours obsessively copying the work in water-colours. Now and again, he did permit himself to have a little social life, and he wrote extensively, too, both for the readers of *Fors* and on his new book about Venice, *St Mark's Rest* (1877-84), which began to appear on 19 May. This Venetian stay had brought him a measure of contentment, and he completed it by taking his time on the journey homewards, in the course of which he

spent a good deal of time studying botany – a pursuit which, like geology, always had powers to soothe him. But the unwonted calm would be short-lived.

ENTER WHISTLER

Back at Herne Hill in July, Ruskin soon set about visiting art exhibitions in London, including Sir Coutts Lindsay's Grosvenor Gallery. It was here that he saw, and was repelled by, a series of eight *Nocturnes* by James McNeill Whistler. He acted in character, and rushed to publish a denunciation in the July *Fors*, Letter 79.

> For Mr Whistler's own sake, no less than for the protection of the purchaser, Sir Coutts Lindsay ought not to have admitted works into the gallery in which the ill-educated conceit of the artist so nearly approached the aspect of wilful imposture. I have seen, and heard, much of Cockney impudence before now; but never expected to hear a coxcomb ask two hundred guineas for flinging a pot of paint in the public's face.

(Two hundred guineas was, it should be underlined, a very considerable price; compare the two hundred and fifty guineas paid by Ruskin's father for Turner's *The Slave Ship*.) There was no immediate response from Whistler, and Ruskin no doubt thought little more about his outburst, until he was obliged to do so by the law: Whistler brought a libel suit against him. He spent the later summer months at Brantwood, troubled by turbulence both in the weather and in his soul. By the time autumn came he was miserable again, and not even the warm reception of his Oxford lectures, based on *Modern Painters*, could improve his mood. Late in the year he had a bitter quarrel with his friend Octavia Hill, with whom he had worked on a philanthropic housing project in Bloomsbury. (Octavia Hill was to become co-founder of the National Trust, which in its early days was an overtly Ruskinian enterprise.)

He spent Christmas with the Aclands in Oxford. In the early New Year, 1878, he visited Windsor Castle; and then paid a visit to the Gladstones at Hawarden. By mid-January, he was happy to be back at Brantwood; but not for long. From February to April, he suffered from serious mental illness. He wrote a terrifying account of the night of 22/23 February:

> I became powerfully impressed with the idea that the Devil was about to seize me, and I felt convinced that the only way to meet him was to remain awake waiting for him all through the night, and combat him in a naked condition. I therefore threw off all my clothing, although it was a bitterly cold February night, and there awaited the Evil One ...

> I walked up and down my room, to which I had retired at about eleven o'clock, in a state of great agitation, entirely resolute as to the approaching struggle. Thus I marched about in my little room, growing every moment into a state of greater and greater exaltation; and so it went on until the dawn began to break ... It seemed to me very strange that that, of which I had such a terrible and irresistible conviction, had not come to pass.

> I walked towards the window in order to make sure that the feeble blue light was really the heralding of the grey dawn, wondering at the non-appearance of the expected visitor. As I put forth my hand towards the window a large

Nocturne in Black and Gold: The Falling Rocket, by J. A. McN. Whistler, 1875. This is the painting for which Whistler was asking 200 guineas

black cat sprang forth from behind the mirror. Persuaded that the foul fiend was here at last in his own person ... I darted at it ... and gathering all the strength that was in me, I flung it with all my might and main against the floor...

A dull thud – nothing more. No malignant spectre arose which I pantingly looked for – nothing happened. I had triumphed! ... I threw myself upon the bed, all unconscious, and there I was found later on in the morning in a state of prostration and bereft of my senses.

Poor cat. This agonising mental illness continued well into April, and fantasies of the Devil returned to plague him again and again. He suspended work on almost everything, even on *Fors*, and did little or nothing for the rest of this year, a period which one of his commentators has fairly called Ruskin's *annus horribilis*. The only happy note was that in October, the granting of a Board of Trade licence finally allowed for the legal constitution of the Guild of St George. Then came one of the most humiliating episodes of Ruskin's public career.

On 25 November, the Whistler trial began. Ruskin's friends considered – and they were surely right – that he was unfit to attend. Arthur Severn attended on his behalf. Thanks in part to Whistler's lively account of the proceedings, later repub-lished (with embellishments to make him seem all the wittier) as part of *The Gentle Art of Making Enemies*, the proceedings were to become, with the Oscar Wilde trial of the following decade, the most famous British legal contest of the nineteenth century.

Far more than wounded pride was at stake here. The trial brought to light ques-tions of aesthetics as well as of law. Is the financial value of a work of art an index of its beauty? Could their be any common ground between Ruskin's moral readings of art and Whistler's defiantly amoral aestheticism? Why is it that Ruskin could not respond to the innovative quality of Whister's work – the aspect that anticipates abstraction – when he had been such a bold and perceptive champion of Turner's innovations? And, had Ruskin actually appeared in court, might he not have found himself more in agreement with Whistler than with those who spoke on his behalf, including Burne-Jones?

As almost everyone remembers, Whistler won his case, though the judge expressed his dim view of the whole farce by granting him precisely one farthing in damages. Whistler, ever the dandy, wore it at the end of a chain. But Ruskin considered that this pecuniary joke was on him, and that the Judge had meant to signify that his opinions as an art critic were scarcely worth a quarter of a penny. It hurt his pride dreadfully.

Early in the new year, 1879, he duly resigned his Slade Professorship. There can be no doubt that this gesture of protest was sincere, but anger was not his single motive. Both Ruskin and his friends knew that he had been brought to the edge of madness and beyond by recent events, and that he was urgently in need of a long period of recuperation. He did little for the rest of the year.

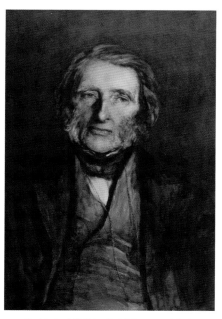

Ruskin in 1879 by Sir Hubert von Herkomer, mezzotint as reproduced in the Library Edition. Herkomer had originally been proposed as Ruskin's successor to the Slade Professorship. In a letter of 1 December Ruskin wrote 'I've been quite a prisoner to Mr. Herkomer who has, however, made a beautiful drawing of me, the first that has ever given what good may be gleaned out of the clods of my face.' It was the last significant portrait to show him without the beard he grew during his illness in 1881

RUSKIN AND THE NATURAL WORLD

Ruskin is so frequently remembered as a commentator on the works of man – be they paintings, buildings, sculptures or whole societies – that it is easy to forget the depth and continuity of his engagement with the natural world. His earliest passion was for geology; his late books were on plants and birds and winds. And throughout his life, he drew and painted water and clouds, mountains and stones, the feathers of birds and the shells of crabs. To miss this extensive aspect of his mind and work is not merely to lose a valuable part of his legacy, but to misunderstand other aspects, too, for Ruskin is what we would nowadays call a 'holistic' thinker.

He saw things both in themselves, and in their relations with many other things: architecture with society, art with morality, all of these with 'Nature'. He thought of living and non-living things alike as organisms, subject to laws of growth and decay, and his own thought can be seen in the same way. The study of nature leads him to art and architecture; the study of art to that of social order; and questions of the sickness or health of societies back again to nature. In the first part of his life, he generally believed that the natural world was a direct expression of God, benevolently provided for the joy and instruction of humankind. Nor was this a merely intellectual disposition; as a young man, he felt the full Romantic rapture of immediate contact with the non-human world. It is revealing that the title page of each volume of *Modern Painters* carried a quotation from Wordsworth.

Study of Leaves, undated, but probably associated with Ruskin's period as drawing master at the Working Men's College. Ruskin made many preparatory studies of this type to teach his students to observe nature closely

Right: Sunset at Herne Hill, seen through the Smoke of London, 1876. Ruskin made cloud studies throughout his life, often on a daily basis

His Wordsworthian sense of rapture did not survive into middle age. First, towards the end of the 1850s, he reports for the first time being bored amid the mountains. Then he comes to see evidence of the 'fallen' state of nature – the daylight, he believed, was growing thin and feeble, the waters befouled, the clouds themselves threatening. In May 1869 he wrote from Switzerland that

> The light which once flushed those pale summits with its rose at dawn, and purple at sunset, is now umbered and faint; the air which once inlaid the clefts of all their golden crags with azure is now defiled with languid coils of smoke, belched from worse than volcanic fires; their very glacier waves are ebbing, and their snows fading, as if Hell had breathed on them; the waters that once sank at their feet into crystalline rest are now dimmed and foul, from deep to deep, and shore to shore. These are no careless words – they are accurately – horribly – true.

This was in some measure a case of investing the outer world with the hastening ills of his inner world – a psychological indulgence which our times call 'projection', and for which he had invented the more pungent term 'pathetic fallacy' in *Modern Painters*. But it was also an accurate reading of a European climate which was indeed mutating in dramatic ways as a result of the chemicals being discharged into the air from thousands of furnaces. Ruskin has the grim honour of being the

Study of Two Stones: another undated drawing exercise; possibly the two fossilised sea urchins described in Elements of Drawing, *exercise VIII*

first major writer to note that the pollutions of industry might damage not merely the air over factory towns but the climate of our whole world.

Ruskin's later works on natural history – *Prosperpina* on flowers, *Deucalion* on rocks and stones, and *Love's Meinie*, on birds – are, as their flavoursome titles might suggest, works of great idiosyncrasy, in which Ruskin darts rapidly from the kind of close observation that orthodox science might accept, to forays into recondite symbolism. On the swallow: 'It is an owl that has been trained by the Graces. It is a bat that loves the morning light. It is the aerial reflection of a dolphin. It is the tender domestication of a trout...' You will not find writing of this kind in, say, Darwin, and it plain that Ruskin, though he had a good deal of time for the biologist on the couple of occasions they met, was no great fan of Darwin's theories.

Some of his arguments, or at any rate his satires against Darwin can be found in the series of Oxford lectures collected under the title *The Eagle's Nest*. They are not always easy to follow, being compounded at various times of mockery, sarcasm, fantasy and piety – especially the last, for one of Ruskin's objections to Darwinism (as he understands it) is that it flatters human arrogance. Here is a sample: '...it is appointed that vertebrated animals shall have no more than four legs, and that, if they require to fly, the two legs in front must become wings, it being against law that they should have more than these four members in ramification from the spine. Can any law be conceived more arbitrary, or more apparently causeless? What strongly planted three-legged animals there might have been! What symmetrically radiant five-legged ones! What volatile six-winged ones! What circumspect seven-headed ones! Had Darwinism been true, we should long ago have split our heads in two with foolish thinking, or thrust out, from above our covetous hearts, a hundred desirous arms and clutching hands; and changed ourselves into Briarean Cephalopoda...' Not very sound science, perhaps; but not bad rhetoric.

Opposite: Study of a Velvet Crab, undated. Ruskin placed this extremely delicate colour study in the Elementary Zoology *section of the* Educational Series *of drawings given to the Oxford Drawing School*

123

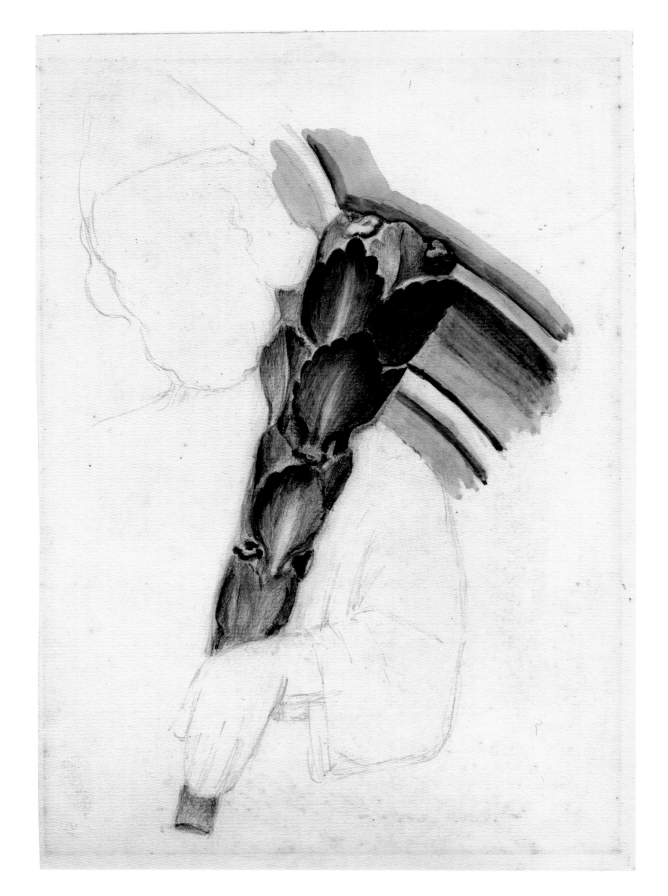

1880-90: LONELY EMINENCE

Self-portrait of Ruskin at Brantwood, leading guests on a walk (detail), possibly on 15 September 1881. Collingwood described these expeditions: 'After luncheon, if letters are done, all hands are piped to the moor. With billhooks and choppers the party winds up the wood paths, "the Professor" first, walking slowly, and pointing out to you his pet bits of rock-cleavage, or ivied trunk, or nest of wild strawberry plants'

Opposite: Study of Gothic sculpture: male figure with leaf staff. The subject of this drawing remains to be identified, but is probably from a French Gothic cathedral, possibly Amiens. Ruskin would have been drawn to this striking piece of decorative design; as he wrote in The Stones of Venice: *'to the Gothic workman the living foliage became a subject of intense affection, and he struggled to render all its characters with as much accuracy as was compatible with the laws of his design and the nature of his material'*

This was to be the last active decade of Ruskin's life. It was a melancholy ten years, punctuated with further bouts of serious mental illness and, eventually, a complete breakdown from which he never recovered.

On New Year's Day 1880, Ruskin finally broke his silence and resumed work on *Fors*, which then continued to appear at fitful intervals until 1884. This letter – the 88th – was complete by 8 February, his sixty-first birthday. On 3 January – Rose's birthday – he opened his Bible at random to find the words 'We know we have passed from death unto life'; he felt that she was attempting to comfort him from beyond the grave.

He spent much of this year brooding on serpents, and lectured on them twice in March, under the banner 'A Caution to Snakes'. (He dreamed of snakes, too, and wrote at length about them in his diaries.) These were, by all accounts, quite brilliant performances, and very well received by the public. Part of the preparation for them included jumping up on a desk and helping Arthur Severn's two brothers manipulate a giant boa constrictor skin to see precisely how such creatures moved. In addition to this, he began the series 'Fiction, Fair and Foul', in the *Nineteenth Century* magazine. It ran, in five parts, from June 1880 to October 1881, and was mainly devoted to Walter Scott, Byron and Wordsworth. He instructed Wedderburn to edit the two-volume collection *Arrows of the Chace* [sic], a gathering of his letters to the press. And he also republished 'The Political Economy of Art', revised, under the title *A Joy for Ever*.

But his most important work of the year was research for a book that, in many respects, returned to the vein of the *Stones of Venice*.

THE BIBLE OF AMIENS

In the late summer and autumn of 1880, he spent several weeks in the north of France – his first trip abroad since he came back from Venice in 1877. The fruit of this trip was to be *The Bible of Amiens* – Amiens was, in his view, the 'Venice of Picardy' – which he had begun to compose by October. He returned to England on 5 November, and gave a talk on his work-in-progress on the following evening to the boys of Eton. A. C. Benson left a vivid and touching account of the evening:

> There is little of it that I remember; there was much of it that I did not understand, for the whole was lacking in coherence and logical connection; but it was an inspiring, appealing, intensely moving performance. I felt that he was a great man, with great and beautiful beliefs passionately held, yet both oppressed and obviously unhappy. He was contending with something, perhaps a vulture gnawing at his heart, like Prometheus. There was never a sign of placid or easy mastery; no appearance of enjoyment, even of interest: it was a duty he had to perform, a service he might do; and at the end he looked old and weary. Then he was thanked and cheered to the echo. He listened patiently enough – but with no satisfaction...

The Bible of Amiens was intended as the first part of a huge, ten-part series of 'Sketches of the History of Christendom for Boys and Girls who have been held at its fonts', with the collective title *Our Fathers Have Told Us*. Subsequent volumes

Amiens From The River ('Jour des Trepassés'), probably 1880. This records a walk along the canal on 31 October; it was used, with added figures and a title referring to All Souls' Day (2 November), as the frontispiece for the third part of The Bible of Amiens. *Proust thought it demonstrated an important part of Ruskin's thoughts: 'It will prove to you, better than anything I could have said, that Ruskin did not separate the beauty of the cathedrals from the charm of the regions from which they sprang'*

would have been on, among other topics, Verona, Pisa and Florence, English and Welsh monastic buildings, Chartres, Rouen and the like. He managed to write only a few short sections of these other books.

By December he was back in Brantwood; once again in a darkening mood. On 5 February 1881 came news of the death of Carlyle. Ruskin marked the day with a cross in his diary. Bad enough that he should lose the man who had taken the place of a father in the imagination; worse still that, with Carlyle dead, Ruskin was now the only crusading general left in the losing war against Mammon. In literal terms, to be sure, he was surrounded by company, and often agreeable company – the Severns, the Brantwood staff, neighbours and visiting friends. In terms of his personal mythology, he was now more lonely than he had ever been. No father and mother; no Rose; no mentor.

His spirits worsened, no doubt in response to this dolorous blow, and by 19 February he was once again in the grip of mania. He threatened members of his household with violence; he once locked the cook in his room, believing that she was the Queen; he became persuaded that everyone was trying to undermine his authority, and would storm around shouting 'I will be master in my own house.' Dragons and snakes continued to haunt his dreams. Thanks to patient and courageous nursing by Joan, he had returned to sanity by 22 March, but, as he confessed to Norton and others, he was finding it hard to concentrate on his work:

> I went wild again for three weeks or so, and have only just come to myself, if this be myself, and not the one that lives in dream.
>
> The two fits of – whatever you like to call them – are both part of the same course of trial and teaching – and I've been more gently whipped this time and have learned more: but I must be very cautious in using my brains yet, awhile.

As the year went on, his inability to focus for long on any one subject grew worse. Concerned about Ruskin's well-being, W. G. Collingwood – his disciple and future biographer – moved to his family cottage near Windermere to be within easy reach of Brantwood. Collingwood and others encouraged Ruskin in soothing hobbies and small projects around Brantwood: drainage of the moor above the estate, taking his boat, Jumping Jenny, out on Coniston Water, collecting and sorting minerals. Ruskin also turned his hand to music, and composed a few songs. His spirits seemed to improve a little.

By March of the new year, 1882, however, he had suffered another serious breakdown, while staying at Herne Hill. Joan was pregnant, and quite unable to deal with him, so the Severns hired a professional nurse, Ruth Mercier. When Ruskin

View from Upper Walk, Brantwood, 1881. Also known as the High Walk, this area to the south of the Brantwood was developed by Joan Severn as a level walk taking in panoramic views of the Coniston Fells and Yewdale

*Ruskin at Brantwood in 1881, by T. A. &
J. Green of Grasmere. A few years later, a
visitor wrote: 'We are probably familiar from
portraits with the refined delicacy of his
features, accompanied with a certain
shagginess of eyebrow and beard, but
the sweetness of his blue eyes and the
peculiarly kindly smile were a glad surprise...
His utterance was sufficiently slow to be
perfectly accurate, distinct and impressive.
His lips indeed seemed to make an effort
to give every word full force. He is rather
short than tall, and has now a very
pronounced stoop. He seems to wear a
good deal of clothing, and some of the
ladies noticed that he had a large and
conspicuous Oxford blue tie, and
an ornamental waistcoat'*

first saw her, dressed in her uniform black, he took her for the Grim Reaper. Sir
William Gull attended him. Of the three episodes of madness in 1878, 1881 and
1882, Ruskin wrote that

> In the first there was the great definite Vision of the contention with the
> Devil, and all the terror and horror of Hell – & physical death. In the second,
> there was quite narrowed demoniacal vision, in my room, with the terrible
> fire-dream in the streets of London; in the third, the vision was mostly very
> sad & personal, all connected with my Father.

Joan's accounts of his behaviour during these episodes make sad reading. Again
and again, he would grow dictatorial, violent, abusive. Somewhere, not too far
beneath these outbursts was the feeling (not altogether groundless) that the
Severns were taking over his house and his life, and pushing him to the margins,
like a marital version of Goneril and Regan. For their part, the Severns were all
too well aware that their material well-being depended on Ruskin's continued
affection and sanity; they were justifiably worried that he might take it into his
head to give away all his possessions and leave them with nothing.

There was more sad news to come: Rossetti died in the same year. Despite
such setbacks, Ruskin rallied his spirits a little. At one point he diverted himself by

making suggestions for a May Queen Festival at Whitelands College – the beginning of a long and charming tradition at that school. He prescribed himself a little more urbane London company by way of a cure, and on 14 June he attended a dinner for the great orientalist Richard Burton given by Bernard Quaritch; Ruskin had been asked to make a brief speech for the guest of honour on the 'benefits and advantages' of travel. He also took some music lessons. And in mid-August, following medical advice from Gull, he set off with his servant Baxter and Collingwood on his penultimate visit to the Continent, which would last for four months; his thirty-fourth such trip. Collingwood later wrote an account of their travels; one of the things that he noticed about his master was Ruskin's extreme sensitivity to the weather.

A diary entry from this trip suggests that Ruskin was beginning to feel that his life was drawing towards its final act:

> It seemed to me, during a somewhat restless and sad interval of the night, as if my life, with its work and failing, were all looped and gathered in between St. Cergues farewell to Mont Blanc in 1845 and St Cergues return in 1882. Thirty-seven years. If I am yet granted peace of heart and time enough to reprove – to sum – they have done some good. Thirty-seven: take ten to learn what I had only then begun to learn, and they are but 3 x 9 for Art, Geology and St. George.

They reached Italy at the end of September. In Florence, Ruskin met an American artist, Francesca Alexander, and her mother. These were to be important new friends for him. 'I never knew such vivid goodness and innocence in any living creature as in this Mrs and Miss Alexander.' Miss Alexander was an artist, and a collector of tales of Tuscan peasant life. Ruskin found both her art and her writings delightful – posterity has not been so enthusiastic – and he soon applied

Study of the plant commonly known as bugle, 5 September 1882; inscribed 'Sub invocationi Sancti Cergui!' ('under the protection of St Cergues!')

A page from Francesca Alexander's
Roadside Songs of Tuscany

himself to promoting her work with great warmth. It was a godsend for the artist, who was already middle-aged and still largely unknown. Thanks to his endorsement, she was soon to be famous. Her illustrated book *The Roadside Songs of Tuscany* was published in 12 parts, 1884-5, with a preface by Ruskin.

In December Collingwood and Ruskin returned to England. Within two days of landing, he delivered a lecture, 'Mending the Sieve', which, again, was a great success. At the very end of the year, on 29 December, he met another female artist, Kate Greenaway for the first time. Soon, he was promoting her drawings with the same enthusiasm he was already giving to Francesca Alexander's work. Almost all of Ruskin's admirers have confessed themselves unable to endorse his enthusiasm, since Kate Greenaway's work – which enjoyed a mild cult revival in the 1960s and 1970s among young people swayed by hippie values – is at best pretty and trifling, at worst simply twee. The sombre verdict must be that Ruskin was yielding to his own streaks of immaturity.

His physical health seemed much improved after the Italian journey, and his friends hoped that a complete recovery might prove possible. Even so, it was increasingly taken for granted that Joan was in charge of Ruskin's welfare, with all the control over his movements and professional decisions that this protective status implied. In March 1883, he was re-elected to the Slade Professorship at Oxford, and for his comeback delivered lectures on 'The Art of England', which devoted warm praise to the lately departed Rossetti, to Hunt, to Burne-Jones and other contemporaries. Though not up to his previous standard, his lectures were enormously popular, and they had to be delivered twice to accommodate all those who flocked to them. (It was in these lectures that he championed both Francesca Alexander and Kate Greenaway.) He was steering cautiously away from any subject that might anger him, and dealing in celebration and nostalgia.

He began to bombard Kate Greenaway with letters at this time, and the

Cloud effect over Coniston Old Man, 1880s. 'The curse on the sky is my chief plague – if only spring were spring! But it's too hard on me, this devil in the wind and clouds and light'. (Diary, 12 March 1880)

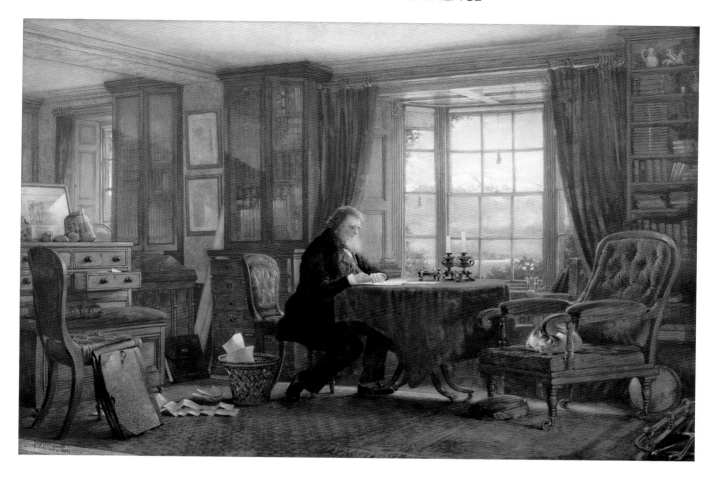

Portrait of Ruskin in his study at Brantwood (probably posed by Laurence Hilliard), by W. G. Collingwood, 1882.
Ruskin is writing before dawn, as was his habit. Proofs are scattered over the floor. A Turner stands on the chest of drawers, behind his row of minerals 'illustrating his theory of agates.' Papers for the Guild of St George are seen in an open drawer; below, on a chest used for framed Dürer prints, is the 14th century Bible which he read daily. The bookcases are for Geology (left) and Botany (centre); between them are rolls of lecture diagrams, and two drawings by Prout. Some of Ruskin's own books, in purple bindings, are propped up in the window; the box holds Daguerrotypes of Venice. Archaic Cypriot pots can be seen in the right hand bookcase, above coin trays. In the fender can just be seen the curious shovel he was proud of having designed

voluminous correspondence has a number of disturbing aspects. It does not take a very suspicious eye to detect that Ruskin found her pictures of little girls rather titillating, and that he was urging her to undress these images stage by stage until they became proper nudes. Perhaps Miss Greenaway mistook the target of his erotic interest; at any rate, when she came to stay at Brantwood, she appears to have fallen quite seriously in love with him. Ruskin made it as clear as possible that he was not interested in her as a mistress or wife: 'I feel this affection you bear me puts me in a place of most solemn trust over you – but I do hope that you will manage to get it put into a more daughterly and fatherly sort of thing.'

THE STORM-CLOUD OF THE NINETEENTH CENTURY

As so often at the onset of autumn and winter, his depression and anxiety deepened with the darkening of the days. In September, he reported that he was 'giddy with the quantity of things I've in hand.' At the end of October, he heard with sorrow of the death of his local friend Susanna Beever. The weather grew foul again that winter, and prompted one of the most important of all Ruskin's late writings.

Thunderclouds, Val d'Aosta, 1884, by Arthur Severn after Ruskin. Inscribed by Severn: 'This may be published. Ruskin quite approves'. This sheet is a copy of an 1858 watercolour by Ruskin, drawn near Turin at the time of his 'un-conversion'. Severn made a large version for use as a lecture diagram for 'The Storm-Cloud of Nineteenth Century'; and this smaller one would have been a preparation for the engraver

In February 1884, he delivered a lecture, 'The Storm-Cloud of the Nineteenth Century', at the London Institution. From our perspective, it is literally the most prophetic of all Ruskin's writings, though to most of its listeners and readers it would have seemed as if Ruskin were merely indulging in that confusion of inner states and outer states which, in earlier years, he had branded 'the Pathetic Fallacy'. He told his audience that the weather – really, the atmospheric conditions of Europe, and perhaps the entire planet – had changed in the course of his lifetime. The skies had grown dark and poisoned, the clouds thicker and more ominous, the rains heavier and the whole world colder. A 'plague-wind' was blowing across the land.

Once again, the newspapers called Ruskin fantastical and mad. Within twenty years, he was proved to be quite correct. Meteorological records show that the 1870s and 1880s were indeed anomalous – the skies darker, the air colder, and so on. Other records corroborate the weather-watchers. The incidence of fatal respiratory diseases soared – so much so in London that the weekly mortality rate jumped 40 per cent. Forests began to droop for want of sunlight. Animals died in thick fogs. And, yes, the winter of 1883-4 was indeed the worst yet. Why? The

quickest answer: sulphur dioxide levels, which had been rising for two centuries and finally peaked in 1880, after which changes in furnace technologies began to reduce the pollution. Far from being insane, Ruskin was utterly precise in his observations, and decades in advance of any other Romantic commentator on the environment. In an age where only fools and scoundrels question the reality of global warming, *Storm-Cloud* is now more urgent reading than it has ever been.

The rest of the year was anti-climactic, or worse. He visited and exchanged notes with Kate Greenaway, but continued to dampen her romantic feelings for him. In May he returned to Brantwood, where he spent a quiet summer, and in Michaelmas term went back to Oxford, where he began to deliver a series entitled 'The Pleasures of England'. Though his recent form had been as dazzling as ever, these new talks made a sorry spectacle. Many of them were half-improvised, and notable mainly for his freakish behaviour – flapping the sleeves of his gown to imitate a bird in flight, for example. Where once the students and the ladies had gathered to drink in words of wisdom, they now came for a cruel laugh, to watch the old man make a spectacle of himself. On the kindly advice of Acland and others, he agreed to cut the series short. He ended the year in great mental distress.

PRAETERITA

Ruskin's life for the next few years – 1885 to 1889 – can be brusquely summarised as a sequence of mental crises, punctuated on the happy side by weeks of calm and on the sorry side by madness. Miraculously, he had one last masterpiece in him: *Praeterita*, his partial autobiography, which he began to write on New Year's Day. The work continued, when he was lucid, until 1889. The first instalments were published in July.

Otherwise, he was unwell. On 22 March 1885 he resigned his Professorship – officially, in protest against a decision to permit the practise of vivisection at the University of Oxford. 'I cannot lecture in the next room to a shrieking cat nor address myself to the men who have been – there's no word for it'. This was sincere horror. But the deeper reality, known to his closest and wisest friends, was that he could no longer be relied on to discharge his duties. He never visited the University again.

In July, he was visited at Brantwood by Mrs La Touche. They had long since made up their differences, but the excitement of this stay and the memories it summoned up were bad for him. On or about 21 July came the onset of his fourth serious bout of mental illness. As he struggled to pull himself together, he said that '...my life looking back on it now – is the woefullest wreck and dream to me.' His only literary accomplishment was to write *A Knight's Faith* – his book for the Shepherd's Library about Herbert Edwardes.

Throughout 1886 and 1887, Ruskin's condition continued to deteriorate. He grew increasingly subject to violent rages, and the Severns realised that it would be dangerous to leave him on his own. There were rumours that he was going to convert to Catholicism, and these were not without foundation, since Cardinal Manning – one of Lytton Strachey's four 'Eminent Victorians' – had invited him to

a number of private lunches, no doubt in the hope of winning a great prize for Rome. But, as Ruskin wrote to an anxious Glasgow correspondent;

> I shall be entirely grateful to you if you will take the trouble to contradict any news gossip of this kind, which may be disturbing the minds of my Scottish friends. I was, am, and can be, only a Christian Catholic in the wide and eternal sense. I have been that these five-and-twenty years at least. [Twenty-five years before 1887 is 1862; he was probably thinking of the 'unconversion' experience of 1858.] Heaven keep me from being less as I grow older! But I am no more likely to become a Roman Catholic than a Quaker, Evangelical, or Turk.

He travelled to Folkestone for a brief holiday; here, his behaviour seemed so peculiar to most people that he became a local figure of fun. He stayed in the resort until October 1887, and then was mainly resident in the nearby resort of Sandgate until 10 June the following year – a sort of compulsory exile from Brantwood, this, as Joan Severn was angrily asserting her will over the old man and had banished him temporarily from his own house. He did, however, make a brief visit to London, where he formed the last serious friendship – or romantic attachment – of his life, with Kathleen Olander, at the time a rather naïve eighteen-year old art student, though in later life a considerable woman. He met her in the National Gallery in November; she was copying Turner's *The Sun Rising in the Mist*. He proposed taking her on as a student; her parents were, at first, dazzled by the prospect of their daughter being advanced by this rich, famous and distinguished man. But when they realised that he was also suggesting that she should become his wife, they were understandably dismayed and banned all future contact.

1888 was to be the year of his last trip to the continent. Arthur Severn accompanied him, and in the course of their trip they ran into two lively young men, Sydney Cockerell and the architect Detmar Blow, who were travelling inspired by *The Bible of Amiens*. There were some spells of pleasure on the way, and even of contentment. In Sallanches; he wrote 'Thank God for all my life to come for

Collier off Sandgate, near Folkestone, 1888. Inscribed: 'Collier, probably brig of about 200 tons Sandgate 22nd March 88 Dead calm'

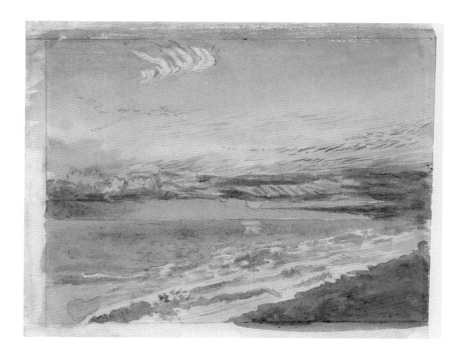

letting me see such loveliness again.' And he enjoyed a meeting with the Alexander ladies at Bassano.

Overall, though, his depression deepened. In May 1889, he left Brantwood and travelled to Seascale, where he wrote – or, to be strictly accurate, dictated to Joan Severn, with whom he was now reconciled – what was to be the last chapter of *Praeterita*. It is entitled 'Joanna's Care' – a mark of gratitude to his nurse. Its final paragraph became well known as a prose-poem, generally titled 'The Fireflies of Fonte Branda': a secular vision of Paradise. One critic has said that it may be the single most beautiful piece of prose in the English language:

> Fonte Branda I last saw with Charles Norton, under the same arches where Dante saw it. We drank of it together, and walked together that evening on the hills above, where the fireflies among the scented thickets shone fitfully in the still undarkened air. How they shone! moving like fine-broken starlight through the purple leaves. How they shone! through the sunset that faded into thunderous night as I entered Siena three days before, the white edges of the mountainous clouds still lighted from the west, and the openly golden sky calm behind the Gate of Siena's heart, with its still golden words, 'Cor magis tibi Sena pandit,' and the fireflies everywhere in sky and cloud rising and falling, mixed with the lightning, and more intense than the stars.

> BRANTWOOD
> June 19th, 1889.

Like Dante, whose *Commedia* ends with 'stelle', Ruskin takes leave of his written work with the word 'stars'.

In August 1889 he suffered a massive breakdown. His active life was done.

1890-1900 AND BEYOND

FIN DE SIECLE

The 1890s is the only decade of the nineteenth century to have branded itself enduringly in the educated imagination as possessing a distinct character of its own – at least, in the realms of literature and the arts. Even those who have not read Holbrook Jackson's classic cultural history of the period *The Eighteen-Nineties* (1913) will usually be aware that it was the age of Beardsley and the *Yellow Book* (launched in April 1894), Shaw and Conan Doyle, early Yeats, early Kipling and early Beerbohm, William Morris's prose romances, novels by Hardy and H. G. Wells. Above all, it was the age of Ruskin's former student, Oscar Wilde – a very minor figure until 1891, nationally famous after the dazzling success of *Lady Windermere's Fan* in 1892, then a figure of universal fear and loathing after the Old Bailey trial of 1895. Holbrook Jackson convincingly suggests that it was Wilde's destruction that reversed the spirit of the age, in effect splitting the Nineties into two distinct cultural phases.

Times were changing rapidly: some distinctively new sensibilities were emerging. A few dates, a few resonant titles. *The Picture of Dorian Gray*, *Tess of the D'Urbervilles* and the first Sherlock Holmes stories belong to 1891; *The Jungle Book*, *The Time Machine*, *Jude the Obscure*, *Almayers's Folly* and Yeats's *Poems* to 1895; *Dracula* to 1897; *Plays Pleasant and Unpleasant*, *The War of the Worlds*, *Wessex Poems* and *The Ballad of Reading Gaol* to 1898. It was also the Ibsen decade: *Ghosts* and *Hedda Gabler* were produced on the London stage in 1891, and there were no fewer than six Ibsen plays in 1893, including *The Master Builder*, *Rosmersholm*, *A Doll's House*, *Brand* and *An Enemy of the People*.

One after another, the quintessential Victorians were leaving the stage. Tennyson died in 1892; Gladstone, whom Ruskin had repeatedly insulted, was generous-minded enough to propose that Ruskin be made Poet Laureate in his place, but withdrew the suggestion when he learned the true state of Ruskin's health. Pater, Christina Rossetti and Robert Louis Stevenson all died in 1894, Coventry Patmore and William Morris in 1896, Lewis Carroll, Aubrey Beardsley and Burne-Jones in 1898 – which was also the year of Gladstone's death.

Ruskin's doctrines – both in pure and in strangely degraded form – were among the most potent forces at work in the national culture. 'Aestheticism' – a cult of artificiality and self-conscious 'decadence' – which dominated the first half of the decade, was widely misunderstood as a logical extension of that 'religion of art' or 'religion of beauty' supposedly outlined in Ruskin's books. In fact – as Proust, among others, shrewdly pointed out – it actually ran contrary to Ruskin's teachings. Ruskin's religion was not Beauty, but Christianity. A more genuine development of Ruskin's ideals, the Arts and Crafts movement, flourished now, and well into the next century. And houses across the nation began to be beautified with Morris designs.

THE LONG SILENCE

Youth is properly the forming time – that in which a man makes himself, or is made, what he is for ever to be. Then comes the time of labour, when, having become the best he can be, he does the best he can do. Then the

Opposite: Ruskin photographed in the study at Brantwood, September 1894, by Frederick Hollyer, 'Datur hora quieti'. Hollyer, one of the great photographers of the period, visited Ruskin with Holman Hunt, who may have posed this picture. The title refers to a poem by Ruskin's favourite Walter Scott, beginning 'The sun upon the lake is low, The wild birds hush their song...'

time of death, which, in happy lives, is very short: but always a time. The ceasing to breathe is only the end of death.

Ruskin had retired into that solitude where prophetic beings often go until it pleases God to call to Himself the cenobite or the ascetic whose super-human task is finished – Marcel Proust, Preface to La Bible d'Amiens, 1904

Of all this fin de siècle ferment, Ruskin knew either little or, more likely, nothing. The last ten years of his life were as secluded from the rough currents of history as his first ten years, though he did sometimes listen attentively as the newspapers were read to him. After being brought back to Brantwood as an invalid, he was kept upstairs in bed for several months, tended for a while by a male nurse, and then – as for the rest of his life – by his servant Baxter and by Joan Severn. Ruskin was almost entirely silent during these first few months of his long illness, and did not appear to know where he was or to recognise anyone, even Joan. It must have been tempting for Joan to have him removed to a hospital or asylum. To her undying credit, and with the help of a competent local doctor, George Parsons, 'Joanna's Care' persisted as long as Ruskin drew breath.

Arthur Severn's conduct was quite different. He had never greatly enjoyed living in Brantwood during wintertime, and from now on often stayed in Herne Hill during the cold weather, enjoying all the diversions of the metropolis and some-times going off on trips to Scotland and the continent. Joan took no holidays for the rest of the century. Around August 1890, Ruskin recovered somewhat and got out of bed; Joan and Ruskin developed a peaceable regime for the semi-

invalid man, which lasted for several years, until his health took another downwards turn. His beard was allowed to grow to a patriarchal length, and he now appeared much older than his years. Earlier in his life, he had written like an Old Testament prophet; now he merely looked like one.

In these years of near-silence and seclusion, he grew more eminent than he had ever been, though less among the bright young things of the varsity and the metropolis than among the working classes. The 1890s was the great decade of Ruskin societies, which were springing up in cities all over the country, and of the cult of self-education among workers: for such self-improvers, Ruskin, whether taken straight or in the diluted form of paraphrase, was mandatory reading. By 1897, there was also a national Ruskin Reading Guild, with its own journal, *Igdrasil*. And in 1899, two American philanthropists founded Ruskin Hall (later Ruskin College) in Oxford, for the higher education of working class students.

Though he was no longer writing anything, his publication list grew ever more impressive. A number of his books were brought back into print again and again, notably *Sesame and Lilies* (long a great favourite at school prize-givings, as browsers of second-hand bookshops will know), *The Seven Lamps of Architecture* and *The Stones of Venice*, by now an indispensable vade mecum for travellers in Italy.

Ruskin's followers also began to re-issue his work in anthology form, and some of these books sold many thousands of copies, beginning with *The Poems of John Ruskin* in 1891. Subsequent collections included *Selections from the Writings of John Ruskin* (first issued in 1893), *The Ruskin Reader* and *Studies in Both Arts* (1895), all edited by Collingwood. Selections by other editors included Ruskin's *Thoughts About Women* (1892), *Ruskin on Music* (1894), *Ruskin on Education* (1894), and *The Bible References of John Ruskin* (1898). 'Ruskin' had become a brand name. There were Ruskin ceramics, Ruskin linen, Ruskin cigars, Ruskin fireplaces.

The view of Coniston Water, from Brantwood, probably 1879, by Albert Goodwin. As a young artist in Maidstone, Goodwin encountered the Pre-Raphaelite painter Arthur Hughes, and was later introduced to Ford Madox Brown and to Ruskin, probably in 1869. He spent time with Ruskin at Abingdon and Matlock in 1871, and in 1872 was invited on a three-month trip to Italy, in a party including the newlyweds Joan and Arthur Severn. As with all his young artist protégés, Ruskin urged Goodwin to look both at nature for inspiration and to Turner as a model in combining colour and form. This view was almost certainly drawn in July 1879, on his only documented visit to Ruskin at Brantwood

THE WORLDS OF JOHN RUSKIN

Though it is sometimes assumed or implied that Ruskin fell completely silent, and, indeed, that he was physically incapable of speech ('...for the last eleven years he lived on at Brantwood in a silent coma' – Sir Kenneth Clark, *Ruskin Today*) , this is not so. Until about 1895 or 1896, he was able to form entire sentences. After that time, he still had the ability occasionally to utter a lucid word or two. It was more the case that he generally preferred not to exercise these abilities. But, apart from periods of minor illness, he remained physically active, even at times reasonably vigorous, until 1899, and took obvious pleasure in walking around the gardens – he walked almost every day – and rowing on Coniston. The impression that he was severely incapacitated was (inadvertently?) strengthened by Joan, who often turned visitors away on the grounds that Ruskin was too ill. For the most part, rightly or wrongly, she was trying to protect him from the dangers of undue stimulation, and a few visitors were always allowed access. Collingwood frequently came and played chess with him, since Ruskin's ability to understand the game was quite unimpaired.

WILLIAM MORRIS: FINAL YEARS

While Ruskin sat and looked at the skies and waters, one of his most important disciples was, as usual, filling the last few years of his life with strenuous work.

The final half-dozen years of William Morris's earthly span were a miracle of effort and accomplishment. In 1890-1, he published *News from Nowhere*, the Utopian novel that remains the most widely read of all his fictions: a vision of a future England which has cast off capitalism and modern industry and so grown healthy, happy and beautiful. In 1890, he also founded the Kelmscott Press (it lasted to 1897), which issued 66 magnificently designed books in all; the Kelmscott edition of *The Nature of Gothic* was published in 1892.

Morris's introduction, as we have seen, was a warm and generous tribute to Ruskin's achievement. As an art critic, Morris wrote, Ruskin '...has let a flood of daylight into the sham-technical twaddle which was once the whole substance of "art-criticism"...' As an independent thinker, Ruskin had challenged the hegemony of the scientific world view 'which has taught us everything except how to be happy.' And as a prophet, 'the lesson which Ruskin... teaches us is that art is the expression of man's pleasure in labour; that it is possible for man to rejoice in his work, for strange as it may seem to us today, there have been times when he did rejoice in it...'

In 1894, Morris took up this theme again in *How I Became a Socialist*:

> Before the uprising of modern Socialism almost all intelligent people were, or professed themselves to be, quite contented with the civilization of this century... This was the Whig frame of mind, natural to the modern prosperous middle-class men...

> But besides these contented ones there were others who were not really contented, but had a vague sentiment of repulsion to the triumph of civilization, but were coerced into silence by the measureless power of Whiggery. Lastly, there were a few who were in open rebellion against the said Whiggery – a few, say two, Carlyle and Ruskin. The latter, before my days of

practical Socialism, was my master towards the ideal aforesaid, and, looking backward, I cannot help saying, how deadly dull the world would have been twenty years ago but for Ruskin! It was through him that I learnt to give form to my discontent, which I must say was not by any means vague. Apart from the desire to produce beautiful things, the leading pattern of my life has been and is hatred of modern civilization.

'....how deadly dull the world would have been twenty years ago but for Ruskin!' This is not the grandest tribute ever paid to Ruskin, but it is one of the most charming and thought-provoking. In Morris's last illness, his doctor said that the fatal condition with which he was afflicted was 'simply being William Morris, and having done more work than most ten men.'

PILGRIMS AND DISCIPLES

Even though Joan Severn kept a careful eye on Ruskin's social diary, and was wary of letting him become over-stimulated, he was visited quite often and by a wide range of friends, admirers and well-wishers. In 1893, one of his oldest friends, Acland, paid an affectionate call. His daughter Angie took the well-known photograph of the two old friends together: Ruskin strokes his long beard; it is hard to guess what he might be thinking.

In 1893, Collingwood published the first official biography *The Life and Work of John Ruskin* with Methuen books – not, that is, with George Allen. It was aimed at the common reader – one who might not have had much formal education. In the same year, Oxford University conferred the degree of DCL on Ruskin in absentia.

About 1895, Kathleen Olander paid a visit to Brantwood., and left a poignant account of her last glimpse of the man who had asked her to marry him.

> I was exceedingly nervous of meeting Mrs Severn, and went round to the back door where I handed my card to a butler, asking him to give it to Mr Ruskin, and requesting he should see me. I do not believe that the card reached Ruskin, for the butler returned with the answer, 'Not today.'
>
> I then went round to the other side of the house and saw Ruskin at the first French window, sitting alone. But I was too alarmed to stay, for I was in full view of the next French window, where people were evidently dining.
>
> I kissed my hand to him, but he never saw me. Nor did we ever meet again.

In about 1898, the writer Frederic Harrison, an eloquent and forceful champion of Ruskin's work, paid a reverent visit to Brantwood, where he found the old man

> – to look at just like Lear in his last scene, but perfectly reposeful, gentle, and happy, taking the air of the fells with delight, joining in games or reading with the family at intervals, but for the most part sitting in his library and softly turning over the pages of a poem, a tale of Walter Scott, or Dickens, or some illustrated volume of views, himself in a bower of roses and gay flowers; silently and for long intervals together gazing with a far-off look of yearning, but no longer of eagerness, at the blue hills of the Coniston Old

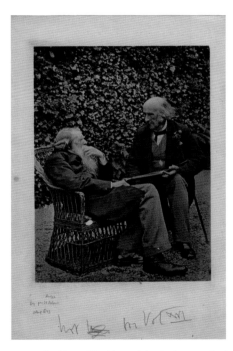

Ruskin and Sir Henry Acland, photographed 1 August 1893 by Acland's daughter Angie, and later annotated for the Library Edition

Man, across the rippling lake, as if – half child again, half wayworn pilgrim – he saw there the Delectable Mountains where the wicked cease from troubling and the weary are at rest....

Another visitor, Hall Caine, wrote of his encounter at about the same date:

I found him very old and bent and feeble, a smaller, frailer man than I looked for, well in health both of body and mind, but with faculties that were dying down very slowly and gently, and almost imperceptibly – as the lamp dies down when the oil fails in it.

His eyes were slow and peaceful, having lost their former fire; and his face, from which the quiet life of later years had smoothed away the lines of strong thought and torturing experience, was too much hidden by a full grey beard. He spoke very little, and always in a soft and gentle voice that might have been the voice of a woman; but he listened to everybody and smiled frequently. All the fiery heat of earlier days was gone, all the nervous force of the fever patient, all the capacity for noble anger and righteous wrath. Nothing was left but gentleness, sweetness, and quiet courtesy, the unruffled peace of a breathless evening that is gliding into a silent night... His whole personality left the impression of the approach of death, but of death so slow, so gradual, so tender and so beautiful, that it almost made one in love with it to see it robbed of every terror.

On the occasion of Ruskin's eightieth birthday in 1899, John Howard Whitehouse (on whom more in a moment) came to Brantwood and read him a national address of congratulation from all the bodies with which he had been associated. Whitehouse recalled that:

He was dressed and sitting in an armchair before a little table. As we entered he attempted to rise, but was evidently too feeble to do so. We shook hands and I told him I was glad to hear he was so well. I then explained that we had brought him a national address, and I read it to him. As I was doing so, I occasionally heard him give a low exclamation – half sob it appeared to be. When I had finished he tried to reply but could only utter a few broken words. He was evidently deeply moved and quite overcome with emotion. After he had looked at the address we withdrew...

What impressed me most when I saw the Master were his wonderful eyes. They are blue and very clear and bright. When, during the reading of the address, I looked up at him, I found them fixed upon me as though he were searching me through and through. No one who meets his eyes can doubt that his mind is perfectly clear...

1900

In the last year of his life, he was too frail to leave his bedroom. He spent many hours sitting in the small, windowed turret in its corner, gazing out over the waters.

Early in the year, there was an epidemic of influenza. Some of the Brantwood servants caught it, and passed it on to the old man. On 18 January, he took his last

Illuminated Address presented by John Howard Whitehouse to John Ruskin on his 80th birthday, 1899. The calligraphy and decoration is by Albert Pilley of Sheffield, and the binding by Thomas Cobden-Sanderson, a remarkable man who abandoned the law in 1886 to take up the craft of bookbinding, having been inspired by Ruskin's writings

Ruskin's deathbed, recorded on 23 April 1900 by Arthur Severn. Ruskin's remaining Turners are hung around the room, together with Conway Castle *by his father, and* Peach and Grapes *by W. H. Hunt, both illustrated on p. 21*

proper meal; sole, pheasant and champagne. Less than 48 hours later, on 20 January, he died in his sleep at 3.30 pm, with Joan Severn holding his hand.

His disciple E. T. Cook gathered many illustrious names for his petition that Ruskin's mortal remains should be buried in Westminster Abbey, and it was rapidly made known that this would have been welcomed by the government and church alike. But – in accordance with the conditions of his most recently drafted will – he was buried, after a modest service, in Coniston churchyard, next to the grave of his friend Susie Beever, on 25 January. His coffin was covered with a pall donated by the Ruskin Linen Industry of Keswick, lined with crimson silk, embroidered with wild roses, and on a grey field the motto 'Unto This Last'. The gravestone, a Celtic cross, was designed by Collingwood.

The mourners were mainly locals.

LEGACY: TRIBUTES

One of the most moving of immediate tributes was Marcel Proust's:

> When I learned of Ruskin's death, I wanted to express my grief to you more than to anyone [he wrote to his friend Mary Nordlinger]. No bitter grief, by the way, but full of comfort. After all, I know how insignificant death is, when I see how vitally alive this dead man is, how much I admire him, hang on his words, try to understand and heed him: him more than many another, living man.

Proust considered that, with Tolstoy, Nietzsche and Ibsen, Ruskin was one of the world's 'directeurs de conscience'. (The parallels between the last decade of Nietzsche's life and the last decade of Ruskin's are, by the way, close to uncanny.) In his obituary – later included in a longer essay – he wrote of Ruskin that 'Dead, he continues to enlighten us, like those dead stars whose light reaches us still, and one may say of him what he said on the occasion of Turner's death: "And through those eyes, now filled with dust, generations yet unborn will learn to behold the light of nature..."'

Newspapers around the world spoke far more generously and affectionately of the dead Ruskin than they had of the living man who had irritated them so often. Many of them adopted the superlatives that had become the common theme of many intelligent essays that had appeared during the years of silence. The words of Robert F. Horton may do service for many similar passages. 'His writings are not a new Decalogue, but in them the old and venerable Decalogue, the indefeasible laws of God, are uttered again with the majesty of lightning and earthquake.' Ruskin, Horton said, 'will be remembered by posterity as the great writer who set in motion the forces of social amelioration.' This may yet come to pass.

LEO TOLSTOY

Tolstoy once said that he had read everything Ruskin had published from *Unto This Last* onwards.

> When Ruskin began to write on philosophy and morality, he was ignored by everybody, especially by the English press, which has a peculiar way of

ignoring anybody it does not like. I am not astonished that people speak so little of Ruskin in comparison with Gladstone. When the latter makes a speech, the papers are loud in their praises, but when Ruskin, whom I believe to be a greater man, talks, they say nothing.

Ruskin was one of the most remarkable men, not only of England and our time, but of all countries and all times. He was one of those rare men who think with their hearts ('les grandes pensées viennent du cœur'), and so he thought and said not only what he himself had seen and felt, but what everyone will think and say in future.

On another occasion:

He was a very great man. I like his face. I have seen two portraits, front face and profile, both after he had grown a beard. He was like a Russian peasant.

MAHATMA GANDHI

Most reference books state, correctly, that Ruskin was an important influence on Mahatma Gandhi (1869-1948), but few give exact details. Here they are: in 1904, Gandhi caught an overnight train from Johannesburg to Durban. He was seen off by an English friend, Henry Polak, who gave him a copy of *Unto This Last* to beguile the long journey. Gandhi began reading the book as soon as his train left the station. He later told a reporter from the *New York Post* that this was the greatest turning point in his life. In his autobiography, *The Story of my Experiments with Truth*, Gandhi explained that

I discovered some of my deepest convictions reflected in this great book of Ruskin's and that is why it so captured me and made me transform my life. A poet is one who can call forward the good latent in the human breast...

The teachings of *Unto This Last* I understood to be:

1. That the good of the individual is contained in the good of all.

2. That a lawyer's work has the same value as the barber's, inasmuch as all have the same right of earning their livelihoods from their work.

3. That a life of labour – the life of the tiller of the soil and the handicrafts-man – is the life worth living.

The first of these I knew. The second I had dimly realized. The third had never occurred to me. *Unto This Last* made it as clear as daylight for me that the second and third were contained in the first. I arose with the dawn to reduce these principles to practice.

Four years later, in 1908, he published his (very loose) translation or paraphrase of the book into Gujarati. He entitled it *Sarvodaya*, or 'The Welfare of All'.

MARCEL PROUST

Marcel Proust, as one of his editors puts it, spent six years of his life – from 1899 to 1905 – as an 'apprentice' of Ruskin: by turns disciple, pilgrim, critic and transla-tor. (Three significant deaths punctuated this apprenticeship: Ruskin in 1900,

Proust's father in 1903, and his mother in 1905.) He first read Ruskin at the age of 28, while on holiday in Evian-les-Bains, and though his initial reactions were far from passionate, he soon went on to develop what amounted to an infatuation for the sage. On his return to Paris, he buried himself in the study of all the works by Ruskin so far translated into French. Then he began to tackle them in English. By February 1900 he already knew five of Ruskin's books 'par cœur'. (The French phrase is not a precise equivalent of the English 'to know by heart': he meant that he lived with them, as it were, in his heart.)

Proust's obituary notice for Ruskin was soon followed by other critical essays. In 1904, the same year that Gandhi had his Ruskinian revelations, Proust published his translation, with Preface, of *The Bible of Amiens*. In 1906, he followed this with *Sesame and Lilies*. By this time he was beginning to turn slightly against Ruskin, suspecting him of hypocrisy in certain areas. Despite this waning of affection, Proust still called him 'one of the greatest writers of all time and all nations.' Proust scholars have demonstrated that Ruskin's presence permeates *A la recherche du temps perdu* in all manner of subtle ways, including its styles.

LABOUR POLITICS

In 1906, the radical journalist W. T. Stead carried out a survey to discover which books and authors had most inspired those forty-five politicians who made up the first Labour Party intake to the House of Commons. Ruskin easily led the field, with *Unto This Last*. (The runners up, in order, were: the Bible, Dickens, Henry George, Carlyle, J. S. Mill – Ruskin's old enemy – Scott, Shakespeare and Bunyan.) It seems fair to conclude that the early Labour Party was far more Ruskinian than Marxist. By 1910, more than 100,000 official copies of *Unto This Last* had been sold, and there were several unauthorised editions in the United States. It had also been translated into French, Italian and German. It became an enormous influence on the Japanese Christian Socialist movement, and then on the followers of Gandhi. It is, simply, one of the books which has shaped our world. It has been said that Martin Luther King studied its pages; as, perhaps (and, if so, alas) did Mao Tse-Tung.

THE GREAT DECLINE

But for much of the early to middle twentieth century, the fact that Ruskin was a living force in the world became almost impossible for the uninitiated to detect – save, perhaps, in the field of modern architecture, for Ruskin was greatly admired by the likes of Frank Lloyd Wright, Walter Gropius and even Le Corbusier.

From 1903 to 1912, the thirty-nine volume Library Edition, edited by E.T. Cook and Alexander Wedderburn appeared on the market. It was a magnificent piece of work, with perhaps the best index (a whole large volume) ever compiled, but to the editors' disappointment, it was not a commercial success – a grave warning sign that Ruskin's name on a book no longer guaranteed healthy sales. One by one, the individual titles began to fall out of print.

The Edwardians and the generations which followed them began to cast a cold eye back on their parents and grandparents; and the First World War bred an

even more bitter view of the Victorians, since it appeared to the intelligent young that it was the elderly survivors of the widow at Windsor who had led Europe into mass slaughter. By as early as 1910, E. M. Forster's novel *Howard's End* was poking gentle fun at the lower-middle class Leonard Bast for reading *The Stones of Venice*; while the publication of Lytton Strachey's *Eminent Victorians* in 1918 provides a useful marker for the consolidation of anti-Victorianism.

'Victorian' now became for a while a curse word, a sneer, summoning up bogeymen of greed, ugliness, materialism, sentimentality, smugness and hypocrisy – that is, pretty much all the things that Ruskin had railed against, as they would have found out had they bothered to open his books. But Ruskin was unthinkingly bracketed with the likes of Palmerston and Samuel Smiles. A new generation either despised him – as D. H. Lawrence did – or lost all awareness of him. By 1938, the critic Cyril Connolly (who himself rather admired Ruskin) could confidently refer to him as a forgotten Victorian.

Ruskin still had his handful of sturdy loyalists, to be sure. In 1919, there were centenary celebrations in London and Oxford, though these were rather muted. In1921 George Bernard Shaw – who continued to admire the Master – published *Ruskin's Politics*: 'The reason why the educated and cultured classes in this country found Ruskin incredible was that they could not bring themselves to believe that he meant what he was saying, and indeed shouting.'

In 1924, Joan Severn died. Arthur, who took little interest in Brantwood, in effect abandoned it to the incompetent care of their youngest daughter, Violet, who allowed it to deteriorate badly. Ruskin's material legacy was looking as fragile and outdated as his intellectual legacy

The full irony of this plummet on the intellectual stock market deserves some savouring. It was precisely in the years when 'thinking' people ceased to care much about what Ruskin had to say about art – or, come to that, about anything – that his ideas about society were being made into realities as never before: that is to say, in the days when the modern British Welfare State was being planned and established. William Beveridge, the author of the famous 1942 Report which established its scope and nature, had attended the philanthropic East End institution Toynbee Hall during its most Ruskinian phase; and so had Clement Attlee, Prime Minister of the Labour Government which had won the 1945 election with a huge majority.

JOHN HOWARD WHITEHOUSE

That the faltering flame of Ruskin's reputation was kept alive at all was due to the efforts of a devoted few. The greatest hero of this period is J. H. Whitehouse – a dogged champion of Ruskin's cause during the bleakest years. Born in 1873, he began his adult life as a young clerk who had helped to organise the thriving Ruskin Society of Birmingham. He went on to become the editor of its journal *St George*. As he grew more successful in life, he devoted more and more time and money to keeping the Ruskinian faith.

In 1919, he founded a school partly based on Ruskin's principles, at Bembridge, on

John Howard Whitehouse teaching from Ruskin's drawings at Bembridge. Many of the works illustrated in this book were collected by Whitehouse; the Castelbarco Tomb, 1869 (illustrated on p. 96) can be seen in the middle row

the Isle of Wight. Ten years later, he extended the school by building the Ruskin Galleries. (It was also in 1929 that Helen Gill Viljoen discovered Rose La Touche's diary, hidden behind a bookcase in Brantwood.) Arthur Severn died in 1931, and many of Ruskin's surviving possessions – for the Severns had begun selling off drawings and other valuables not long after his death – were dispersed in sales.

In 1932, Whitehouse managed to buy Brantwood, began to restore it, and in 1934, opened it to the public as a Ruskin memorial – a function it carries out, in greatly improved manner, to the present day. He began the slow process of collecting the treasures that the Severns had dispersed, and did well at the task. He died in 1955; all admirers of Ruskin should honour his memory. His chairmanship passed to a former Bembridge pupil, R. G. Lloyd (later Lord Lloyd of Kilgerran), and in 1957 James Dearden was appointed curator of the collection. Dr. Dearden – another Bembridge pupil – is also a Trustee and former Master of the Guild of St George.

REVIVALS

The darkest years were from about 1920 to the 1960s. Then, by fits and starts, the academic world on both sides of the Atlantic began to rediscover what had been lost in the decades of anti-Victorianism. In 1961, the American scholar John D. Rosenberg published a fine monograph, *The Darkening Glass: A Portrait of Ruskin's Genius*, and also brought out an excellent anthology, *The Genius of John Ruskin*. In 1964, Sir Kenneth Clark, noting that Ruskin's work was almost entirely

The Ruskin Library, University of Lancaster. Its architect, Richard MacCormac described the idea of it standing 'on a plateau of wavy meadow grass like an island surrounded by water, a metaphor for Ruskin's Venice.' Inside, the building is deliberately church-like, with the collection protected within a shrine, a building within a building

out of print, published the appealing if unrepresentative anthology *Ruskin Today*. In 1969, James Dearden organised a conference at Brantwood which led to the foundation of the Ruskin Association.

Biographies, critical writings, exhibitions and exhibition catalogues, conferences and conference papers began to appear from the early 1970s onwards, and a rising generation of scholars and teachers began to return Ruskin to the syllabus, and to the minds of their students. Many of them soon found that, far from being out-moded, some of Ruskin's writings had a still greater pertinence for the twentieth century than they had possessed for their contemporaries. The former Marxist art critic Peter Fuller launched a widely-read magazine with the significant title *Modern Painters*, and, before his premature death in a road accident, was devoted to re-considering Ruskin's aesthetics in a series of articles and books.

In 1993, a Ruskin Foundation was created, to take on the management of the archive collected and preserved by Whitehouse – which, it was decided, would be housed in a new building on the campus of Lancaster University, reasonably close to Brantwood; Lancaster had started a Ruskin Programme under the direction of Prof. Michael Wheeler. That library, a splendid building designed by Sir Richard MacCormac, was duly opened in 1998. In 2000, the centenary of Ruskin's death was marked by a flurry of activities, including a major exhibition at Tate Britain: *Ruskin, Turner and the Pre-Raphaelites*. There were radio programmes, a television documentary, newspaper articles, conferences, books... The extent to which Ruskin had once again become a name to conjure with was well indicated by the entry for him, written by Robert Hewison, in the new *Dictionary of National Biography*. To the surprise of almost everyone who considered the matter, the length of this 2001 entry was almost exactly the same as that which appeared in the first edition of 1901.

1890-1900 AND BEYOND

Has Cyril Connolly's forgotten Victorian now been adequately remembered, then? Not altogether. As I write this chapter, scandalously few of Ruskin's many, many works are available in reasonably priced, well-edited editions. (Some of us involved in the making of this book are trying to do something about this.) Two honourable exceptions are the Penguin *Unto This Last*, edited by Clive Wilmer, and the Everyman *Praeterita*, edited by Tim Hilton. Some others are available in reprint form: *caveat emptor*. For those who don't mind electronic reading, the Library Edition is now available on CD-ROM. Otherwise, and for the time being, new readers of Ruskin will have to join the ranks of veteran readers, and haunt second-hand bookshops or their web-sites.

To read Ruskin is to enter on a mental adventure. He will sometimes baffle you, surprise you, confuse you and even infuriate you. He will ask you uncomfortable questions about the way you live and the things you take for granted, and anger you into violent disagreements or – worse! – into shame-faced agreement. He will help you open your eyes to things you have seen all your life, such as clouds and rocks and leaves, and let you see them as if you had never seen them before. Or he will lead you to look truly at a some rare things: perhaps a piece of wrought iron-work beneath an old window in a Swiss village ; perhaps a painting by Carpaccio or Cimabue. Some of his prose is plain as a children's book or a Bible, some as intricate as a Persian tapestry. Almost all of it shines with ardent life and quicksilver intelligence, and a few passages are among the most beautiful ever achieved in the English language. Please read him.

WHAT NOW?

If this book has encouraged you to pursue the matter further, there are various starting points.

Apart from tracking down and reading Ruskin's works, one of the simplest and most enjoyable is to visit:

BRANTWOOD

Brantwood today, looking towards Coniston past the dining room

A museum and gardens based in Ruskin's long-term home overlooking Coniston water, now administered by the Ruskin Foundation (www.ruskin.org.uk).

The house itself contains a generous collection of mementoes from Ruskin's life, including books, drawings and paintings by himself and others, photographs, geological specimens, musical instruments, clothes and other household possessions. The fine gardens include an allegorical walk based on Dante's ascent from Hell to Heaven, and the rough-hewn stone chair on which Ruskin liked to sit and contemplate water in his later years. Among the other amenities are a boathouse – which contains Ruskin's beloved 'Jumping Jenny' – a café, a bookshop (which usually has a number of second-hand copies of books by and about Ruskin) and two exhibition spaces, which host several displays of modern art every year.

The upper storey of Brantwood has been developed into a flat for visiting scholars and thinkers, with a meeting room for small conferences. Brantwood is open to the public for much of the year, though with more limited visiting hours in the winter months. For further details, contact Brantwood, Coniston, Cumbria, LA21 8AD; tel: 015394 41396; www.brantwood.org.uk.

RUSKIN MUSEUM

A couple of miles away, in Coniston village, is the independent Ruskin Museum (Cumbria LA21 8DV; tel 015394 41164; www.ruskinmuseum.com), founded by W. G. Collingwood in 1901 and substantially renovated in 1999 with a National Lottery grant. Purists note: the Museum is dedicated as much to local culture and history as to Ruskin.

A short walk away is the graveyard where Ruskin's mortal remains are buried.

RUSKIN LIBRARY

The Ruskin Library, on the campus of Lancaster University, holds the single largest collection of books, pictures and archive material relating to Ruskin, on behalf of the Ruskin Foundation. A reading room is open by appointment, and galleries with changing displays are open to the public daily. Lancaster University, Lancaster LA1 4YH; tel: 01524 593587; www.lancs.ac.uk/users/ruskinlib/.

RUSKIN SOCIETY

Affiliated to the Ruskin Foundation is the Ruskin Society, which organises talks, visits and other events of interest to Ruskinians. There is a small annual membership fee. For details, contact the society c/o The Old Brew House, 20 Cole Green, Nr Hertford, Herts SG14 2NL.

How to be Rich: *a comic book version of* Unto this Last *sponsored by the Ruskin Foundation*

WHAT NOW?

Another aspect of the Ruskin Foundation is its work in education, the rehabilitation of criminal offenders and other charitable work, most of it under the banner heading of RUSKIN FOR ALL. Perhaps the most well-publicised, and occasionally controversial venture which the Foundation has sponsored has been the publication of comics – two to date – which attempt to translate some of Ruskin's key ideas into an idiom both attractive and comprehensible to older children, or to readers with limited English. Drawn by the brilliant cartoonist Hunt Emerson, and scripted by the present author, the two comics to date are *How to be Rich* (an ironic title, as the reader soon comes to learn; the strip rapidly updates the parables and arguments of Ruskin's *Unto This Last* for the world of globalization, fast food, drug dealing and trashy celebrity culture) and *How to See,* a more eclectic sampling of Ruskin's ideas about educating the eye. More than 10,000 copies of each of these comics have been used in schools, prisons and other institutions, where they have met with almost unanimous enthusiasm – despite the misgivings of some Ruskinians. There are plans for a third and final volume, *How to Work,* which will return to Ruskin's discussions in 'The Nature of Gothic' and elsewhere on the miseries and joys of work and enforced idleness.

Finally, the Foundation also sponsors a newspaper, the *Haverigg Seagull*, which is written and produced almost entirely by inmates of the nearby prison. In addition to providing an outlet for the inmates' individual points of view, working on the paper also trains participants to NUJ standards.

THE GUILD OF SAINT GEORGE

continues its charitable work as begun by Ruskin, mainly in the areas of education in fine art and craftsmanship, the development of the rural economy, and industrial design. Among its recent accomplishments was the inauguration of a nationwide 'Campaign for Drawing', which proved highly successful in showing people of all ages both the pleasures and the usefulness of developing the skills of hand and eye. It publishes an annual journal for the members, who are known as Companions, and holds an annual conference.

The Guild also owns farmlands and orchards, which are being restored and developed as Ruskin might have wished; and the contents of the Ruskin Gallery, now housed in Sheffield's municipal art gallery. For details contact: Millennium Galleries, Arundel Gate, Sheffield S1 2PP; tel: 0114 2782600; www.sheffieldgalleries.org.uk

RUSKIN TODAY

is a small, informal group of interested people from various parts of the Ruskin world, which meets at irregular intervals in an attempt to keep all sides aware of developments.

WEBSITES

There are many websites devoted to aspects of Ruskin's writings and life. The Wikpedia entry on Ruskin, though far from reliable in every point of information in the main body of its text, provides a handy short-list.

RECOMMENDED READING

Almost all of the following are either still in print, or reasonably easy to find.

1. Modern Editions

Dinah Birch, (ed.), *John Ruskin: Selected Writings* (Oxford World's Classics)
Sir Kenneth Clark (ed.), *John Ruskin: Selected Writings* (Penguin Classics)
Andrew Hill (intr.), *Unto This Last* (Pallas Athene)
Tim Hilton (ed.), *Praeterita* (Everyman)
J. G. Links (ed), *The Stones of Venice* (abridged) (Pallas Athene)
William Morris (intr. and designed), Robert Hewison, Tony Pinkney and Colin
 Franklin, (commentary), *The Nature of Gothic* (Kelmscott, facsimile Pallas Athene)
Sarah Quill, *Ruskin's Venice: The Stones Revisited* (extracts, with photographs) (Lund
 Humphries)
John Rosenberg (ed.), *The Genius of John Ruskin* (University of Virginia)

2. Biographies

a. Period:
 W. G. Collingwood, *The Life and Work of John Ruskin* (Methuen)
 E. T. Cook, *The Life of John Ruskin* (George Allen)
b. Modern:
The major biography of recent years has been by Tim Hilton:
 John Ruskin: The Early Years (Yale)
 John Ruskin: The Later Years (Yale)
Of the many other biographies – most of them worth reading – the richest is
probably Derrick Leon's *Ruskin the Great Victorian* (RKP). Robert Hewison's *John
Ruskin* (OUP) and Francis O'Gorman's *John Ruskin* (Sutton) are refreshingly brief,
readable and sound. More detailed are John Dixon Hunt's *The Wider Sea: A Life
of John Ruskin* (Dent) and John Batchelor's *John Ruskin: No Wealth but Life* (Chatto).
James Dearden's *John Ruskin: An Illustrated Life of John Ruskin 1819-1900* (Shire
Publishing) is crammed with fascinating images of Ruskin, period and modern.

3. Criticism and commentary

P. D. Anthony, *John Ruskin's Labour* (CUP)
Linda Austin, *The Practical Ruskin* (Johns Hopkins)
Dinah Birch, *Ruskin's Myths* (Clarendon)
Stuart Eagles, *After Ruskin* (OUP)
Elizabeth K. Helsinger, *Ruskin and the Arts of the Beholder* (Harvard)
Robert Hewison, *John Ruskin and the Argument of the Eye* (Thames & Hudson)
Robert Hewison, Ian Warrell and Stephen Wildman, *Ruskin, Turner and the
Pre-Raphaelites* (Tate)
Robert Hewison, *Ruskin on Venice* (Yale)
John A. Hobson, *John Ruskin, Social Reformer* (Adamant Media)
Francis O'Gorman, *Late Ruskin: New Contexts* (Ashgate)
Marcel Proust, *On Reading Ruskin* (Yale)
John Rosenberg, *The Darkening Glass* (Columbia)
John Unrau, *Looking at Architecture with Ruskin* (Thames & Hudson)
Paul H. Walton, *The Drawings of John Ruskin* (Hacker)
Michael Wheeler, *Ruskin's God* (CUP)

SOURCES

Brief references are given below to quotations unattributed in the text.

p.12 quotation from David Thomson, England in the Nineteenth Century, 1963, p. 32.

pp. 15-6 Ruskin, Notes on the Present State of Engraving in England (1876)

p. 17 Condition of the Working Class in England, 1845, (trans. 1887)

p. 19 Praeterita vol I, 5

pp. 20-1 Praeterita vol I, I

p. 21 Praeterita vol I,122; W. G. Collingwood, The Life and Work of John Ruskin, vol I, p. 25

p. 22 Praeterita vol I, 38

p. 24 Praeterita vol I, 83

p. 28 Praeterita vol I, 87

p. 29 Praeterita vol I, 180

p. 31 Praeterita vol I, 210

p. 32 Praeterita vol I, 212

pp. 32-3 Praeterita vol I, 226

p. 33 Praeterita vol I, 231

p. 33-4 Praeterita vol I, 227

p. 35 Praeterita, vol II, 17; vol II, 19

p. 35 Praeterita, vol II, 60

p. 39 quoted Praeterita, vol II, 60

p. 42 Brontë quoted W. G. Collingwood, The Life and Work of John Ruskin, (1893), vol I, p. 162; Eliot quoted M. H. Spielmann, John Ruskin (1900)

p. 46 Letter to his father, 24 Sep 1845; Praeterita II, 140

p. 49 Ruskin quoted J. H. Whitehouse, Ruskin the Prophet (1920), p. 122

pp. 49-50 Effie and Ruskin quoted M. Lutyens, Millais and the Ruskins (1967), p. 191

p. 52 quoted Library Edition vol 8, introduction

p. 54 quoted M. Lutyens, Effie in Venice, (1965) p. 146 and J. D. Hunt, The Wider Sea (1982), p. 205

p. 63 quoted M. Lutyens, Effie in Venice, (1965) p. 170-1

p. 66 quoted Library Edition, vol. 36, p. 115

p. 67 quoted M. Lutyens, Millais and the Ruskins (1967), p. 9

p. 71 Canon Dixon, quoted in E. P. Thompson, William Morris, 1955

p. 74 Praeterita, vol III, 27

pp. 77-8 Praeterita, vol III, 23

p. 85 Carlyle quoted in E. T. Cook, The Life of John Ruskin, 1911

pp. 86-87 quoted J. D. Hunt, The Wider Sea (1982) p. 272

pp. 88-9 Letter quoted in E. T. Cook, The Life of John Ruskin, 1911

p. 99 Modern Painters V

p. 101 Letter to Mrs Cowper, quoted J. D. Hunt, The Wider Sea (1982) p. 331

p. 106 Fors Clavigera 5

p. 107 Letter to Norton, quoted J. D. Hunt, The Wider Sea (1982) p. 343

p. 116 Letter quoted in E. T. Cook, The Life of John Ruskin, 1911

pp. 118-9 quoted Library Edition, vol. 38, p. 172

pp. 121-2 Preface, The Queen of the Air

p. 125 A. C. Benson, Ruskin, a Study in Personality (1911)

p. 126 Letter to Norton, quoted J. Batchelor, John Ruskin: No Wealth but Life (2000) p. 301

p. 128 Brantwood Diary, quoted J. Batchelor, John Ruskin: No Wealth but Life (2000) p. 304

p. 129 quoted J. Batchelor, John Ruskin: No Wealth but Life (2000) p. 306

p. 133 quoted J. Batchelor, John Ruskin: No Wealth but Life (2000) p. 312

p. 134 quoted Collingwood, The Life and Work of John Ruskin (1893), vol II, p. 511

p. 135 Praeterita, III, 86

pp. 137-8 Fors Clavigera 32

p. 141 quoted J. Batchelor, John Ruskin: No Wealth but Life (2000) p. 320

pp. 141-2 F. Harrison, Ruskin (1902)

p. 142 H. Caine, Recollections of Rossetti (1882); J. H. Whitehouse, Ruskin the Prophet (1920)

p. 143 quoted W. Kemp, The Desire of My Eyes: The Life and Work of John Ruskin (1990), p. 463

pp. 143-4 quoted Derrick Leon, Ruskin: The Great Victorian (1949), p. 578

P. 146 quoted W. Kemp, The Desire of My Eyes: The Life and Work of John Ruskin (1990), p. 186

ILLUSTRATIONS

Unless otherwise noted, all illustrations are by Ruskin, are on paper, and are from the Ruskin Library, Lancaster University (Ruskin Foundation).

Front Cover: Detail of illustration p. 8

p. 1 Study of Roses, from the dress of Spring in Botticelli's 'Primavera', 1874. Pencil, ink, watercolour and bodycolour, 16.2 x 24.2 cm. (RF 1168)

p. 2 Spiral Relief, North Transept Door, Rouen Cathedral, 1882, inscribed 'Feb. 1882'. Sepia and bodycolour on cream card, 21.3 x 17.2 cm. (RF 1197)

p. 4 Mountain Rock and Alpine Rose, 1844 (or 1849?). Pencil, ink, chalk, watercolour and bodycolour 29.8 x 41.4 cm. (RF 1395)

p. 7 Study of a lion, c. 1870. Pencil, black ink, watercolour and bodycolour, 12.4 x 17.3 cm. (RF 936-3)

p. 8 Self Portrait, 1874. Pencil, 25.4 x 20.4 cm. (RF 991)

p. 11 Flower Study – Sketches of Parts of Flower. Pencil and watercolour, 9.4 x 12.2 cm. (RF 1270)

p. 13 Funnels and sails, page from Ruskin's diary notebook, 1847. Pencil, ink and watercolour, page 25.2 x 20 cm. (RF MS 5)

p. 18 John Ruskin aged three and a half, 1822, by James Northcote. Oil on canvas, 126.7 x 101 cm. Courtesy of the National Portrait Gallery, London

p. 19 Ruskin's birthplace at 54 Hunter Street; photograph

p. 20 John James Ruskin, 1848, by George Richmond. Chalk, wash and bodycolour, 52.4 x 39.2 cm. (RF 420)

p. 20 Margaret Ruskin, 1825, by James Northcote. Oil on canvas, 75 x 62.2 cm. (RF 758)

p. 21 Conway Castle, by John James Ruskin, c. 1795-1800. Watercolour, 26 x 35.5 cm. (RF 458)

p. 21 Peach and Grapes, by William Henry Hunt, 1858. Pencil, watercolour and bodycolour, 37 x 44.5 cm. (RF 735)

p. 22 No. 28, Herne Hill, Pencil and ink, 12 x 14.3 cm. (RF 1316)

p. 22 Ruskin's House, Herne Hill: back of house; view from Nursery, of sunrise over Forest Hill; Ruskin's old Nursery, by Arthur Severn. Ink, pencil and bodycolour on paper, each 18 x 11.5 cm. (RF 514, 516)

p. 23 Map of Scotland, inscribed 'March 27 John Ruskin aged nine 1828'. Ink and watercolour, 25 x 20 cm. (RF 951)

p. 24 Opening from the 'First Sketchbook,' 1829-32. Pencil, 21 x 26 cm (open). (RF 1518)

p. 25 Title page to the 'Iteriad', 1831. Ink; size of notebook 25 cm. Beinecke Rare Book and Manuscript Library, Yale University, New Haven

p. 26 Merton College and Magpie Lane, Oxford, c.1838. Pencil and bodycolour, 45.8 x 27.5 cm. (RF 967)

p. 27 Cameo portrait of Ruskin, by Constantin Roesler Franz, 1840. Cameo, cut in pink and white shell. (RF 721)

p. 28 Page from Italy by Samuel Rogers, 1830, with vignette by J. M. W. Turner

p. 28 An English family at Calais; a traveller contemplating the Alps, 1833, from Ruskin's album entitled Poems 1833. Ink, size of notebook 20 cm. Beinecke Rare Book and Manuscript Library, Yale University, New Haven

p. 29 Calais from the sea, probably 3 June 1835; inscribed 'Calais from the Sea JR'. Pen and ink over pencil, 18 x 26.8 cm. (RF 1184)

p. 29 The Piazzetta, Saint Mark's and the Entrance to the Ducal Palace, Venice, 1835, inscribed in black ink: 'Part of St Mark's Church and entrance to Doges Palace. VENICE J.R.' Pencil and ink, 26.7 x 36.4 cm. (RF 1055)

p. 30 Mount Pilatus, Lake Lucerne, 1835-36. Inscribed ' This drawing done by Prof. Ruskin was given to me. F. Crawley'. Pencil, ink, watercolour and bodycolour, 24.8 x 29.5 cm. (RF 1437)

p. 31 Henry Acland, by J. E. Millais, 1853. Pencil and watercolour, 36.8 x 26.3 cm. (RF 355)

p. 32 Christ Church, Oxford, 1842; watercolour reproduced in the Library Edition of Ruskin's Works, vol. 35, opposite p. 188

p. 32 'Mr. Adams' pretty house of sixteenth-century woodwork', c. 1836. Pen and ink drawing reproduced in the Library Edition of Ruskin's Works vol. 35, opposite p. 199

p. 33 Dr. Buckland lecturing at the Ashmolean, 1822, contemporary print, reproduced in The Life and Correspondence of William Buckland by Mrs. E. O. Gordon, 1894

p. 34 Opening and illustration from Ruskin's article 'The Poetry of Architecture', 1838, in J. C. Loudon's Architectural Magazine

p. 35 Winchelsea, by J. M. W. Turner, 1828. Watercolour, touched with bodycolour, with graphite and some scraping-out, 29.3 x 42.5 cm. © Trustees of the British Museum

p. 36 'Pass of Faido: Simple Topography' and 'Pass of Faido: Turnerian Topography', engravings published in Modern Painters IV, 1854. Library Edition, vol. 6, between pages 34 and 35

p. 37 The Annunciation, after Fra Angelico, 1845. Pencil, 21.2 x 24.5 cm. (RF 1114)

p. 38 Bridge at Terni, 1841. Pencil and watercolour, 44 x 31 cm. (RF 1006)

p. 39 'The Author of Modern Painters', photogravure after watercolour of 1843 by George Richmond. (RF 813)

p. 40 Casa Contarini Fasan and other palaces on the Grand Canal, Venice, May 1841. Photograph after watercolour, original 42.7 x 31.6 cm.

p. 40 Titlepage to The King of the Golden River, by Richard Doyle, 1851

p. 41 The Ruskin House, 163 Denmark Hill, by Arthur Severn. Pencil and wash, 22 x 28 cm. (RF 794)

p. 42 The Slave Ship or 'Slavers Throwing overboard the Dead and Dying —

ILLUSTRATIONS/INDEX

INDEX

References to Ruskin have been collected under the headings Life; Homes of; Writings and publications; Publications edited by others; Images of; and Images by.
Numbers in italic refer to illustrations and captions.

INDEX